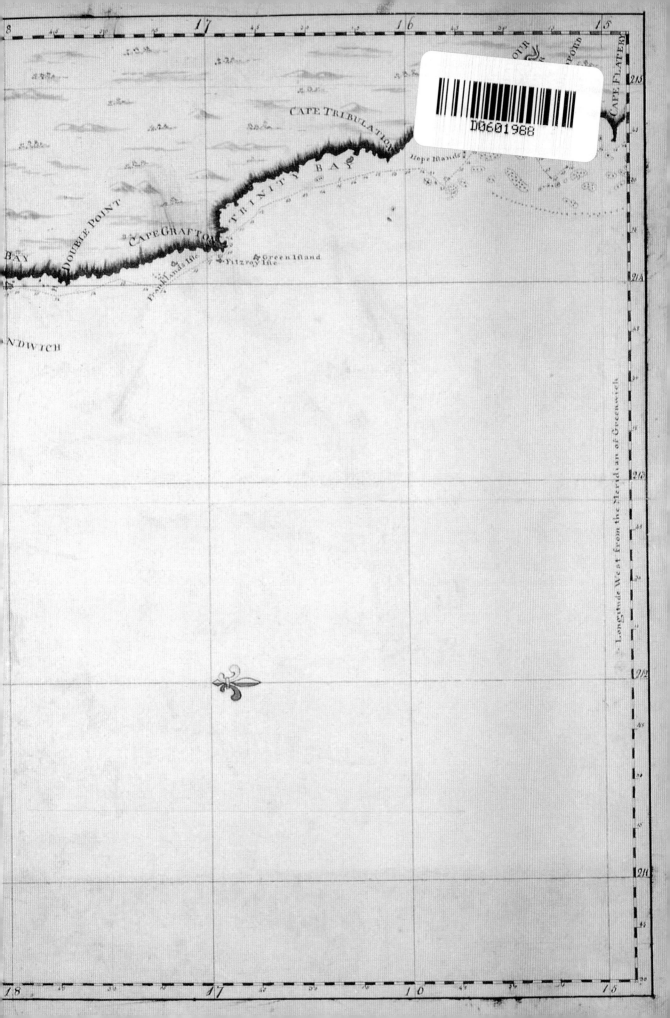

8        17        16        15

CAPE TRIBULATION

Hope Islands

CAPE FLATERY

215

TRINITY BAY

DOUBLE POINT

CAPE GRAFTON

Green Island

Franklands Isle    Fitzroy Isle

BAY

214

NDWICH

Longitude West from the Meridian of Greenwich

213

212

211

18        17        16        15

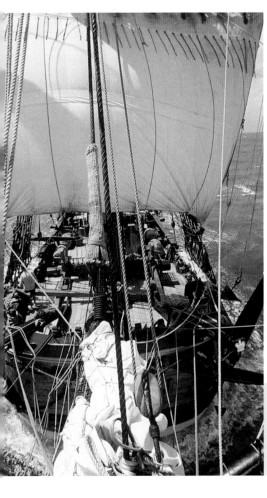

# The Ship

Retracing Cook's *Endeavour* Voyage

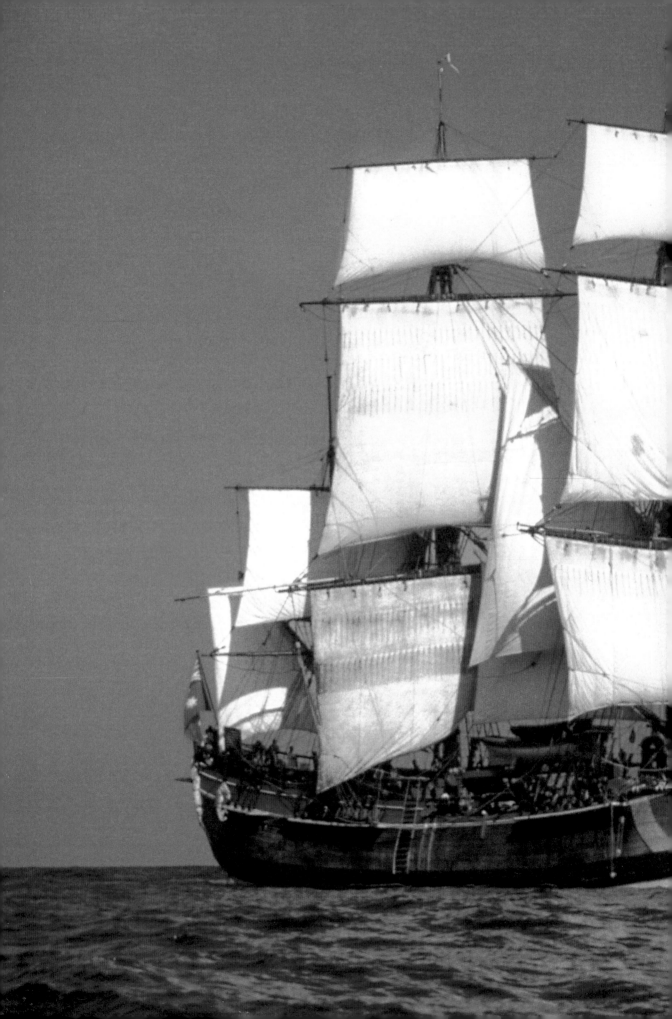

# The Ship

Retracing Cook's *Endeavour* Voyage

Simon Baker

BBC

# In memory of Peter

This book is published to accompany the television series *The Ship*, first broadcast on BBC2 in 2002.

Series Producer and Director: Christopher Terrill
Executive Producer: Laurence Rees
Production Executive: Ann Cattini
Associate Producer: Simon Baker

Published by BBC Worldwide Ltd, Woodlands,
80 Wood Lane, London W12 0TT

First published 2002
Copyright © Simon Baker
The moral right of the author has been asserted.

ISBN 0 563 53463 X

Editorial Director: Shirley Patton
Project Editors: Patricia Burgess, Martin Redfern
Art Director: Linda Blakemore
Designer: Martin Hendry
Picture Researchers: Deirdre O'Day, Miriam Hyman
Indexer: Margaret Cornell
Production Controller: Christopher Tinker

Set in Adobe Garamond and Helvetica Neue
Printed and bound in Italy by LEGO SpA
Colour separations by Kestrel Digital Colour, Chelmsford

# Contents

 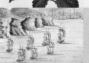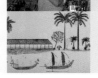

# Introduction

Captain James Cook (1728–79) has been lauded as a founding father of modern Australia and New Zealand, and celebrated as an icon of discovery and exploration. To many he is a hero, rising from humble origins to head three epic voyages around the world. By the end of his career, he had charted the Pacific, the least-known part of the world in the eighteenth century, and in so doing had mapped a quarter of the Earth's surface. This achievement began with his first circumnavigation in the *Endeavour*. For this voyage Cook's brief was to observe an eclipse of the sun from the island of Tahiti and then to search for *Terra Australis Incognita*, a southern continent presumed to exist but that no European had ever seen. It was during his search that Cook charted numerous islands of the Pacific and became the first European both to explore and survey the whole of New Zealand, and to 'discover' the east coast of New Holland, present-day Australia.

In recent years, however, Cook has become a more ambivalent figure of history. As a forerunner of British imperialism, he is a symbol of the colonialism, dispossession and oppression that sometimes followed in the wake of his explorations. Once celebrated for his uniqueness, his steadiness of purpose and his humane approach to the people and societies he encountered in the course of his travels, he has also been questioned on these very same grounds. Who was the real Captain Cook? What was the significance of his achievements then? What do they mean today?

Much has been written about Cook and his voyage on the *Endeavour*. To help us try to answer the questions raised the BBC history department decided to follow in his footsteps – or in this case, sail in his wake. A crew of volunteers and specialists would board a replica of the *Endeavour* and retrace a single leg of Cook's voyage in the Pacific. This would be a unique and illuminating way of coming closer to understanding both the man and the voyage. History seen from the same ship, the same seas and the same landscape would, it was hoped, shed new light on the past and provide fresh insights.

We would leave behind the modern conveniences of instant communication, speedy travel and creature comforts, and embark on a voyage that would take us out of the world we were used to and allow us a glimpse into the past. We would learn things that could not be gleaned from books alone. Cook and his crew travelled approximately 40,000 miles (64,000 km) simply by force of wind, often through uncharted waters, and in a wooden vessel not more than 106 feet (32 metres) in length. By sailing for six weeks in a replica of his ship we would come closer to understanding what this actually meant.

But which leg of Cook's voyage would we retrace? A key moment in 1770, when Cook was preparing to leave the South Pacific and sail home, suggested that we should begin in Australia. By that point Cook had followed his instructions from the Admiralty in London to the letter: he had successfully reached Tahiti and observed an astronomical eclipse; he had explored and charted the Society Islands; then, in search of the mythical

The replica *Endeavour* was a faithful reproduction of James Cook's ship and exercised demands on the BBC's volunteer crew that reflected those imposed on our eighteenth-century counterparts. Six weeks on board would challenge our romantic ideas about what it would have been like to sail in the age of 'scientific voyaging'.

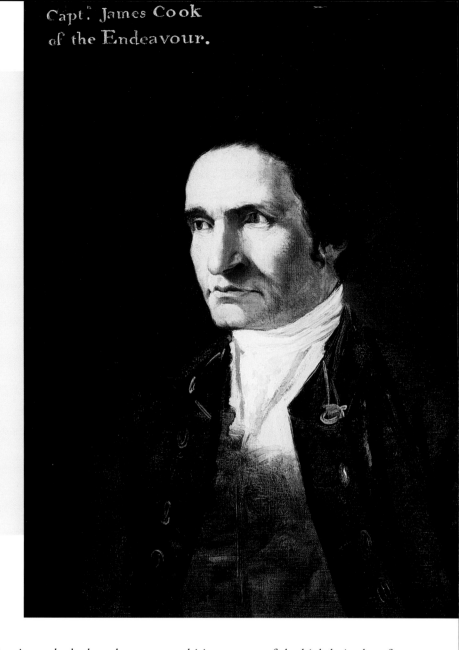

Capt. James Cook
of the Endeavour.

Captain James Cook, painted in the undress uniform of a junior captain, by William Hodges, the artist who accompanied him on his second voyage to the South Pacific between 1772 and 1775. This portrait is considered by some to be the truest likeness of Cook.

Great Southern Continent, he had made a more ambitious sweep of the high latitudes of the South Pacific than any European explorer before him; finally, he had become the first European to systematically explore and survey the coasts of New Zealand, a feat he had achieved in a mere six months. Now all he had to do was make his way home.

Instead of sailing straight for England, however, Cook went beyond his instructions and embarked on what was to be the greatest success of his three-year voyage. Even though he had already accomplished more than his predecessors in the Pacific, and despite the fact that his crew were eager to return to Britain, Cook decided that he 'had other and more greater objects in view, viz. the discovery of the whole Eastern Coast of New Holland'. This ambitious decision literally put that part of present-day Australia on the map.

This is where the BBC voyage of 2001 picked up the story. Over six weeks we would follow the route of Cook's original voyage between Cape Grafton, near present-day

Cairns in Australia, and Batavia, present-day Jakarta in Indonesia. This leg would take us to several remote places where some of the most momentous and exciting episodes of the original voyage took place. On the Great Barrier Reef, for example, the *Endeavour* ran aground, forcing Cook and his crew to beach the ship and set up camp on land while repairs were carried out. It was during this time that they made their first and only sustained contact with the Aboriginal people. On reaching Possession Island, off the northernmost tip of Queensland, Cook laid claim to his 'discovery' of the eastern coast of Australia in the name of King George III. On the final stretch to Batavia the crew were suffering, so Cook dropped anchor at the paradise island of Savu to take on fresh provisions. This 3500-mile (5600-km) leg of the *Endeavour*'s journey had encompassed danger, cultural contact, imperial possession and the rigours of long voyaging. By revisiting the sites of these experiences, we hoped to reach a better understanding of the voyage as a whole.

The BBC crew consisted of volunteers and specialists, some of whom had previous experience at sea. All of us nonetheless had to be taught how to sail the replica square-rigged *Endeavour* by members of its sixteen permanent crew. Like Cook's men, the volunteers would be divided into three watches to carry out the work of sailing, cleaning and running the ship. We would be hauling and easing ropes, furling and setting sails, dropping and weighing anchor, lowering and hoisting longboat and yawl, scrubbing decks, climbing the rigging, repairing the sails, turning our hands to the many tasks that travelling under sail requires. Sometimes it would be unremittingly hard work, at others simply routine. But whether we were busy or bored, the voyage would open our eyes to the realities of life at sea and help us imagine what it would have been like for the company on the original *Endeavour*.

In other respects too we would be emulating life on board the original *Endeavour*: we would sleep in hammocks, wash on deck with buckets of salt water and exist on the same diet as Cook's men – porridge, salt beef and pork, cheese, hard tack biscuit, soup, suet pudding, sauerkraut and, for as long as they lasted, fresh vegetables and fruit. Chickens, kept in a coop on deck, would provide eggs, and a goat would give a small quantity of milk, just as on the original *Endeavour*. Fresh fish, caught from the ship, would supplement our diet whenever possible.

Inevitably, there were limits on the extent to which we would live in the past. BBC producer Chris Terrill decided against trying to re-create the exact conditions of eighteenth-century life at sea as it would be both impossible and dangerous to do so. He also decided that the crew would not dress up or mimic the strict hierarchy that distinguished officers and other ranks. Rather, by sailing the replica ship, living on it and engaging with the elements, we aimed to come closer to understanding what life on board the *Endeavour* was really like. Indeed, a deeper appreciation of the past would not be long in coming. As we began to live in close quarters with little privacy, and settle down to the rigorous, often repetitive routine of life on board, we soon lost our romantic ideas about sailing an historic tall ship.

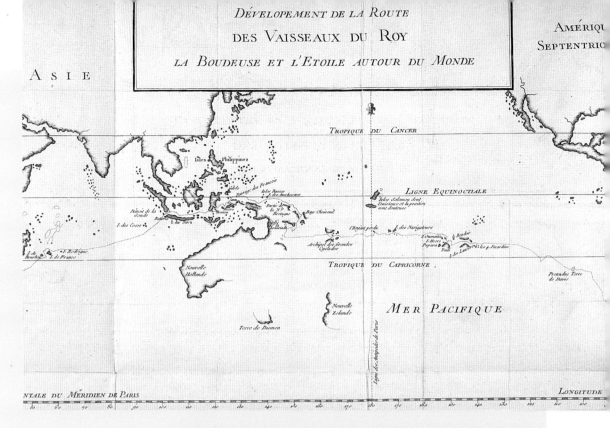

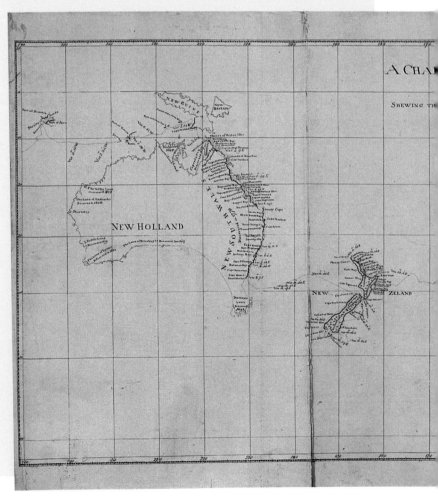

**ABOVE:** An anonymous map of 1771, showing the routes of the French ships *La Boudeuse* and *L'Etoile*. The explorer Louis-Antoine de Bougainville had crossed the Pacific a year before Cook, but the charts he produced added little to what was already known. By contrast, Cook made accurate maps of the Society Islands, New Zealand and the eastern coast of Australia, showing these landmasses much as we know them today.

**RIGHT:** 'A Chart of the Great South Sea or Pacifick Ocean' by James Cook and his junior cartographer and draughtsman, Isaac Smith, between November 1768 and January 1771.

# Cook's Reputation

Through our attempt to come closer to the past, we also hoped to shed new light on it and to re-evaluate Cook and his legacy. Since his death in Hawaii in 1779, Cook has been mythologized in biographies, commemorated with statues and paintings, and become an instructive exemplum in history lessons for generations of schoolchildren. His standing as a highly accomplished cartographer, navigator and explorer (a reputation that began during his own lifetime) remained for many years undisputed. Was it justified? We hoped to find out.

The foundations of Cook's reputation rest on the achievements of the *Endeavour* voyage. The maps with which he returned to London in 1771 allowed Europeans to see for the first time what the geography of the South Pacific actually looked like. The extent of his success can be gauged by contrasting his work with that of the French explorer Louis-Antoine de Bougainville, who, a year earlier, had also sailed across the Pacific from South America. The Frenchman's most significant achievement was to pinpoint more accurately the islands of present-day Vanuatu. In all other respects, the new map that he presented to the French court was identical to those that already

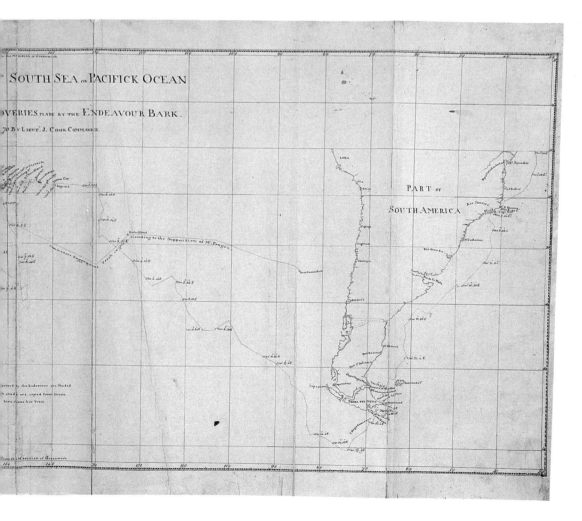

existed. By contrast, Cook's chart revealed an entirely different kind of Pacific. It now included more of the Society Islands, New Zealand and eastern Australia, plus firm proof that there did indeed exist a strait between New Guinea and the tip of present-day Queensland.

These were the principal successes of Cook's first world voyage. His methodical and meticulous approach to exploration and surveying, which had ensured unprecedented accuracy, would also characterize his two further voyages to the Pacific. By the end of his career he had spent nearly ten years on ships of exploration.

While charting the South Pacific, Cook and his company also tried to fulfil his instructions from both the Admiralty and the Royal Society to make respectful contact with indigenous people and engage their 'friendship and alliance'. Attempts to do so met with limited success, but it is clear that Cook approached these encounters with a sensitivity that distinguished them from those on earlier voyages of exploration.

Contact between the *Endeavour* crew and the societies of the South Pacific was recorded in detailed ethnographic accounts, as well as in drawings and paintings. Publication of this information opened the eyes of Europeans to cultures beyond their own. Although some idealized these 'primitive' societies and some even satirized European contact, others sought to learn from the differences. Undeniable, however, was that a new era of 'scientific voyaging', with its emphasis on a secular and rational pursuit of knowledge, had begun.

Cook's work represented the enlightened face of exploration, but it also led to the expansion of Empire under the guise of science, friendship and trade. As a direct result of the *Endeavour* voyage, European colonization of the Pacific soon began to take place. Indeed, it was on the recommendation of certain members of the ship's company that Botany Bay in Australia was chosen as a site for white settlement. Of course, in order to reach it, the First Fleet used Cook's charts.

## New Contexts

One of the monuments to Cook at Endeavour River, which we visited early in the voyage, had the inscription 'He left nothing unattempted', a statement that conceals more than it reveals. Recent scholarship has sought to clarify the vagueness of such praise and question the basis of Cook's reputation. As historian Randolph Cock has observed, his achievements had much in common with those of other British explorers of the time, such as John Byron and Samuel Wallis in HMS *Dolphin*. They too sailed into the unknown, made discoveries in their own right, experimented with the advances in navigation and tested ways of maintaining the health of their crews. Indeed, the information with which they returned materially assisted Cook on his voyages. This suggests that he was not as unique an explorer as his reputation tells us. Also, was Cook the consummate professional, as has been thought for so long, or did he in fact meet with a series of lucky escapes? The defensiveness he displays in his journals about the

risks he took, one might argue, disguises an ambition that actually invited danger. While Cook has been praised as a humane, exemplary commander in his dealings with 'natives', a significant number of the *Endeavour*'s encounters ended in violence and death. Over the last twenty-five years Cook's reputation has been reassessed from the point of view of the indigenous peoples involved. In the light of oral history and close re-readings of the *Endeavour* journals, could these sensitive meetings have been better handled?

As Cook's voyage was originated by the Royal Society in London, his company included a non-naval contingent of botanists, artists and an astronomer. The team invited to participate in the BBC project also came from similar disciplines and backgrounds. By comparing and contrasting their work on board the ship with that of Cook's crew, they hoped to re-evaluate the voyage and its achievements from a variety of perspectives. The navigating team, for example, would try to sail the ship by using eighteenth-century techniques, an exercise that would lead them to understand the challenges and frustrations of navigating by the stars. Others, such as the artist and botanist from the Royal Botanic Gardens at Kew, would compare their activities with those of Sydney Parkinson and Joseph Banks, their eighteenth-century counterparts, coming to a new understanding of them and their work in the process.

The BBC also invited a team of historians on board, their task being to examine different aspects of the original voyage while working as ordinary seamen. By the end of the six-week journey they would have been forced to challenge some of their most ingrained academic beliefs. For example, Jonathan Lamb, a specialist in eighteenth-century voyage literature, would consider afresh the dangers and risks to which Cook exposed his crew in making his way through the labyrinth of the Great Barrier Reef. What was it, other than simple ambition, that drove Cook to return to these dangerous waters in order to map the coast rather than steer clear of them as other explorers had done? Indeed, being exposed to dangers and associated thoughts of mortality would lead to a fuller understanding of Cook, and also of the men who sailed his ship.

As representatives of the two indigenous peoples perhaps most affected by the *Endeavour*'s exploration of the Pacific, Maori and Aborigines were invited to participate as crew members. Their view of Cook and his impact on their countries would be very different from the prevailing Western attitude. Within the close confines of the ship they would challenge many of our assumptions and force us to face those whose lives had been directly affected by the white settlement that followed Cook's territorial claims in the South Seas. Their point of view was all the more pertinent given that Cook's route took us to the places where his influence is celebrated in statues, monuments and art. The crew would talk and learn more about what it might mean to be a Maori or an Aborigine today, seeing beyond the stereotypes that imperialism has created.

In many different ways, therefore, the voyage would offer a unique opportunity for historical inquiry. The mixed crew of specialists and volunteers hoped that being on the ship itself would cast light on the past and bring us closer to it.

## The Replica

The *Endeavour* is acclaimed as the best tall ship reconstruction in the world, and its existence gave us the very opportunity we had been seeking – namely, for a single TV camera and a crew of experts and volunteers to look at Cook and his achievements from the perspective of two centuries 233 years apart. However, the replica ship offered more than this: its structure of wood, sails and rope reflects an age of scientific revolution, human ingenuity and secularity. The ship seemed the perfect context from which to assess the original *Endeavour* expedition as a voyage of the Age of Enlightenment.

The replica *Endeavour* inspired both the series and its producer, Chris Terrill, when he flew to Australia to see the ship for himself. In the journal he kept of the production he wrote:

I was so excited to finally see the *Endeavour*. Actually, I was more nervous than excited – a bit like the feeling you get on a blind date. I knew the first sighting was going to be all important – it was going to colour my future relationship with the ship and therefore the outcome of the whole venture. I scanned the

horizon and then caught my breath as I looked up and saw over the roof the top of three huge masts draped with rope. More rope than I could have imagined. I was transported into the past and the future simultaneously. I could instantly envisage the adventure of our voyage in 2001 with surging excitement but I could also sense the aura of history which seemed to drip off the very yardarms, rigging and bowsprit of one of the most extraordinary ships I had ever seen. She was not beautiful – not like the *Cutty Sark* or the *Victory* – but she was very unusual and very striking. She had 'chutzpah'. And, glory be, she was no plastic Airfix kit. She was the real McCoy – not so much a replica but a reincarnation perfect in every detail.

The idea of building the replica ship was conceived during Australia's bicentennial celebrations in 1988. During this time the nation celebrated 200 years since the arrival of the First Fleet from Britain – ships that found their way to the east coast of Australia as a direct result of Cook's voyage in the *Endeavour*. A new Australian National Maritime Museum was being planned for Sydney's Darling Harbour, and a replica of Cook's ship *Endeavour*, it was suggested, would make a fine showpiece. During the course of its planning and construction some of the top maritime specialists from all over the world became involved in the project.

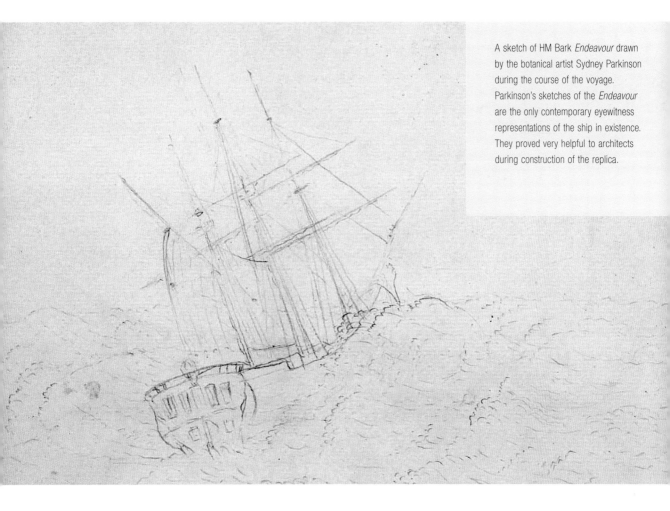

A sketch of HM Bark *Endeavour* drawn by the botanical artist Sydney Parkinson during the course of the voyage. Parkinson's sketches of the *Endeavour* are the only contemporary eyewitness representations of the ship in existence. They proved very helpful to architects during construction of the replica.

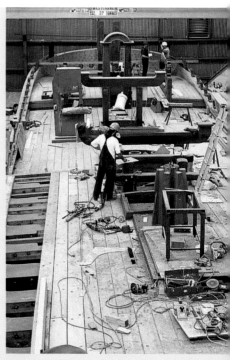

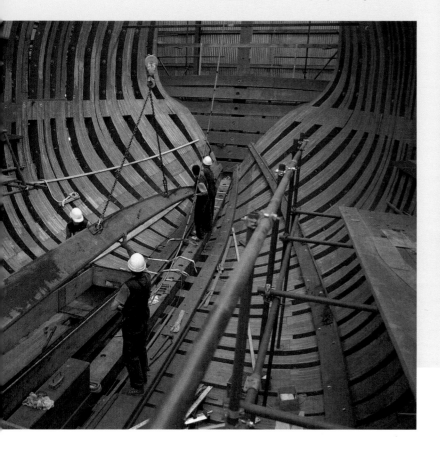

BELOW: The replica *Endeavour* under construction in Fremantle, Western Australia, *c.* 1990. The work involved was on a massive scale and took six years to complete. Some of the ship's timbers were moulded into shape by steaming them.

ABOVE: The weather deck of the replica *Endeavour* taking shape in 1992. Visible are the after hatch, the gallows on which the spare masts, spars and yards would be lashed, and, just beyond, the belfrey, soon to house the ship's bell.

Before construction began, the project team were forced to define their aims in building the ship. What kind of replica would the *Endeavour* be? The answer they reached sought to combine the best historical accuracy with the demands of both a limited budget and the need to ensure that the ship would have a long life: to be a financial success, it was estimated that the replica would need to sail for forty years in contrast to the original ship's lifespan of twenty-nine years.

The design of the replica was copied directly from the original Admiralty plans of Cook's ship. Although these draughts showed complete profile and body plans of the different decks, they did not tell the whole story. It was therefore decided to supplement the plans with sketches of the *Endeavour* drawn by Cook's artist, Sydney Parkinson, and to consult the written specifications of similar ships held in Admiralty records. In terms of actual construction, the project team agreed that, wherever possible, traditional tools should be used; where this proved financially or practically impossible, modern machinery would take over. Finally, the team would attempt to build the

replica with the same types of material used in the original ship, only making substitutions when these materials were no longer available, too expensive or not sufficiently durable.

Work began in 1988 and the project team soon faced their first compromise. The body of Cook's ship was made from oak with an elm keel: oak in the sizes required would be too expensive and also prone to rot and attacks from marine borers, such as woodworm. In its place Australian jarrah hardwood was used. A second problem was finding large enough pieces of solid timber for the ship's hull and main masts. In the end, they had to be assembled from laminated wood, which was a feat of construction in itself. Masts and ribs were put together from thick planks piled one on top of the other. These were then shaped using traditional and modern tools, and glued together.

Fitting the planks around the carcass of the ship was another complicated procedure. In order to adapt them to the convex shape of the hull, these timbers were steamed to make them more malleable; once steamed, they had to be fitted into place within ten minutes. Large iron bolts were used to fasten the joints of the wood together, just as they had done on the original ship. The planking too was fastened in traditional manner, with trunnels – large wooden nails. More delicate woodcraft, such as the decorative carvings around the stern and quarter windows, was undertaken by a skilled hand-carver.

A forge was set up in the ship's yard and here blacksmiths fashioned all the iron fittings for the body of the ship plus the masts and rigging: hundreds of bolts, rings, spikes, plates, straps, hinges and hooks were required. They also made the firehearth and the ship's lanterns. Meanwhile, a separate team fashioned the 700 blocks that would allow the ropes to manoeuvre the sails. These were made from she-oak wood; the dead-eyes, pins and cleats to which the ropes would be 'belayed' or fastened during sail-handling were made from oregon.

The ship's rigging is composed of 'standing rigging' – a fixed network of ropes that supports the masts and yards – and 'running rigging', which describes the ropes that are constantly on the move, being hauled and eased in the setting and putting away of sails. A reliable system of ropes on board a tall ship is paramount, and the project team needed to ensure that the material and production of the ropes were just right. The first problem of how to make four-strand cable-laid rope was neatly solved when an Australian rope manufacturer was found to own a working nineteenth-century 'rope walk'. But what material should he use? Unfortunately hemp, the material used on Cook's *Endeavour*, was no longer a possible option. It was finally agreed to substitute this with a mixture of natural and man-made fibres: manila would be used on the standing rigging after it had been pre-stretched (a process that involved hanging the rope from a construction crane with blocks of concrete); the running rigging would use man-made polypropylene.

The sails were made from a synthetic material called Duradon. This looks and feels like flax, from which the original *Endeavour*'s sails were made, but is lighter to handle and more resistant to rot. Some of the smaller sails were sewn by hand, but the great expanses of the fore and main mast sails were sewn by machine.

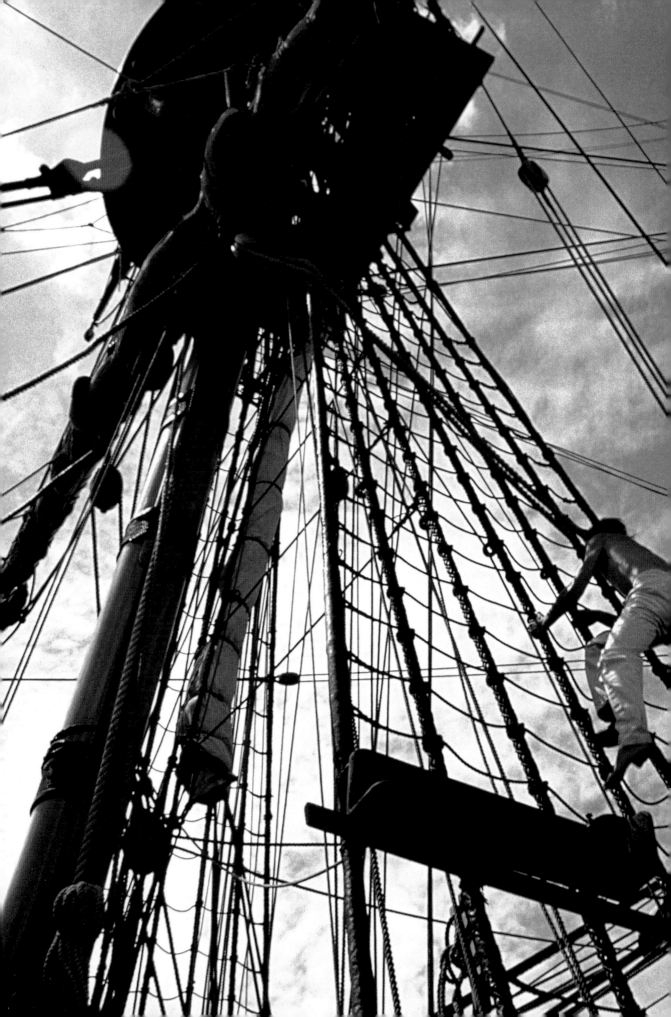

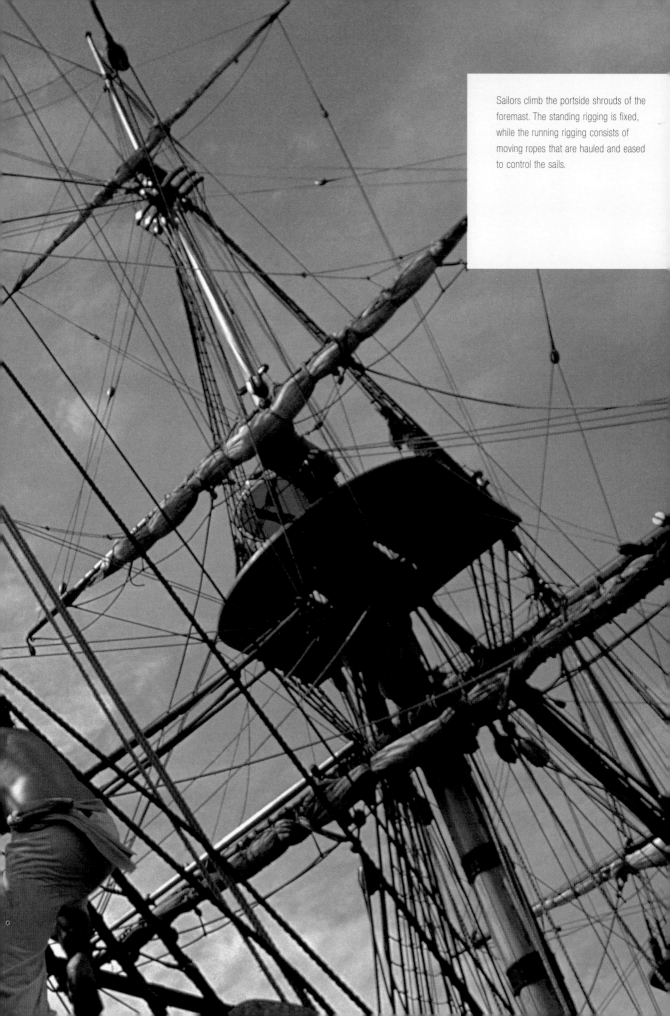

Sailors climb the portside shrouds of the foremast. The standing rigging is fixed, while the running rigging consists of moving ropes that are hauled and eased to control the sails.

There was no compromise in terms of modern facilities, however. The Australian Maritime Safety Authority required that certain health and safety features be in place before the replica could take passengers and go to sea: the ship therefore had to be fitted with propeller engines, an engine room, a modern galley, and washing and toilet rooms. These amenities were installed in the hold as modules so that they could easily be removed to leave the ship in its authentic state. A modern navigation and communications room was tucked away on the after deck in what was once a pantry on Cook's vessel.

The ship took six years to complete at a cost of AU$17 million (£6 million), but its construction had also been a labour of love for the 100 men and women who built it. During those years the funding for the project suffered because of a world recession, and work was suspended several times. Despite this, the building team persevered and saw the ship through to completion in 1994. In May of that year the *Endeavour* undertook her maiden voyage from Fremantle to Sydney, where the ship was put on exhibition. Since then it has been run as a hugely successful moving museum. It has visited all the southern and eastern states of Australia, and completed its first round-the-world voyage in 2000. The *Endeavour* then set about a circumnavigation of Australia, and it was during this time, from August to October 2001, that the BBC voyage was undertaken.

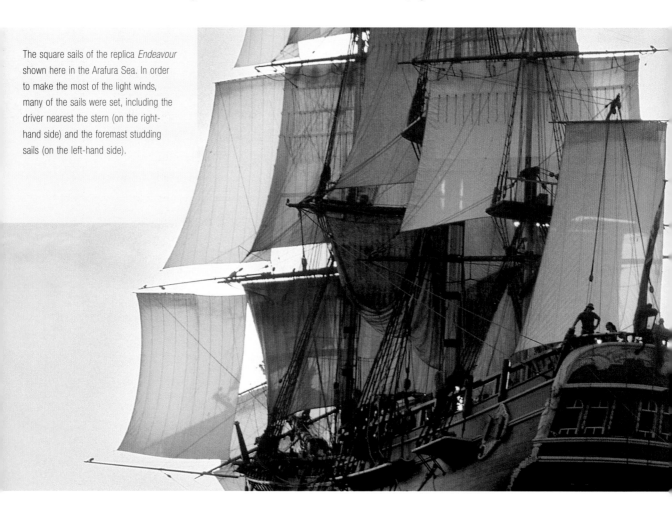

The square sails of the replica *Endeavour* shown here in the Arafura Sea. In order to make the most of the light winds, many of the sails were set, including the driver nearest the stern (on the right-hand side) and the foremast studding sails (on the left-hand side).

# Journal of the Voyage

This book is intended as an introduction to the history of the *Endeavour* voyage. Drawing on contemporary accounts, Part One describes how the expedition was planned, who would participate in it, and how the *Endeavour* was chosen and modified for the journey ahead. Part Two then focuses on the most thrilling stretch of the voyage, between present-day Cairns and Jakarta, comparing and contrasting the historical and modern expeditions through a variety of themes – science, imperialism, navigation, and the experiences of land and sea.

BBC Books also commissioned some of the specialists who participated in the six-week voyage to write journals of their thoughts and experiences. The accounts would be a chance for the specialists to reassess the original voyage and to determine whether re-tracing part of Cook's route inspired fresh ways of looking at the past. They would reflect what the journal writers learnt about Cook's voyage through the television project. The historians, for example, had written on the subject previously and now had a chance to find out what voyaging was like for themselves. Others, such as the botanists and navigators, would be emulating the techniques of their eighteenth-century counterparts. How would their views change in the light of the six-week voyage?

It is appropriate that these journals were commissioned for this book because written records were central to the original *Endeavour*'s voyage. Indeed, it is thanks to the detailed journals kept by Cook, his officers and the gentlemen that we know so much about the original journey. Their accounts reveal an enlightened search for knowledge, but were also decisive in helping them to beat off the threat of a territorial claim from de Bougainville. On hearing from a ship off the Cape of Good Hope that the Frenchman had voyaged across the Pacific in 1768 and landed at Tahiti, 'discovered' by the British ship the *Dolphin* the year before, Joseph Banks articulated the thought shared also by Cook: 'How necessary then will it be for us to publish an account of our voyage as soon as possible after our arrival if we mean that our own country shall have the honour of our discoveries! Should the French have published an account of Mr de Bougainville's voyage before that of the…*Dolphin*, how infallibly will they claim the discovery of…Tahiti as their own.'

The *Endeavour* journals written by Cook and Banks (as well as the charts and pictures produced under their aegis) conveyed not just new geographical knowledge but also constituted the 'discovery' itself: the journals are a record of possession and a pragmatic report on the prospect of new markets and trade in the Pacific. However, they are also much more. They reveal the wealth of new information – in geography, natural history, anthropology and astronomy – with which the ship returned; they reflect the characters of the writers, not least Cook himself, who is by turns meticulous, determined, phlegmatic, anxious and ambitious; and they express the writers' belief in man's ability to rationalize, measure and understand the unexplored and unknown world. These aims, whether or not Cook and others on the *Endeavour* achieved them, epitomize the spirit of the voyage and also of the age. This book explores how.

PART ONE
# Preparation

# Origins

Nearly two and a half centuries ago James Cook, captain of the *Endeavour*, dropped anchor off the eastern coast of Australia near a headland that he named Cape Grafton. In 2001 the BBC voyage that sought to retrace part of his route would depart from this same spot. While the replica ship was being prepared and provisioned, it was moored in the modern port of Cairns about 12 miles (20 km) away. Television producer Chris Terrill described the activities in his journal:

Today the *Endeavour* was tied up alongside in the busy Cairns harbour. She looked incongruous to say the least – and absolutely tiny compared to her modern counterparts. At her bow was a towering bulk cargo ship taking on freight – heavy machinery and engine parts. At her stern was a frigate of the Royal Australian Navy taking on stores and ammunition. And behind her, with foghorns blasting, was a string of enormous oil tankers heading out to sea. Surrounded by the noise of drills, cranes, forklifts and diesel engines, the *Endeavour* was silent. Apart from the water lapping gently against her hull, she had no voice, but she had huge presence. With her mast swaying gently in a freshening breeze, she had poise and

Java la Grande, a detail from the *Vallard Atlas* of 1547 by an anonymous artist. Before the South Seas had been explored, mapmakers transferred alluring ethnographic details from the known world to fill in the blank spaces further south. Here a raja's procession, camels, coconut palms and houses on stilts from Sumatra in present-day Indonesia are used to suggest the unknown and exotic *Terra Australis Incognita* (Great Southern Continent). Cook's voyage of discovery on the *Endeavour* would dispel the remnants of such fanciful thinking and seek to depict the South Seas as they actually were.

personality. The permanent crew were busy carrying on stores and provisions – barrels and boxes in their hundreds. There had to be enough food on board to feed 56 people for six weeks – that's three meals a day for 42 days – a total of 7056 meals. No cranes here – just muscle power and human chains. It was not difficult to imagine the scene 233 years ago in Plymouth when the original *Endeavour* was being stocked up with the victuals needed for her trip – one that was to last not six weeks but three years!

When, in August 1768, Captain James Cook oversaw the provisioning of the *Endeavour* at Plymouth, he was about to embark on an ambitious voyage of discovery. The preliminary (and public) purpose of his mission was to sail to the island of Tahiti in the South Pacific and observe an eclipse, the Transit of Venus. However, he also received a sealed packet of additional instructions. These requested that he try to discover, explore and survey the Great Southern Continent, a hypothesized landmass which, even as late as the mid-eighteenth century, was believed to exist somewhere in the South Pacific. The exotic, paradise island of Tahiti was perhaps the gateway to it.

The Royal Society's plans for this voyage had started several years earlier: at the beginning there was no element of discovery, no Tahiti and no *Endeavour*. Even Captain Cook did not feature in the plans. Observation of the eclipse was the only consideration.

# The Transit of Venus

During the Seven Years War (1756–63), Britain and France had been sworn enemies in matters political and military, but had nonetheless remained competitive friends in matters of science. In 1761 the Royal Society of London, a prestigious scientific body established to advance 'practical knowledge', had participated in the Paris Academy's observations of an eclipse, the transit of the planet Venus across the sun. This enterprise was the first international scientific venture undertaken on a global scale. The next eclipse was due to take place on 3 June 1769, and the fellows of the Royal Society, not wishing to be outdone by their European rivals, took it upon themselves to coordinate the observations. This effort would be grander than previously – 151 observers would witness the eclipse from seventy-seven observation sites – and it was hoped that the results would be more conclusive than those achieved in 1761.

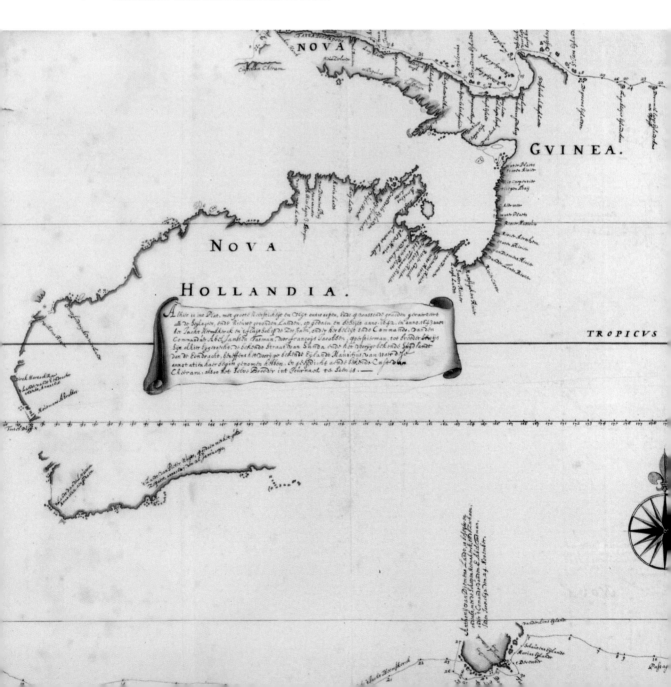

The Transit of Venus, which occurs four times every 243 years, had enormous significance for the scientists of the day. By observing from different parts of the globe the time the planet took to cross the sun, astronomers would be able to assemble sufficient data to calculate by trigonometry the sun's diameter, and in turn the Earth's distance from the sun. This last measurement would provide scientists with the Astronomical Unit, the yardstick by which the dimensions of the Earth's solar system might be measured.

While many of the observations would be from the northern hemisphere, the Royal Society would be responsible for sending a delegation to the southern hemisphere, specifically to the South Pacific, where the visibility would be best. This observation base would be the principal station: seen from a different latitude to that of the northern stations, Venus would appear to take a shorter amount of time to cross the face of the sun. It would be the difference between the various stations' readings that would provide the data for more accurate calculations. There was a problem, however: no one

'General Map of Tasman's Discoveries in 1642–3 and 1644' by François Visscher. This chart shows how far the Dutch had charted and explored the continent they called New Holland (present-day Australia) since the beginning of the sixteenth century.

knew what the South Pacific looked like nor exactly where to send the astronomers.

In the mid-eighteenth century the South Pacific was the last great unknown area on Earth. The coastlines of North and South America, Asia and Africa had all been mapped, and appeared in atlases of the period looking much as we would recognize them today. Even the greater part of Australia was known, Dutch explorers having successfully outlined its north, south and west shores in the seventeenth century and named it New Holland. However, the area stretching southwards from New Guinea to Tasmania and eastwards through the chain of Pacific island groups was only vaguely known to Europeans. No one had fully explored it, let alone charted it, and maps of the period left this area completely blank apart from a small stretch of coastline that the Dutchman Abel Tasman had seen from his ship in 1642 and was soon to be named New Zealand.

As a result, when, in February 1766, Thomas Hornsby, professor of astronomy at Oxford and a fellow of the Royal Society, gave his paper 'On the Transit of Venus in 1769' and suggested seventeen Pacific island groups as possible stations for the British astronomers, no one could say for certain where these places were. Drawing on inaccurate charts, Hornsby mentioned locations whose longitudes and latitudes were not known; these 'suitable' places were islands that had been stumbled upon in previous centuries by European explorers and sometimes not found again. (Alvaro de Mendaña, for example, attempted to colonize the Solomon Islands, which he had already claimed in 1568, but failed to find them again when he returned twenty-seven years later.)

The Royal Society met again in November 1767 to hear further suggestions, and were still none the wiser. As Cook historian Glyn Williams has shown, it was becoming clear that an expedition to mark the eclipse would, of necessity, have to be a voyage of discovery too: the observers would have to discover their own observation stations. It was essential, the meeting concluded, to find an informed person to lead the expedition. At this point, the name of Alexander Dalrymple was put forward.

Dalrymple, a passionate geographer and historian, arrived back in England in 1765 following several years abroad working for the East India Company. On returning, he set about promoting himself as a suitable candidate to lead the astronomical expedition. (His civilian status was thought to be no bar because the voyage was being arranged under the auspices of the Royal Society rather than the Admiralty.) During his time with the East India Company, Dalrymple had spent five years in positions of command, principally aboard the schooner *Cuddalore*, and had proved his skill in navigation, cartography and surveying. Over and above this practical experience, he also claimed an extensive historical knowledge of prior voyages in the Pacific. This, he hoped, would impress the selection board that he could deliver the astronomers to a suitable destination in time for the Transit of Venus.

To this end, Dalrymple compiled *An Account of the Discoveries Made in the South Pacific Ocean Previous to 1764*, in which he summarized the voyages of earlier Spanish and Dutch discoverers in the Pacific. As well as cataloguing the places at which they had landed, he analysed the thought processes that led them to decide on their courses.

LEFT: Engraving of Alexander Dalrymple by John Brown. Dalrymple was the first candidate nominated to lead the *Endeavour* voyage. His ambitions overreached his qualifications, and he was discounted from commanding a Royal Navy ship on the grounds of his civilian status.

BELOW: Alexander Dalrymple never went to the South Seas, but in 1767 he published his 'Chart of the South Pacifick Ocean' to accompany his account of European exploration in the area before 1765. Drawing on new archival evidence, he suggested that New Guinea, New Holland and Terra del Espiritu Santo (present-day Vanuatu) were separate landmasses, although other charts of the period showed them joined together. Dalrymple gave the botanist Joseph Banks a copy of his theoretical chart, and Cook later proved that its suppositions were correct.

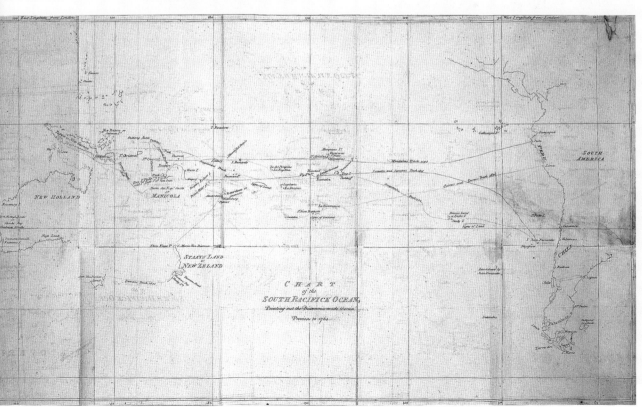

He concluded by boldly suggesting 'what may be further expected' in the area.

Dalrymple's account also included his own chart of the South Pacific Ocean, which drew on archival information to refine and improve similar charts of the region by the French cartographers Jacques Nicolas Bellin and Robert de Vaugondy. Most significantly, Dalrymple separated the islands of Espiritu Santo (present-day Vanuatu) from the New Holland mainland, and marked a passage between the south of New Guinea and the tip of present-day Queensland, Australia. Although James Cook would later prove these facts by exploring and charting the region, Dalrymple had used historical research to suggest that this was the true geography three years before the *Endeavour* had even reached these waters. His chart was the most up-to-date map of the South Pacific in existence – and he had not even been there.

Throughout 1767 Dalrymple was active in Royal Society circles; the publication of a few copies of his work in October of that year was designed to strengthen his bid to head the expedition. By December, his ambition was achieved: he had been officially nominated by the Royal Society to lead the astronomers to the South Pacific.

His appointment, however, was thwarted in the new year. The Royal Society depended upon the Royal Navy to provide a ship for the voyage, and the Admiralty,

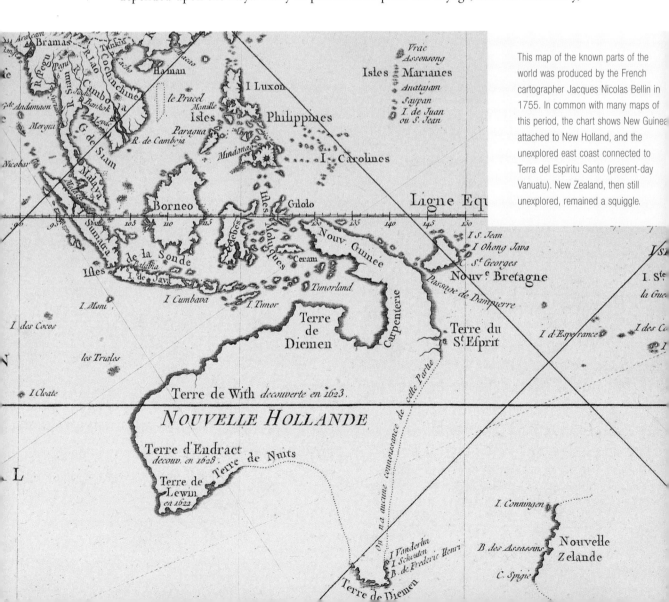

This map of the known parts of the world was produced by the French cartographer Jacques Nicolas Bellin in 1755. In common with many maps of this period, the chart shows New Guinea attached to New Holland, and the unexplored east coast connected to Terra del Espiritu Santo (present-day Vanuatu). New Zealand, then still unexplored, remained a squiggle.

its governing body, would not countenance a civilian as captain. The First Lord of the Admiralty recalled that the last scientific voyage headed by a civilian, Edmund Halley, had resulted in mutiny and disaster. Such an appointment, it was reported to the Royal Society, was 'totally repugnant to the rules of the Navy'. A mere four months before the ship would have to set sail, the vacancy for captain was once again open.

Although this was the end of Dalrymple's hopes 'to be engaged in discovery', his involvement had expanded the possible scope of the expedition. By circulating his work among the fellows of the Royal Society, Dalrymple had pressed not only his candidature but also the argument that the astronomical expedition was an opportunity to go in search of new discoveries in the South Pacific. The greatest of these discoveries, promised Dalrymple, would be the Great Southern Continent.

## The Great Southern Continent

Dalrymple's *Account* was not only a font of historical research on the geography of the Pacific, it was also a carefully planned argument for the existence of the Great Southern Continent. Dalrymple drew on earlier accounts of partial discoveries and 'sightings' by previous explorers, and also cited the counterpoise theory, which stated that a landmass must exist to the south in order to balance the landmass of the north. Indeed, the purpose of his chart of the South Pacific Ocean was to outline the parameters within which the Great Southern Continent might lie.

This continent, which Dalrymple emphatically claimed 'equal in extent to all the civilized part of Asia, from Turkey to China inclusive', had been speculated about for centuries. Previous discoverers claimed either to have sighted it or that the islands they came across were enticing signs of it. Nonetheless, the continent remained undiscovered, so explorers and governments continued to hypothesize its existence and idealize its riches.

Dalrymple was among those who saw the discovery of the Great Southern Continent in commercial terms, an attitude perhaps engendered during his apprenticeship with the East India Company. The discovery of the continent, he claimed, potentially offered opportunities for trade that would add not only to the 'benefit of mankind', but to 'the glory and interest' of his country.

It was not only British theorists who believed in a Southern Continent. In the seventeenth century, inspired by his compatriot's discovery of Espiritu Santo, the Spanish explorer Juan Luis Arias had petitioned his king for financial aid on the same grounds as Dalrymple. He described the Southern Continent as:

> ...greatly stored with metals and rich in precious stones and pearls, fruits and animals; and from the discoveries and investigations which have been already made in this southern hemisphere, there has been found such fertility, so great plenty and abundance of animals, swine, oxen and other beasts of different kinds fit for the sustenance of man as has never been

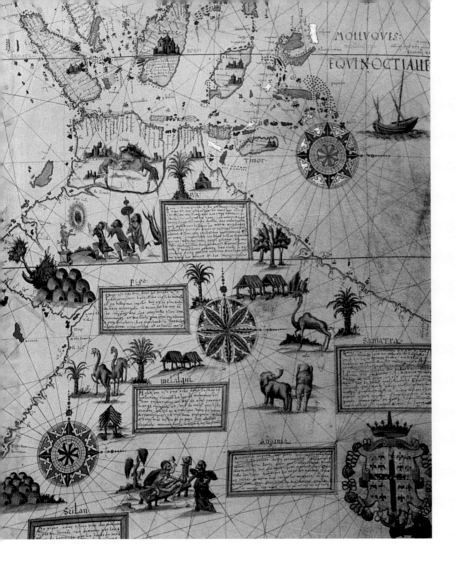

LEFT: A detail from Pierre Descelier's 'World Chart' of 1550 showing some of the strange sights that the Great Southern Continent was believed to contain. Many still believed the landmass to exist at the time of the *Endeavour* voyage.

RIGHT: This world map, produced by Abraham Ortelius in 1570, showed the vast extent of the 'Great Southern Continent Not Yet Discovered' as it was hypothesized in the sixteenth century. Since ancient times it was believed necessary for this landmass to exist in order to counterbalance the weight of the land in the northern hemisphere.

seen in our Europe; also of birds and fishes of different species, and amongst them all, those which we most value as wholesome and delicate on the shores of our own ocean; and fruits, some of which we already know, and others of different kinds, all of which may well excite the greatest admiration.

Since the existence of a Southern Continent still lay unproven by the mid-eighteenth century, imaginative ideas about its potential treasures ran rife among explorers everywhere, not least in Britain and France. Another expert on Pacific voyages, Charles de Brosses – whose work influenced Dalrymple's *Account* – used the current French geographical scholarship on the existence of the Southern Continent to advance the argument for exploiting it:

It is not possible that there is not in such a vast sea some immense continent of solid land south of Asia capable of keeping the globe in equilibrium in its rotation... How can we doubt that after its discovery such a vast expanse of land will supply objects of curiosity, opportunities for profit, perhaps as many as America furnished in its novelty? How many peoples different from each other and certainly very dissimilar to us in face, manner, habits,

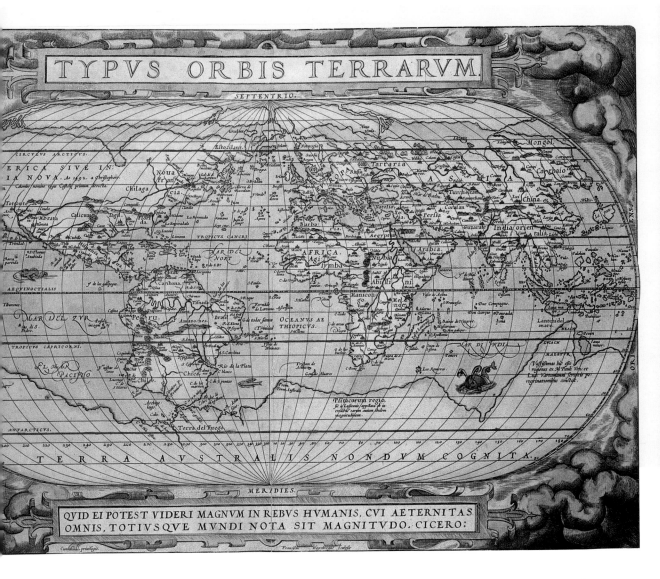

ideas and worship? How many animals, insects, fish, plants, trees, fruits, medicinal drugs, marbles, precious stones, fossils and metals?

Following the Seven Years War, initiatives to search for the Great Southern Continent were taken up by the Admiralty, their eagerness to find it being fired by a desire to forestall French ambitions in that area. The fear was that if the French found the continent first, they would establish a commercial empire there based on the model of the Dutch in the East Indies and the Spanish in Latin America. Through trade, this continent would serve to benefit whichever European nation first made contact with it.

Partly motivated by this fear, the Admiralty set in motion two voyages, both in HMS *Dolphin*. In the first, between 1764 and 1766, John Byron was sent to survey the Falkland Islands, first sighted, but not named, in the late sixteenth century, thus securing them from the French and Spanish. At the time these islands were considered to be a key

strategic possession since they were a gateway to Pacific trade and exploration and would enable British ships to avoid reprovisioning at Spanish and Portuguese ports on the mainland of South America. Once refreshed at the Falkland Islands, British ships could then pursue long voyages in the Pacific. Byron was, however, also instructed to explore the Pacific coast of North America, and on his subsequent course across the ocean claimed to have encountered dramatic signs of the Southern Continent itself: the sea swell from the southwest had disappeared and 'vast flocks of birds' were observed. Byron concluded, 'This is a convincing proof that there is land that way and had not the winds failed me in the higher latitudes I make no doubt that I should have fallen in with it and in all probability made the discovery of the Southern Continent.'

On the basis of Byron's report, and wary of the French explorer Louis-Antoine de Bougainville's activities in the region, the Admiralty dispatched Samuel Wallis on a second expedition in the *Dolphin* just three months after Byron had returned. His instructions were 'to discover and obtain a complete knowledge of the land or islands

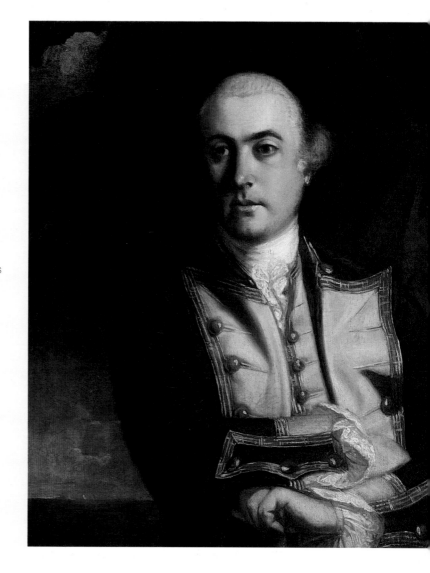

Commodore John Byron, painted by Joshua Reynolds. Byron sailed around the world on a voyage of exploration in HMS *Dolphin* between 1764 and 1766. This was immediately followed by Captain Samuel Wallis's two-year circumnavigation in the same ship. Together these expeditions to the Pacific laid important groundwork for the *Endeavour* voyage in terms of discoveries, shipboard innovations and the experiences of their captains and crew.

supposed to be situated in the southern hemisphere'. According to speculation then doing the rounds in government circles, these lands were believed to exist 'in latitudes convenient for navigation and in climates adapted to the produce of commodities useful in commerce'.

Using the astronomical expedition as an opportunity to search for the Great Southern Continent was an idea first put forward by Alexander Dalrymple, but it was not because of him that the Admiralty finally did so. The spur was the exciting news with which Captain Wallis returned in May 1768. Finally, it seemed, the elusive landmass might be within their grasp.

## Paradise in the South Seas

The voyages of John Byron and Samuel Wallis in HMS *Dolphin* broke important ground for future exploration of the Pacific, and Cook would be the first to benefit. For example, Wallis learnt that a better way to enter the Pacific was not by the Straits of Magellan as he had done, but by the Strait of Le Maire, a more negotiable and less time-consuming route. After entering the Pacific, both Byron and Wallis had come across numerous islands, new 'discoveries' in themselves. The most important of these, originally named King George's Island by Wallis in June 1767, was Tahiti.

> We have discovered a large fertile and extremely populous island in the South Seas… The *Dolphin* came to an anchor in a safe, spacious and commodious harbour where she lay about six weeks. From the behaviour of the inhabitants we had reason to believe that she was the first and only ship they had ever seen… It is impossible to describe the beautiful prospects we beheld in this charming spot; the verdure is as fine as that of England; there is plenty of livestock and it abounds with all the choicest productions of the Earth.

Wallis, it seems, had discovered a paradise. Tahiti was taken as further evidence for the idealized Southern Continent, and stories abounded of the South Pacific as exotic, luxurious and fertile.

The more immediate consequence of the discovery, however, was that Tahiti could be the specific destination from which the Royal Society's astronomers could carry out their observation of the Transit of Venus. The purser and master of the *Dolphin*, the first ship on which new advances in navigational techniques were used, had successfully worked out the island's exact longitude and latitude. This meant that now, in order to accomplish their work, the *Endeavour* and its company would no longer have to contemplate searching the vast expanses of the Pacific for a suitable observation site. The additional worry of the scientists missing their astronomical appointment through fruitless exploration was also put aside: now that they knew exactly where they were going, the voyagers could estimate how long it would take them to reach Tahiti comfortably.

Even more significantly, they knew that Tahiti had abundant fresh food and water. This allowed the Admiralty to enlarge the scope and purpose of the voyage. Until then, the prime difficulty of Pacific exploration had been sustaining seamen for months without making landfall. Apart from the island of Juan Fernandez, there were no known places to reprovision ships between Chile and Australia, a distance of 10,000 miles (16,000 km), so every Pacific exploration had to be cursory. Tahiti, being at the halfway mark, would be the perfect reprovisioning station for any ship on a trans-Pacific crossing. It would also allow a sustained attempt at searching for the elusive Southern Continent, which the *Dolphin*'s master, George Robertson, thought they had actually passed: 'We saw the appearance of a very high land to the southward, but the weather being so thick and hazey we could not see it plain enough to see it for certain.' This was truly tantalizing information, not least because it supported Byron's evidence of a Southern Continent.

By May 1768 the Admiralty and the Royal Society had agreed upon a new captain to head the *Endeavour* expedition. James Cook, the lowly master of HMS *Grenville*, satisfied

both selection boards, the first with his surveys of the St Lawrence River, Nova Scotia and Newfoundland, the second with his part in observing an eclipse in 1766. Following his appointment, the Admiralty promoted him to lieutenant and gave him command of his new ship. In anticipation of his later work in observing the Transit of Venus, Cook also received 100 guineas from the Royal Society.

## Secret Orders

Even though the exploration element of the *Endeavour*'s voyage was deemed secret, everyone in London seemed to know about it. Throughout the summer of 1768 there was constant newspaper speculation about what the expedition hoped to achieve. While observation of the Transit of Venus, the official reason for the voyage, aroused much interest, attention also focused on its undeclared purpose, namely the search for the Great Southern Continent.

Adding to its high profile were newspaper reports that more civilians would be joining the voyage as supernumeraries – the botanists Joseph Banks, 'a gentleman of considerable fortune', and Dr Daniel Solander 'of the British Museum'. Never before, it seemed, had a voyage generated such excitement. On the day of the *Endeavour*'s departure, the front page of the *London Gazette* was devoted to it:

### ADVENTURE IN THE SOUTH PACIFIC

Lieutenant Cook sets sail in *Endeavour* Bark to observe the Transit of Venus at Tahiti then to search uncharted waters

Plymouth: This afternoon at 2 o'clock His Majesty's Bark *Endeavour*, with fair wind behind her, weighed anchor and set sail for the South Pacific island of Tahiti. In command is a Lt. James Cook whom we revealed last week is believed to be carrying with him secret orders from the Admiralty instructing him to search the uncharted waters of the far South. This verdict has been strengthened since a person of considerable repute committed a minor indiscretion at a dinner in London this past week in the home of a certain lady by referring to a destination beyond Tahiti…

Cook's supposedly secret instructions from the Admiralty were as ambitious as the newspaper report suggested. A brief look at them shows how far the voyage had developed since first mooted at the Royal Society.

### SECRET

Additional Instructions for Lt. James Cook Appointed to Command His Majesty's Bark the *Endeavour*

Whereas there is reason to imagine that a continent or land of great extent may be found to the southward of the tract of any former navigators in pursuit of the like kind; you are therefore in pursuance of His Majesty's pleasure hereby required and directed to put to sea with the bark you command so soon as the observation of the Transit of Venus shall be finished and observe the following instructions.

You are to proceed to the southward in order to make discovery of the continent above-mentioned until you arrive in the latitude of 40 degrees, unless you sooner fall in with it. But not having discovered it or any evident signs of it in that run, you are to proceed in search of it to the westward between the latitude before mentioned and the latitude of 35 degrees until you discover it, or fall in with the eastern side of the land discovered by Tasman and now called New Zealand.

While Wallis had been required to go 'in search of the land or islands supposed to lie in that part of the Southern Hemisphere', Cook's instructions were more specific, drawing as they did on the latest information. Indeed, the explicit instruction to head southward from Tahiti was probably a direct consequence of the supposed sighting of the Southern Continent from the *Dolphin*.

However, this was not the only way in which the instructions went further than those of Cook's predecessors. Should he discover the continent, Cook was asked to carry out a comprehensive survey of it:

> …exploring as great an extent of the coast as you can; carefully observing the true situation thereof both in latitude and longitude, the variation of the needle, bearings of headlands, height, direction and course of the tides and currents, depths and soundings of the sea, shoals, rocks etc, and also surveying and making charts and taking views of such bays, harbours and parts of the coast as may be useful to navigation.

Indeed, on any coast discovered, Cook's investigations were to proceed further than surveys and include detailed descriptions of the environment:

> …the nature of the soil and the products thereof; the beasts and fowls that inhabit or frequent it; the fishes that are to be found in the rivers or upon the coast and in what plenty; and in case you find any mines, minerals or valuable stones, you are to bring home specimens of each, as also such of the seeds of trees, fruits and grains as you may be able to collect and transmit them to our secretary that we may cause proper examination and experiments to be made of them.

Finally, the instructions asked the captain to take possession, 'with the consent of the natives', of any new lands the *Endeavour* came across. This was standard procedure among all European explorers in the mid-eighteenth century, but Cook was also required:

> …to observe the genius, temper, disposition and number of the natives if there be any and endeavour by all proper means to cultivate a friendship and alliance with them, making them presents of such trifles as they may value, inviting them to traffic and showing them every civility and regard; taking care however not to suffer yourself to be surprised by them but to be always upon your guard against any accident.

In this respect, the Admiralty and the Royal Society were again working together. Although Wallis had received similar instructions regarding the treatment of indigenous people, Cook's were supplemented by a separate list of 'Hints' compiled by the President of the Royal Society, Lord Morton. Among these guidelines he suggested that Cook and his crew should endeavour:

> • To exercise the utmost patience and forbearance with respect to the natives of the several lands where the ship may touch.
> • To check the petulance of the sailors, and restrain the wanton use of firearms.
> • To have it still in view that shedding the blood of those people is a crime of the highest nature. They are human creatures, the work of the same omnipotent Author, equally under his care

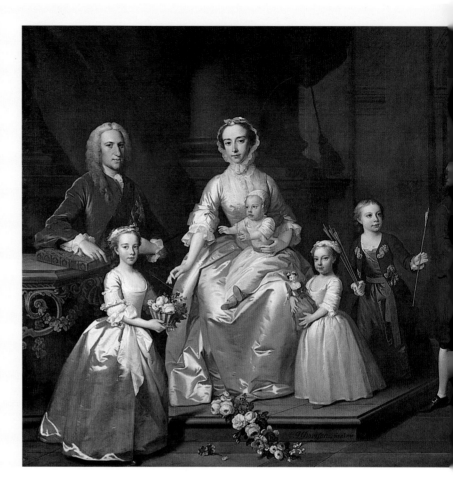

James Douglas, 13th Earl of Morton, painted with his family by Jeremiah Davison in 1740. Lord Morton was president of the Royal Society between 1764 and 1768. His guidelines on scientific exploration and the treatment of indigenous people exerted considerable influence on the *Endeavour* voyage. He, however, never knew this as he died only a few weeks after the ship set sail.

with the most polished Europeans; perhaps being less offensive, more entitled to his favour.

• Should they in a hostile manner oppose a landing, and kill some men in the attempt, even this would hardly justify firing among them, till every other gentle method had been tried.

This approach to handling encounters with indigenous peoples was a recent innovation and reflected a change in the nature of exploration and discovery by Europeans since the sixteenth and seventeenth centuries. These guidelines show the scientific and rational face with which Cook and others in the ship's company would attempt to make contact with the societies of the South Pacific. However, they would also become the standard by which Cook's encounters would be judged on his return.

Setting sail from Plymouth on 26 August 1768, the *Endeavour* was embarking on a novel, high-profile voyage of science. On board were astronomers, botanists and artists; the venture had been initiated by the venerable Royal Society, and even King George III had agreed to sponsor it with a donation of £4000. More than this, however, Cook's secret instructions would make the *Endeavour*'s voyage the most ambitious attempt to discover and explore the Great Southern Continent yet undertaken. Who were the people who would help him in this task?

# Captain and Crew

The *Endeavour* was an overcrowded ship when it set off. Although only 106 feet (32 metres) in length, it carried a company of no fewer than ninety-four. On board were men from all parts of the British Isles and from all walks of life: gentlemen, officers, marines, able seamen and servants. They were a microcosm of British society in the 1760s, and now they found themselves in the close confines of a small wooden vessel. The man who would lead this motley company had to have (aside from navigational and cartographic skills) confidence, tact and intelligence.

## James Cook

In an age when wealth and patronage usually ensured that the well-born and well-connected attained positions of honour, such as leading royal expeditions, James Cook was a notable exception. He had come from humble origins and reached this pinnacle of his career less by patronage or privilege than by simple hard work and ambition.

Born in Marton-on-Cleveland, Yorkshire, in 1728, Cook was the son of a farm labourer and had shown a proficiency in mathematics from a young age. When he was eighteen he became apprenticed to the ship-owner John Walker in the nearby port of Whitby. Walker's ships carried coal along the dangerous North Sea trade routes between Newcastle and London. On board these ships Cook gained a wealth of experience in both navigation and seamanship, sailing unpredictable waters in difficult conditions. When, at the age of twenty-seven, he was offered the post of captain on one of Walker's ships Cook declined it in order to join the Royal Navy as a mere able seaman. No one knows for sure why he made this bold decision, but in the light of Cook's career as a whole, one might guess that he foresaw there a greater chance of success and glory for a man of his ambition.

In the navy, Cook rose quickly through the ranks. During his apprenticeship in Whitby, he had spent his winters diligently studying navigation at Walker's house. Now his experience and hard work began to pay off. Within a month of joining HMS *Eagle*, he was appointed master's mate. In 1757 he sat his master's exams and was soon appointed master of HMS *Solebay* and then of HMS *Pembroke*, the latter taking him to Nova Scotia in 1758. Here, Britain and France had extended the theatre of the Seven Years War and were fighting over their colonial territories in North America.

As master, Cook was responsible both for maintaining the routine of the ship and for navigation, but he had the good fortune to meet Major Samuel Holland, a military engineer, who taught him plane-table surveying – the standard method of mapping. Cook was now embarked on a career as a hydrographic surveyor, charting seas, lakes, rivers and coastlines. Among his first surveys were those of the St Lawrence River, Carbonear and Harbour Grace.

After the war came to an end in 1763, Cook was promoted and returned to North America as a surveyor aboard HMS *Antelope*. There then followed a period of five years,

when his routine was to spend summers surveying the coasts of Newfoundland, and winters in east London with his wife, Elizabeth, whom he had married in December 1762, and their first child, James. During this time Elizabeth gave birth to two more children and conceived another. While at home, Cook would work on his surveys in meticulous detail, and these would become the standard charts for many years to come.

By 1767 Cook, now in charge of the schooner HMS *Grenville*, had charted the north and west coasts of Newfoundland, and also the south coast as far east as St Lawrence Harbour. His work in this area made him well known to the Lords of the Admiralty, but it was rather a different task that brought him to the attention of the august fellows of the Royal Society, namely, the successful observation of an eclipse from the Burgeo Islands. Although it is unclear how Cook's appointment to head the *Endeavour* voyage was eventually decided, his qualifications as an astronomer, surveyor and navigator made him a natural choice. Despite this wealth of experience, however, Cook still held the rank of master. The Admiralty remedied this discrepancy on 25 May 1768, when they appointed him to the command of His Majesty's Bark *Endeavour* as first lieutenant.

When he set off, James Cook was in a better position than any of his predecessors in the South Pacific to carry out the full scope of his instructions.

## Supernumeraries

Those engaged in the non-naval work of the voyage come under the heading 'supernumeraries', being extra to the usual number of crew carried on the ship, and outside its naval hierarchy. The most influential of these was Joseph Banks, a naturalist and a wealthy landowner from Lincolnshire. Aged just twenty-five, Banks came to participate in the expedition by exerting his influence as both a fellow of the Royal Society 'well versed in natural history' and a 'gentleman of large fortune'; he contributed no less than £10,000 towards the voyage. Banks, a prominent figure in London society and recently engaged to be married, spent the night before his departure to Plymouth at the opera. There a witness recorded how he saw 'Miss Harriet Blosset, with Mr Banks, her betrothed. Miss Harriet [is] desperately in love with Mr Banks [and]…resolved to spend in the country all the time he is away. Miss Blosset, not knowing that he was to start the next day, was quite gay. Banks drank freely to hide his feelings.'

Into the already crowded conditions of the *Endeavour* Banks brought a retinue of eight employees: two natural scientists, two trained artists and four servants. Also accompanying him were two dogs, who, as historian Antonia Macarthur has observed, would prove very useful in gathering fowls for the gentlemen's pot when Banks went out shooting. Among other 'essentials' he brought on board were items of furniture, including a bureau, scientific equipment for observing and dissecting specimens, paper for drying plants, bottles, boxes and tin trunks for storing them, and 150 books.

During the three-year expedition, his extraordinary energy and enthusiasm for natural history would transform his unofficial role into an essential part of the scientific,

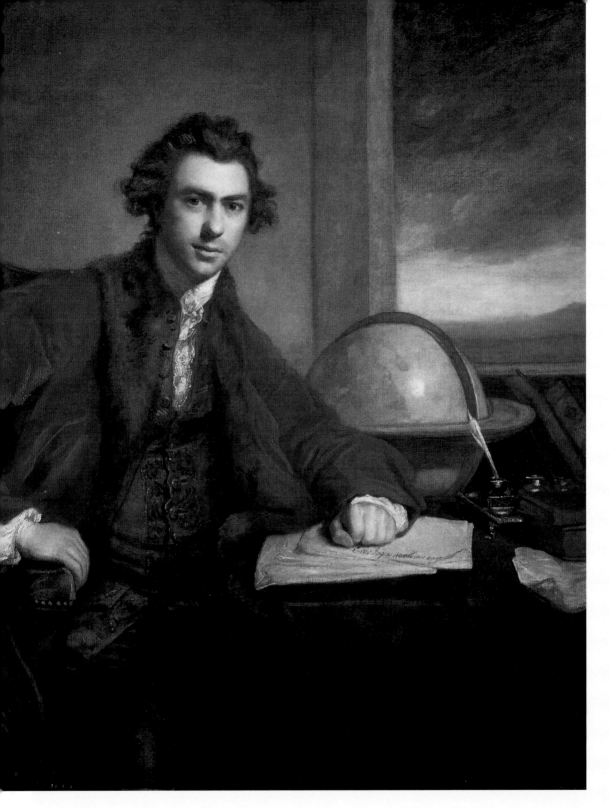

A portrait of Joseph Banks by Sir Joshua Reynolds (1773). A wealthy young landowner and fellow of the Royal Society, Banks saw the *Endeavour* voyage as an opportunity to make his name in the new science of botany. He had already undertaken an expedition to Newfoundland, and on his return was keen to join the proposed voyage to the South Seas. While a generous financial contribution secured his place on the voyage, he more than justified his inclusion by producing a fascinating body of ethnographic, zoological and botanical work.

anthropological and imperial work of the voyage. When at sea, he was impatient to go ashore and collect specimens; when he had finished collecting, he was eager to re-embark, excitedly anticipating the next landfall. Through his tireless collecting and classifying of plants and animals, he constantly sought to extend European knowledge in the field of natural history. His other significant contribution to the voyage would be the wealth of ethnographic detail with which he recorded encounters with the peoples of the Pacific. Every aspect he learnt about an indigenous society was recorded in his journal, and he never shirked from engaging in the new experiences that these encounters entailed.

One of the naturalists in Banks's retinue was also a man of repute. The Swedish scholar Dr Daniel Solander had been a pupil of Carolus Linnaeus, one of the most celebrated scientists of the eighteenth century. In addition to establishing the first universal system of plant classification, Linnaeus also inspired a tradition of scientific travel. Solander, one of his most able pupils, had found a post at the British Museum classifying the botanical specimens collected by those who had travelled to all quarters of the known world. It is more than likely that Solander was inspired to join the *Endeavour* expedition after receiving specimens recently collected by Wallis's crew in Tahiti. Whatever his motive, when the invitation came, Solander wrote that 'such an offer and such an opportunity should not be turned down'.

Solander was thirty-five, portly and perhaps not as exuberant a fellow as his former student, Banks. The botanist John Ellis wrote to Linnaeus of him: 'He is exceedingly sober, well behaved and very diligent, in no way expensive. I can assure you the more he is known, the more he is liked.' Solander was accompanied by a fellow Swede, Herman Spöring, whom Banks employed on the *Endeavour* as a secretary. Like Solander, Spöring had studied medicine before coming to the new science of botany. He had also studied watch-making, which proved a useful skill when some of the ship's navigation instruments were broken during the voyage and Cook asked him to mend them.

The two artists employed by Banks were Alexander Buchan, responsible for landscapes and figure drawings, and Sydney Parkinson, who specialized in botanical artwork. Unfortunately, soon after arriving in Tahiti, Buchan suffered a fatal epileptic fit. Parkinson gamely shouldered most of his workload, but the talented Spöring also helped out and produced some fine drawings too.

Sydney Parkinson was Scottish, from a Quaker background and only twenty-three years of age when he joined the ship. Before embarking on the *Endeavour*, he had worked on the collection of botanical specimens that Banks had brought back from his first field trip abroad. A specialist in natural history painting, Parkinson produced 955 drawings of flora and 377 drawings of fauna during the *Endeavour* voyage, an extraordinarily prolific output. He also turned his hand to landscape and figure drawings, scenes of indigenous society, and sketches of the ship itself. He even helped in the surveying work by drawing the coastal views that Buchan would otherwise have undertaken.

The few portraits we have of Parkinson support the impression of him given in his journal of the voyage: he was a sensitive, thoughtful young man, who showed a deep sympathy with the societies of the South Pacific. Drawing brought him into a close and unthreatening relationship with the indigenous subjects of his life drawings, an opportunity that others, apart from Banks and Solander, did not share to the same degree. The extent of Parkinson's interest in the societies that he encountered is reflected in the vocabularies he collected during his meetings with Tahitians, Maori and Aborigines.

Charles Green, a former assistant to the Astronomer Royal, was appointed by the Royal Society to join the ship as the principal observer of the Transit of Venus. Thirty-three years old and the son of a Yorkshire farmer, Green was responsible not only for

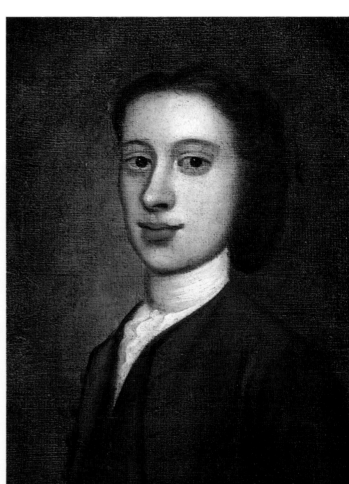

BELOW: Dr Daniel Solander, fellow of the Royal Society, was a Swedish botanist who had studied under the eminent natural historian Carolus Linnaeus. Solander was working at the British Museum on the collection of specimens brought back by the *Dolphin* from Tahiti when Joseph Banks, his former student, invited him to join the *Endeavour* voyage. This portrait is believed to have been painted by Johann Zoffany.

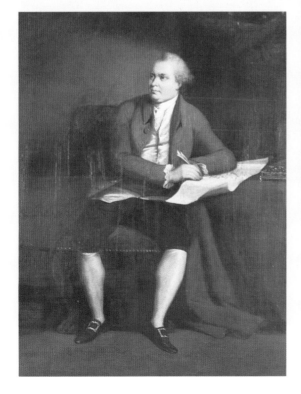

ABOVE: A painting of the artist Sydney Parkinson, thought to be a self-portrait. As a botanical artist, Parkinson had worked on depicting the specimens that Joseph Banks had brought back from Newfoundland. He was invited to join the *Endeavour* expedition as one of Banks's eight employees.

observing the eclipse from Tahiti, but also for assisting in navigating the ship. Under his supervision were various scientific instruments to help him in both these tasks. While the Royal Society provided Gregorian reflecting telescopes, astronomical quadrants and a pendulum clock to mark the eclipse, the Admiralty provided the sextants that would help Green and Cook to navigate using the latest developments in the techniques of astronavigation.

Green occasionally drank too much and has been described as 'waggish'. However, he was highly conscientious in taking the observations required for navigating by the stars. He even continued to do so when the ship was on the brink of being destroyed on the Great Barrier Reef. Although he was assiduous in teaching the other junior officers scientific navigation by the stars, he did not always have much success in winning their enthusiasm for the subject.

## Officers, Men and Marines

Since the *Endeavour* was a newly commissioned Royal Navy vessel, there was no crew already associated with the ship. As a result, the majority of her company were pulled together from different ships and assigned to the *Endeavour* from the Admiralty books without consulting even the captain. Overall, the crew were young, few above the age of thirty, and from all quarters of England, Scotland and Wales, as well as further afield. Although in some respects a job lot, the chosen men turned out to be a skilled, competent and reliable crew.

Most of the ship's company went aboard the *Endeavour* in June and spent the summer preparing the ship for its long voyage to the South Pacific. The crew could be away for as long as three years, and there was much work to be done in order to get the ship ready to sail. On arrival, each of the crew was entered into the ship's books and numbered off. This allowed the purser to organize the men's wages and allowances of food and drink during their time on the ship. Depending on rank, each of the crew was allotted a space in which to sleep, eat and store a few belongings. Some, such as the warrant officers, had cabins and swinging cots; others, such as the able seamen and marines, were given hammocks to sling in the open spaces of the mess deck.

On board were lieutenants, petty officers, marines, able seamen, servants and idlers (specialist non-seamen, some of whom were warrant officers), including a carpenter, a butcher and a one-handed cook called John Thompson. (Thompson had been sent by the Admiralty after Cook complained that the first cook selected for the voyage was lame. Cook complained again when Thompson arrived, but the Admiralty refused to provide another replacement. By all accounts, Thompson performed his duties ably.) The surgeon and his mate, under the guidance of the Sick and Hurt and Victualling Boards, had the task of keeping the crew healthy during their three years at sea. They were also responsible for testing specific measures to prevent scurvy from taking hold.

Before embarking on the *Endeavour* expedition, Cook's longest voyage had been across the Atlantic. Now, as he prepared for the lengthy journey to the Pacific, he would

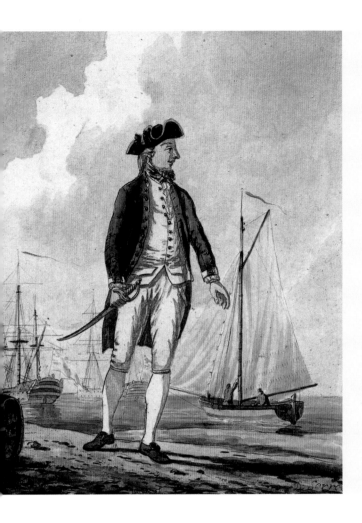

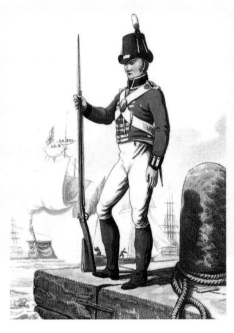

LEFT: An eighteenth-century midshipman, depicted here by Dominic Serres, was a petty officer who had the freedom to walk the quarterdeck, and was often in training to become an officer. There were four midshipmen on the *Endeavour*.

BELOW: A private of the Marines, an armed corps of men established by the Admiralty in 1755. Although marines helped with some of the sailing work on board ship, their main function was to defend landing parties and guard certain parts of the ship, such as the ammunition store.

be grateful for the experience of those officers and seamen who had joined the ship from HMS *Dolphin*. Robert Molyneux, the master, and Richard Pickersgill, the master's mate, had helped carry out the surveys of Tahiti after its 'discovery' by Wallis. Their charts were given to Cook when he received his instructions from the Admiralty, and their surveying experience would greatly assist him in undertaking the surveys of Tahiti, the Society Islands, New Zealand and eastern Australia. Also from the *Dolphin* were able seaman Francis Wilkinson, soon promoted to master's mate, and John Gore, third lieutenant on the *Endeavour*. Gore was a skilled seaman and a man of action who had previously sailed with both Wallis and Byron. Charles Clerke, too, had sailed with Byron in the *Dolphin* before he was appointed master's mate on the *Endeavour*. The experience of these men in sailing outside the Atlantic and establishing friendship and trading relations with the Tahitians was to prove enormously valuable to Cook.

There are no records that describe what the seamen aboard the *Endeavour* thought about the voyage to Tahiti. Few of them could write, but they were forbidden to keep

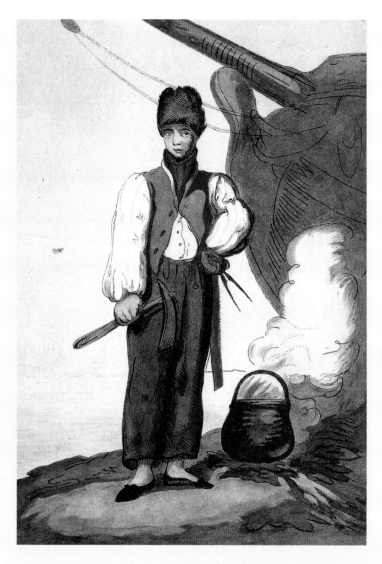

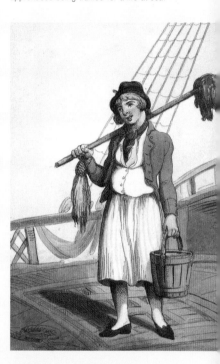

LEFT: The ship's carpenter, one of the specialist non-seamen, was also a warrant officer. John Satterley, the carpenter on the *Endeavour,* had a crew of four to help him.

BELOW: A typical cabin boy. Many of the officers on the *Endeavour* voyage had servants, usually young boys who were apprentices being trained for a life at sea.

RIGHT: 'Saturday night at sea', an etching by George Cruickshank, shows the nature of life on board ship while off duty. Seamen on the *Endeavour*, as on other ships of the period, entertained themselves with music, story-telling, games and lots of drinking.

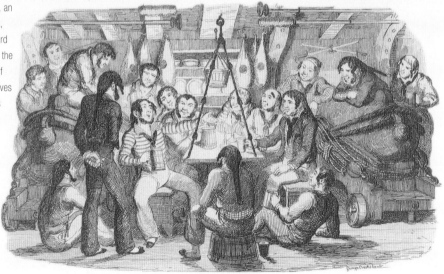

written journals anyway; officers frowned upon literacy in the ranks. However, five of the *Endeavour*'s crew came from HMS *Grenville*, where they had served under Cook when he was making his surveys of Newfoundland. No doubt many of the crew would have asked the *Grenville* sailors what Cook was like. They, in turn, heard stories from the *Dolphin* crew about Tahiti, an exotic paradise island where, it seemed, there was no work to be done, where the people were friendly, where sex was accessible to everyone in exchange for trifling objects, and where fruit and food grew abundantly on trees. It is not difficult to imagine how these tales might have inspired the sailors.

Although exploration offered the chance to visit exotic places entirely different from their own world, this would not have been the real reason for men wishing to join the *Endeavour*. Ultimately, they went to sea because it was a job: it offered a potentially better standard of living than on land, perhaps as an agricultural worker, which was then the principal occupation open to the poor and uneducated. Rural life involved uncertain harvests and often a hand-to-mouth existence. By contrast, life at sea seemed more reliable: there were hot meals every day, including meat four times a week, and regular pay. Although long voyages posed greater risks and dangers, they offered employment and income over a longer period of time. Cook records how on Friday 19 August, while waiting for favourable winds to speed their departure, the crew were paid some of their wages in advance. The *London Gazette* later reported that, 'There has been much carousing in the dockside taverns by the crew, who received two months' payment in advance and anticipate being away from England's shores for a considerable period of time. They were informed they will receive no additional monies until the end of the voyage.'

The last men to join the crew were twelve marines – an armed corps of men – who arrived on board just three weeks before the *Endeavour* was to sail. Their late arrival suggests that they were almost an afterthought, and reflects how the voyage had changed in its ambitions since first proposed. The ship's company would need protection now that the voyage was one of exploration rather than merely astronomical observation. They would certainly encounter new and potentially hostile people in the South Seas, but as the voyage had been extended to three years, there was also the risk of conflict arising on board, within the ship's company itself.

On 26 August 1768, Cook wrote: 'At 2 p.m. got under sail and put to sea, having on board 94 persons, including officers, seamen, gentlemen and their servants, near 18 months provisions, 10 carriage guns, 12 swivels with good store of ammunition, and stores of all kinds.' Also on board were dozens of chickens, some sheep, a goat to supply milk for the officers, a pig and a sow and their litter of piglets. The ship had all the trappings of a grand Royal Navy adventure at sea. The vessel itself, however, was very similar to one that Cook had worked on years previously out of Whitby: it was a slow, ugly, broad-bowed bark which, in its previous incarnation, had carried coal up and down the North Sea coast of Britain. How had such a lumbering vessel been chosen for such an expensive and important voyage of exploration?

# Search for a Ship

On 16 February 1768 a petition to King George III was signed by the Royal Society, requesting that 'about £4000' be put towards the astronomers' voyage to the South Seas. Just over two weeks later a positive response was conveyed to the Lords of the Admiralty: not only would the King help finance the expedition, but it was also His Majesty's pleasure 'that a proper vessel be prepared'. The Admiralty instructed the Navy Board accordingly, but after this burst of activity, their lordships were informed that no suitable ship was available. Several were nonetheless offered for their consideration, but these were turned down on the grounds that they were either not designed for long voyages or could not be prepared in time. On 21 March, however, the Navy Board suggested 'a cat-built [steeply broad-bowed] vessel, which would be roomy enough for the purpose. One of about 350 tons can be purchased in the River Thames.' The merchant collier eventually chosen was the *Earl of Pembroke*, a three-masted square-rigger, having square sails on each mast, and triangular fore and aft sails. The ship's original function meant that it was sturdy, had a bluff (vertical) bow and a broad, flat hull of an unusual convex shape. This

Cat-built barks such as this one, said to be the *Earl of Pembroke* and shown here leaving Whitby in a painting by Thomas Luny (*c.* 1790), were designed for carrying coal. This ship was bought by the Navy Board for £2307. 5s. 6d., then converted for the expedition to the South Pacific led by Captain James Cook. For this adventure she was renamed the *Endeavour*.

very un-Royal Navy-like ship, to be renamed *Endeavour*, was neither elegant nor fast. Of her speed, Joseph Banks wrote in his journal on 24 February 1769, 'this morn found studding sails set and the ship going at the rate of 7 knots [8 mph], no very usual thing with Mrs Endeavour'.

Nonetheless, the ship was well suited to the task in hand: its vast hold offered plenty of space for the provisions required during three long years at sea. In addition, being flat-bottomed gave the ship a very shallow draught, which made it ideal for sailing in shallow waters while surveying South Pacific coastlines. It also meant that the ship could be beached easily – a valuable asset if the hull needed repairs after running aground or being attacked by marine borers.

Contrary to the normal naval procedure of paired ships undertaking long voyages so that one could help the other out in the event of accident, wreckage or illness, the *Endeavour* was sailing alone. The earlier voyages to Tahiti by Byron and Wallis in the *Dolphin* had the security of a second ship accompanying them. Perhaps because the *Endeavour* voyage had been conceived to further astronomy rather than discovery, Cook did not have that luxury. Certain unfortunate experiences, however, meant that he would never again risk taking only a single vessel on future voyages.

While Cook had no part in choosing the *Earl of Pembroke*, historian Glyn Williams has argued that perhaps the ship helped choose him. Cook had worked on similar merchant vessels when apprenticed in Whitby, and this might have given him an advantage over other candidates for the South Seas venture. His lowly status as a master also made him unlikely to balk at captaining such a humble vessel. Whatever the case, the match came about, and it was a well-made one. Following his return from the South Pacific, he wrote to his friend and former employer John Walker: 'I sailed from England as well provided for such a voyage as possible and a better ship for such a service I would never wish for.'

## Conversion Work Begins

Upon purchasing the *Earl of Pembroke*, the Admiralty directed the Navy Board 'to cause her to be sheathed, filled and fitted for that service, to be registered on the List of the Navy as a Bark by the name of the *Endeavour*'.

Sheathing and filling involved applying a special protective layer to the hull in order to make it water-tight for the three-year voyage, and also to defend it against *teredo* worm, a marine borer common in the tropical waters of the Pacific. The exterior of the

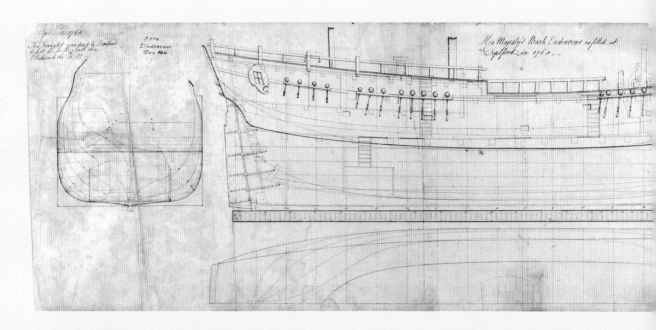

ABOVE: These profile plans of the *Endeavour* were drawn up during the ship's refit at Deptford in the summer of 1768. The cross-section shows the ship's flat hull and huge storage capacity, ideally suited for carrying many months' worth of provisions for a long voyage to the South Pacific. Joseph

Banks recorded how the ship sailed admirably in a gale and 'the seamen in general say that they never knew a ship lay to so well as this does, so lively and at the same time so easy'. He, however, often felt frustrated at its slow speed, noting that it was 'more calculated for stowage than for sailing'.

OPPOSITE: These Admiralty deck plans of the *Endeavour*, drawn up at the Deptford Yard in July 1768, show that cabins were added to accommodate the gentlemen/supernumeraries on the after fall deck. As a result, the officers' cabins were moved below and built at the stern end of the lower deck.

hull was first matted with thick paper rags and tarred with horsehair. Then it was sheathed with planks about an inch thick. These planks were fastened with numerous wrought-iron nails, creating a layer of metal. The spaces in between the boards were then caulked, a process in which unravelled rope (oakum) was squeezed into the gaps and sealed with pitch or tar. The whole surface was then rigorously planed down to ensure that it would travel as smoothly through the water as possible. Finally, the hull was coated with a thick white mixture of fish oil, turpentine and brimstone.

The work of fitting the ship was even more time-consuming. Decks and cabins were added to accommodate the ninety-four people who would make up the company. In its original form, the *Earl of Pembroke* had only two small decks – an after fall (upper) deck and a foremost fall deck – the other areas being taken up by cargo. The *Endeavour* needed a whole lower deck to be added, which ran the length of the ship. This deck had to be fitted in line with the fourteen existing beams of the hold, and as a result had a higher ceiling in the main mess area than is found on other ships of the period. Even very tall people could stand here without stooping.

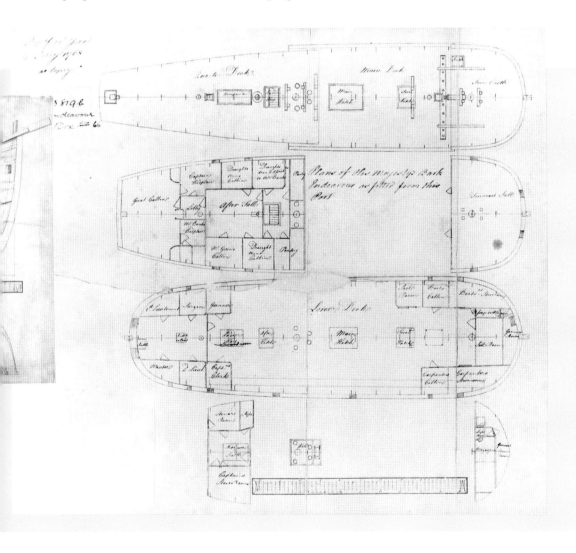

## Lower Deck

Accommodating everyone, while maintaining the separations that naval hierarchy demanded, was the principal reason for adding a lower deck. Only the ship's petty officers' cabins could fit in the existing foremost fall deck. The foremost part of the new lower deck was taken up by the cabins and storerooms of the boatswain and carpenter, as they are on the replica *Endeavour*. The storerooms offered sufficient space for the ropes, nails, tar, grease, paint, varnish, brushes and brooms, lanterns and candles, saws, mallets, hammers and other tools and supplies that the craftsmen would require to maintain the ship while at sea. Every eventuality was covered, from broken windows to holing by rocks. Near the boatswain's cabin were two sail rooms, where the vital extra sails were stowed. These would be checked for damp regularly during the voyage, while those in use would be given maximum wear and tear before the canvas was replaced and put to other uses. Much time and care was expended on the sails because without them the ship had no engine.

In the middle of the lower deck was the galley, where the cook, his mate and the cooks of the mess would work. It was equipped with an iron firehearth – a stove with an open fire behind it for grilling and roasting – a table for food preparation, and shelves for storing cooking utensils. On the replica *Endeavour* there is a modern galley in the hold, so the firehearth on the lower deck is used to house a ventilation system. For the BBC project, however, in the interests of historical inquiry, the ventilation system was dismantled, the firehearth carefully insulated, and the stove made to work just as on Cook's ship. Caroline MacDermott, the experienced cook aboard the replica *Endeavour*, had only ever used the modern galley below. She described in her journal seeing the eighteenth-century stove working for the first time.

### 20 August 2001

It's a monster, huge, black and quite daunting. Wally, the ship's engineer acting as fireman/stoker, showed me how to lay the fire, first with paper, then kindling, then bigger pieces. Chris Terrill filmed the ceremonial first lighting, and as the fire caught and crackled and got hotter, I threw the oil and chopped suet, all the veggies plus some herbs and mustard seed into the large pan. It all began to sizzle and then in went the meat. I waited for it to brown a little then topped it up with water, put the lid on and waited, all the while Wally tending the fire. The two 'cauldrons' weigh very heavy on their own, so we won't be able to lift them with anything inside. The area around the stove is going to be dangerous too because every inch of it gets hot once the fire has been lit. I've decided to wear the normal protective chef's gear that I usually use in my twentieth-century galley: if the weather is rough, then it's going to be all too easy to stumble against the hot metal, resulting in one barbecued chef!

On the same lower deck as the galley was the main mess area for the able seamen. Here the *Endeavour* was fitted with swinging mess tables, shelves to store mugs, bowls, plates and spoons, and chests on which the sailors would sit. In the same space above the tables the seamen would sling their hammocks at night. Admiralty regulations stipulated a mere

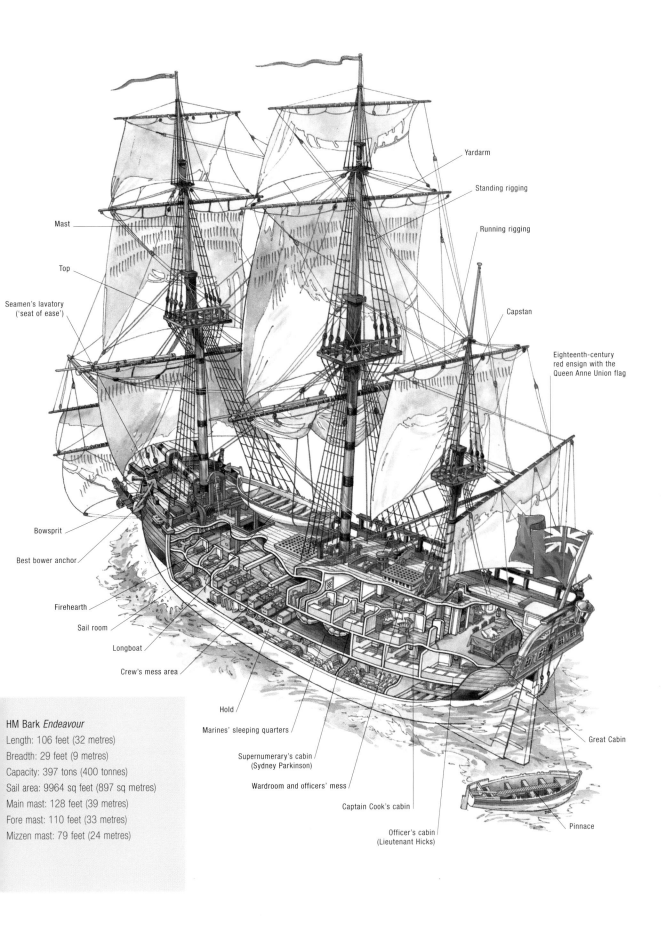

Mast

Top

Seamen's lavatory
('seat of ease')

Bowsprit

Best bower anchor

Firehearth

Sail room

Longboat

Crew's mess area

Hold

Marines' sleeping quarters

Supernumerary's cabin
(Sydney Parkinson)

Wardroom and officers' mess

Captain Cook's cabin

Officer's cabin
(Lieutenant Hicks)

Yardarm

Standing rigging

Running rigging

Capstan

Eighteenth-century
red ensign with the
Queen Anne Union flag

Great Cabin

Pinnace

**HM Bark *Endeavour***

Length: 106 feet (32 metres)

Breadth: 29 feet (9 metres)

Capacity: 397 tons (400 tonnes)

Sail area: 9964 sq feet (897 sq metres)

Main mast: 128 feet (39 metres)

Fore mast: 110 feet (33 metres)

Mizzen mast: 79 feet (24 metres)

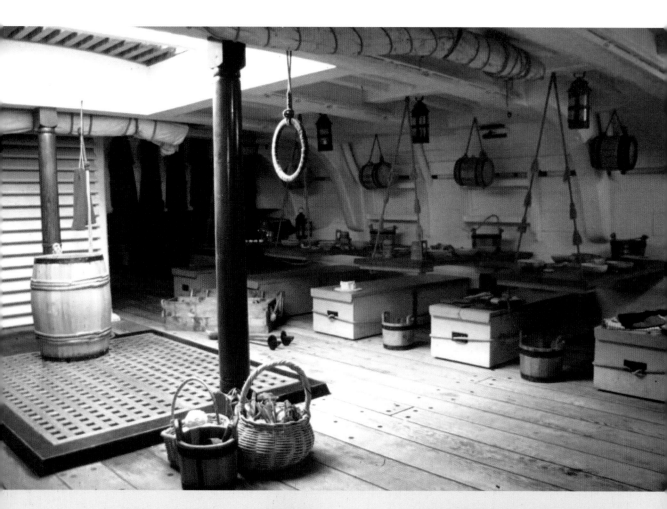

ABOVE: The main mess area of the replica *Endeavour*. Here volunteers and historians slung their hammocks, ate and relaxed while off watch duty. Other specialists, such as the navigators, the botanist and the artist, occupied the cabins of their eighteenth-century counterparts.

RIGHT: As eighteenth-century Admiralty regulations specified, hammocks were slung just 14 inches (35 cm) apart, which brought the twenty-first-century seamen into closer contact than they were otherwise used to.

14 inches (35 cm) between the hammocks, so the BBC volunteers would quickly find out what it was like to live cheek by jowl. Privacy would be non-existent. Together we would sleep, eat and rest in the same space as the smoking stove. Iain McCalman, a historian who joined the ship's company as an able seaman, described his first night's sleep: 'We slung our hammocks in the very confined, hot and fetid galley, where all the hands are sleeping like a series of fruit-bats from the ceiling, snoring, farting, grunting, the night noises of a giant bat company.'

Moving aft, the ceiling height drops to just 4 feet 6 inches (135 cm) in the marines' sleeping area – a test in itself for the volunteers, as it probably was for the original marines. This cramped space effectively divided the seamen's mess area from the officers' cabins at the stern end of the lower deck, thereby reinforcing the distinction between the ranks. Vanessa Agnew, another of the historians invited to join the ship as an able seaman, described her first impression in her journal:

27 August 2001
The spaces of the ship are hermetically sealed. So insular is our existence on the lower deck, I've not yet seen the captain's quarters, nor those of the supernumeraries. It has come as something of a surprise to find how isolated even Cook's junior officers would have been from the seamen, isolation that was enforced by the quartering of marines in the low-ceilinged waist of the ship.

Furthest aft, in the small space between the officers' cabins, Cook's junior officers (the midshipmen and mates) slung their hammocks. During the day they also messed here, setting up their own table and sitting on chests. The cabins that surrounded this space housed the officers, the second and third lieutenants, the gunner, the surgeon, the master and the captain's clerk, many of whom had been moved down here in order to accommodate the supernumeraries on the after fall deck. With space denoting status, the gentlemen upstairs were clearly an elite, and the internal alterations would have indicated that this voyage was like no other Royal Navy venture. The officers' cabins were tiny (6 x 5 feet/180 x 150 cm), but had portholes to let in light and air and offered a modicum of privacy. Like the gentlemen, officers provided their own bedding, curtains and furniture, and also came equipped with whatever instruments, such as telescopes and sextants, might be necessary on the voyage. During the BBC voyage of 2001 the *Endeavour*'s professional crew slept in the former officers' cabins.

## After Fall Deck

The ship's most stately and spacious rooms were the wardroom and the Great Cabin on the upper deck, otherwise known as the after fall deck. Surrounding these two spaces were the cabins of the gentlemen and the captain.

During the summer months, when the ship was being prepared at Deptford Yard, Joseph Banks paid several visits to supervise the modifications being carried out. He ensured that his cabin, which led into the Great Cabin, had sufficient storage space and

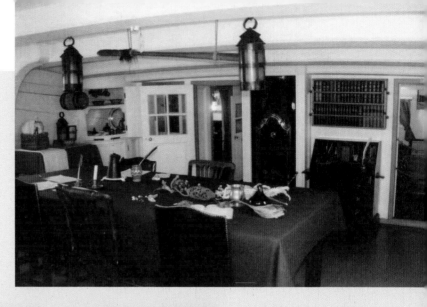

cupboards for his scientific and botanical equipment. On the replica *Endeavour*, the botanist, Tom, slept in this cabin, even though Banks and his former tutor, Solander, often abandoned their bunks for hammocks slung in the roomier Great Cabin.

The captain's cabin was situated on the port side of the after fall deck and had two doors, one leading into the Great Cabin, the other into a passageway that led towards the quarterdeck. Cook and the remainder of the gentlemen had swinging cots; these are similar to hammocks, but have a wooden frame that keeps them open and makes them more comfortable. Each of the after fall cabins had a porthole for light and ventilation. On the BBC voyage, Lucy, the botanical artist, slept in the cabin occupied by Parkinson on the port side of the wardroom on the original ship, while John, the senior member of the navigating team, occupied the astronomer Green's cabin on the starboard side.

Using only eighteenth-century techniques, John and the navigating team worked on their calculations in the wardroom, where Cook's officers had also worked on their logs and charts, benefiting from the light that came through the large deck hatch above. They

also messed together here: the after fall deck was fitted with two pantries in which crockery, cutlery, glasses and cooking utensils were stowed. In these pantries servants prepared food for both the officers and the gentlemen, heating it on a small stove fitted in the Great Cabin. It was served then to the officers in the wardroom, and to the gentlemen in the Great Cabin. On our voyage in 2001, however, everyone ate in the main mess area on the lower deck.

The Great Cabin was traditionally the space reserved for the captain, but on Cook's voyage it became a meeting place and work area for him and the supernumeraries. Its spaciousness and large windows made it the ideal work space – cool, bright and airy. With all their tasks of charting, calculating the ship's position, writing up their journals, classifying, drawing and preserving botanical and zoological specimens, this room would have been a hive of activity during the three years at sea. Banks himself described the scene one day before the ship made its first landfall in New Zealand.

*3 OCTOBER 1769*

Now do I wish that our friends in England could by the assistance of some magical spying glass take a peep at our situation: Dr Solander sits at the cabin table describing, myself at my bureau journalising, between us hangs a large bunch of sea weed, upon the table lay the wood and barnacles; they would see that notwithstanding our different occupations our lips move very often, and without being conjurors might guess that we were talking about what we should see upon the land which there is now no doubt we shall see very soon.

During the BBC voyage, the captain, Chris Blake, Tom and Lucy all carried out their work in the Great Cabin. In her journal Lucy described her first impression of it: 'The Great Cabin is magnificent; it's about twice as large as I had expected and full of glorious light and breeze.' Banks and Solander had also appreciated the room's spaciousness, not least to accommodate their bundles of equipment, materials and books, and to store the specimens that were currently being studied. Only once these had been drawn, classified, dried or preserved would Banks allow them to be stored in the hold below. The specimens that Tom and Lucy collected soon began to take over the Great Cabin, making it resemble a greenhouse, so one can imagine how much busier the room would have been under the influence of Banks's energetic collecting over a three-year period.

## The Hold and the Weather Deck

In the replica *Endeavour* the hold is fitted with modern amenities, including wash rooms, an up-to-date galley and an engine room. Since we would be washing on deck, using an eighteenth-century stove for cooking, and sailing by force of the wind, only the lavatories and sinks were kept operational during the six-week BBC voyage. The remainder of the space on the replica ship was freed up and used for storage, as it had been originally.

On Cook's *Endeavour*, the massive hold was divided into five separate areas. Situated aft was a dry room for storing bread. Next to this was the steward's storeroom, where he

organized the day's food supplies and also slept. The adjacent captain's storeroom held the additional personal provisions that Cook bought with his extra victualling allowance of £120 provided by the Royal Society. At the foremost part of the hold was a magazine room, lead-lined and plastered to keep the powder dry. A marine would have stood guard here to watch over the ship's ammunition. The huge space between these rooms at either end of the hold was taken up with provisions for the crew. Indeed, the ship's capacity to carry three years' worth of stores was perhaps its most valuable quality. A look at the provisioning list suggests how much space would have been required.

### VICTUALLING BOARD MINUTES, 15 JUNE 1768

Let the following provisions be sent to the said Bark as desired, viz: Bread in Bags 21,226 pounds. Ditto in Butts 13,440 pounds. Flour for Bread in Barrels 9,000 pounds. Beer in Puncheons 1,200 gallons. Spirits 1,600 gallons. Beef 4,000 pieces. Flour in lieu of ditto in half barrels 1,400 pounds. Suet 800 pounds. Raisins 2,500 pounds. Peas in Butts 187 bushels. Oatmeal 10 ditto. Wheat 120 bushels. Oil 120 gallons. Sugar 1,500 pounds. Vinegar 500 gallons. Sauerkraut 7,860 pounds. Malt in hogsheads 40 bushels. Salt 20 ditto. Pork 6,000 pieces. Mustard seed 160 pounds.

…the *Endeavour*…will afford an opportunity for a fair trial to be made of the efficacy of sauerkraut against the scurvy. Write the commanding officer, a proportion for twelve months for seventy men will be sent aboard at the rate of two pounds per man per week.

These provisions were carefully arranged in the hold to make the most of the space available. Fresh water for drinking and cooking was kept in huge barrels known as tierces. Strictly rationed, water was siphoned off into smaller casks and carried up to the lower deck and the weather deck, where it was poured into scuttlebutts; from here seamen could ladle the water into their mugs and chat as they drank, conversation that became known as 'scuttlebutt talk'.

The weather deck is made up of the forecastle, the main deck and, at the stern, the quarterdeck. Here, during the summer of 1768, the *Endeavour*'s sailing equipment was renewed and repaired in preparation for the voyage ahead. A new tiller was fitted, designed to swing clear of the chimney flue from the Great Cabin stove. Banks requested that a special platform be built above it so that the gentlemen could walk over it without fear of impediment. In the space underneath this bridge pens were built for the sheep and pigs, while the chickens were housed in a coop stowed in one of the ship's small boats. The chicken coop on the BBC voyage, however, remained on the quarterdeck, finding its most convenient place beside the glass hatch above the wardroom. Unlike Cook's goat, which freely roamed the deck, our goat was tethered beside the main companionway, but some of the crew took great care to walk her around the deck every day, giving her, albeit briefly, the freedom of her eighteenth-century counterpart.

Two binnacles, or cabinets, were fitted either side of the wheel. These were designed to carry the ship's compasses and sand-glasses, as well as a lantern for navigating at night.

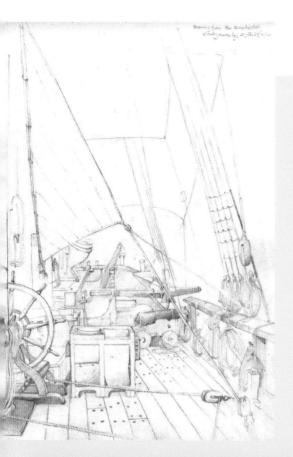

RIGHT: Most eighteenth-century ships were reminiscent of farmyards as they always carried animals to provide fresh food. Cook sailed with chickens, goats, sheep and pigs, as well as Banks's two dogs. The BBC voyage, being much shorter, included a goat for the first two weeks, and also had some chickens housed in a coop on the quarterdeck.

LEFT: The weather deck of the replica *Endeavour* drawn by Lucy Smith during the BBC voyage. The picture includes the binnacle and one of the ship's carriage guns.

BELOW: This view towards the quarterdeck, showing the ship's wheel and tiller, was taken at Cairns harbour on the evening before the ship set sail for Cape Grafton. There the volunteers would row out and join the ship for the first time.

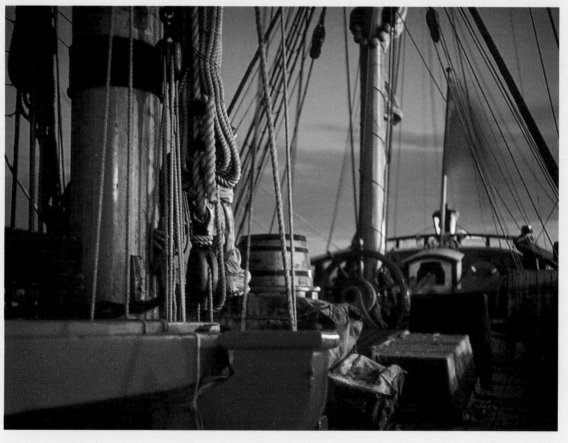

The *Endeavour* carried various types of small boat – the longboat (bottom right), the pinnace (left and top right) and the yawl. The ship also found space for a boat belonging to Banks and one for the boatswain, although the latter was washed overboard in a gale. These sketches were made by Sydney Parkinson in 1769–70.

BELOW: As in Cook's day, the pinnace on the replica *Endeavour* was used for many purposes, which included taking groups of people ashore.

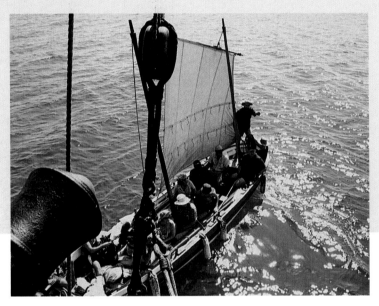

Deck equipment, such as the pumps, was renewed, and the ship's three small boats – the yawl, the pinnace and the longboat – were hoisted above the large hatch on the main deck. These boats were essential for surveying work, navigation, fishing, landing shore parties, repair work to the ship, carrying casks and stores, and even, in emergency, towing the ship. Like our predecessors, we too would become adept at lowering, sailing and rowing the ship's small boats during our many landfalls.

Once the spars, rigging and sails had been renewed and fitted, all that remained to be done was the finishing touch of paint. The ship's upper sides were coated in a varnish of pine, and the principal lines and features of the weather deck were painted in the Royal Navy colours of black, blue and yellow. The *Earl of Pembroke*, a merchant collier, had become His Majesty's Bark *Endeavour*. From Deptford in southeast London she would sail along the Thames to Galleons Reach to take on her guns, move on to Plymouth for provisioning and receiving the last of her company, and finally set sail for the South Pacific.

# From England to *Terra Australis*

The *Endeavour* voyage, over two years in planning and preparation, was a monumental undertaking, and there was neither the time nor the finance for the BBC to retrace it in its entirety. We picked up the route in northern Australia and followed it to Indonesia – a 'mere' 3500-mile (5600-km) stretch of the original 40,000-mile (64,000-km) journey. Although the eclipse at Tahiti and the discovery of the Great Southern Continent had been the goals of the original voyage, they were part of something much greater. This section therefore offers a broad outline of the voyage from its start to the point (Cape Grafton) at which the BBC voyage began – a thumbnail sketch of a remarkable adventure.

On 19 August 1768 the *Endeavour*'s crew expressed their 'cheerfulness and readiness to prosecute the voyage' and were given two months' wages in advance. They would receive the rest when and if they returned. Since this was an official Royal Navy voyage, the crew were also read the 'Articles of War', outlining the rules under which the expedition would be conducted.

A week later, when favourable winds permitted, the expedition got under way. In between the normal tasks involved in running a ship the men would talk, drink, carve scrimshaw and play cards and dominoes. Musical intervals came courtesy of a fiddler and a flute-player among the seamen, and a drummer and a fifer among the marines. The officers' pastimes included reading, writing in their journals and playing backgammon. In many respects this was a voyage like any other.

What made the voyage different from its predecessors was the contingent of scientists on board. Among these men, none of whom had been on such a long voyage before, homesickness inevitably reared its head quite early on. Scarcely out of European waters, Joseph Banks expressed some of these feelings in his journal.

> Today…we…took our leave of Europe for heaven alone knows how long, perhaps for ever; that thought demands a sigh as a tribute due to the memory of friends left behind and they have it; but two cannot be spared, it would give more pain to the sigher, than pleasure to those sighed for. It is enough that they are remembered, they would not wish to be too much thought of by one so long to be separated from them and left alone to the mercy of winds and waves.

During the ship's first landfall, at Madeira on 13 September 1768, stocks of fresh beef, onions, vegetables, wine and water were replenished. Sadly, this routine operation was marred by the death of the quartermaster, who was caught in the buoy rope and drowned. Life at sea was always hazardous.

Heading south again, the ship crossed the Equator, where those who had never crossed it before had to undergo a ritual conducted by the boatswain: each was tied to a rope hung from a yardarm and dunked in the sea three times from a great height. Banks excused himself, Cook, Solander and his dogs from this indignity by offering up a quantity of brandy instead.

Arriving at Rio de Janeiro in Brazil on 13 November 1768, Cook reprovisioned the ship, and one of his men tried to desert – a common occurrence among crews of the time. He also lost another able seaman, who fell overboard and drowned.

The ship then headed further south, into the cold, rough seas of the South Atlantic, where Cook began his passage around Cape Horn via the Strait of Le Maire. Ploughing through squally weather and violent tides, Cook recorded how the *Endeavour* 'frequently pitched her bowsprit in the water'. The ship eventually dropped anchor in the Bay of Good Success in Tierra del Fuego. Here the shore party received a friendly welcome from the Ona of Patagonia, who, so far as Cook could observe, had no form of government, no utensils and no 'means of going upon the water'. They were, he concluded, 'perhaps as miserable a set of people as are this day set upon the earth'. The ship's artists drew these people and their homes – some of the first Europeans to do so. Meanwhile, Banks led a natural history expedition inland. During this the artist Alexander Buchan suffered an epileptic fit, the ill-equipped group became caught in a snowstorm, and two of Banks's servants died of exposure. Such were the hazards of exploration.

Despite the contrary winds, currents and tides, the *Endeavour* rounded Cape Horn on 25 January 1769 and headed northwest for Tahiti. Cook, having the benefit of

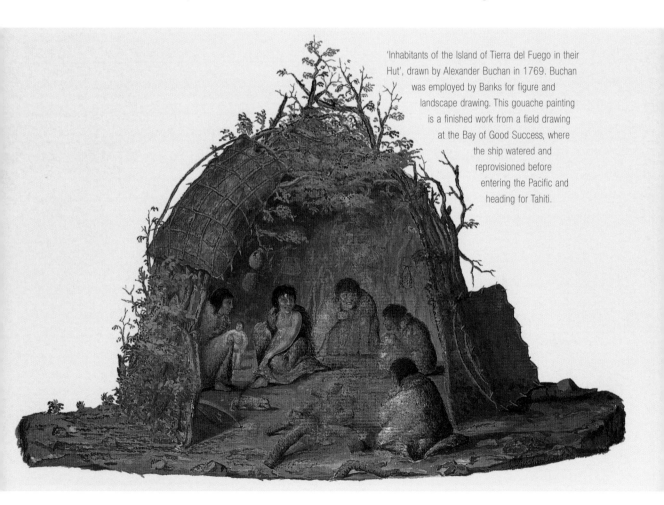

'Inhabitants of the Island of Tierra del Fuego in their Hut', drawn by Alexander Buchan in 1769. Buchan was employed by Banks for figure and landscape drawing. This gouache painting is a finished work from a field drawing at the Bay of Good Success, where the ship watered and reprovisioned before entering the Pacific and heading for Tahiti.

bearings, charts and logs supplied by Captain Wallis of HMS *Dolphin*, was the first to make his way unerringly to the island. This information, together with his skill as a navigator, allowed the ship to arrive on 13 April 1769, in good time for the Transit of Venus. A site was chosen for the observation camp, and the men built a secure place, protected by a stockade, from which the astronomers would work. Fort Venus, as it was called, was surrounded by tents, in which many of the ship's company slept. As they were here for three months, the crew and gentlemen had time to establish friendly relations with the Tahitians, learn some of their language and teach their own, explore their exotic surroundings and trade. However, the most important business was the Transit of Venus.

On 3 June 1769, the day of the eclipse, the weather conditions were perfect and remained so during the six hours in which three teams of observers watched from three different locations. Later, however, they found their readings differed from each other's in one major respect – the point at which Venus entered and left the face of the sun. This was on account of a blurring caused by 'an atmosphere or dusky shade around the body of the planet' which obscured the points of contact. The conflicting results led to the success of the observation being disputed, not least by the Astronomer Royal Nevil Maskelyne on the *Endeavour*'s return, and by the great Cook scholar J.C. Beaglehole

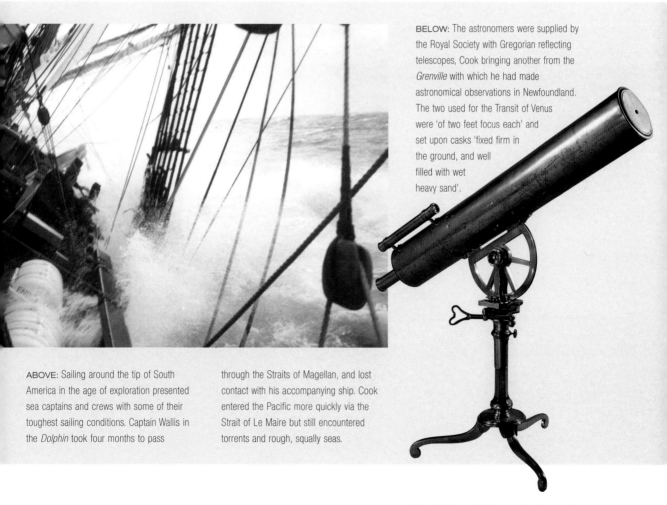

BELOW: The astronomers were supplied by the Royal Society with Gregorian reflecting telescopes, Cook bringing another from the *Grenville* with which he had made astronomical observations in Newfoundland. The two used for the Transit of Venus were 'of two feet focus each' and set upon casks 'fixed firm in the ground, and well filled with wet heavy sand'.

ABOVE: Sailing around the tip of South America in the age of exploration presented sea captains and crews with some of their toughest sailing conditions. Captain Wallis in the *Dolphin* took four months to pass through the Straits of Magellan, and lost contact with his accompanying ship. Cook entered the Pacific more quickly via the Strait of Le Maire but still encountered torrents and rough, squally seas.

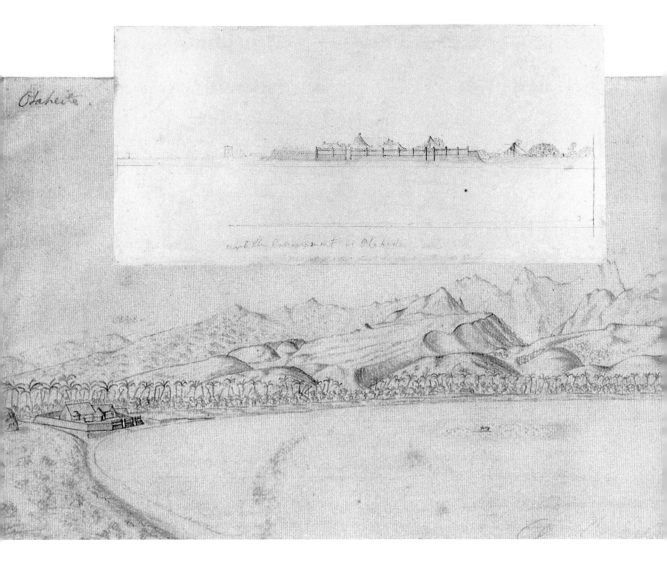

Otaheite.

more recently. However, astronomy historian Wayne Orchiston maintains that the results succeeded in producing a more accurate value for the Astronomical Unit – the distance between the sun and the Earth – and hence the scale of the solar system.

When the *Endeavour* set sail on 13 July 1769 to explore the neighbouring islands – named the Society Islands by Cook – she had on board two new additions to the ship's company: Tupaia, a high priest and navigator who had befriended Banks during his stay, and his servant, a boy called Tayeto. Tupaia would prove valuable to Cook not only for his skills in navigation and knowledge of safe harbours, but also for his talents as a translator, mediator and expert in local protocol. This smoothed relations with the Society Islanders from the start, and allowed contact to be informative and friendly.

Cook charted seven of these islands before going in search of the Great Southern Continent. First he headed to the latitude 40° south. Finding nothing there, he then headed west and set about exploring New Zealand, of which Europeans knew very little. Cook charted and surveyed both islands in just six months. In the process, he dispelled all previous speculation and put the autonomous New Zealand on the map.

While this part of *Endeavour*'s voyage was highly productive, it was also characterized by unpredictable encounters with the Maori people. Violence and killings marked several

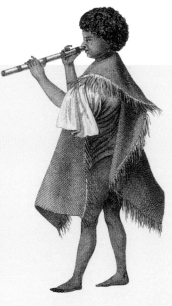

ABOVE: Tayeto, the young servant boy of Tupaia, a high priest from Raiatea. Tayeto and his master joined the *Endeavour* at Tahiti and accompanied the Europeans around the Society Islands, New Zealand and eastern Australia.

LEFT AND INSET: Fort Venus was built by the *Endeavour*'s crew soon after their arrival at Tahiti in order to provide a secure place from which to observe the astronomical eclipse known as the Transit of Venus.

of the landings, the superior firepower of the Europeans never failing to gain the upper hand. Cook, however, was anxious to fulfil his brief as specified in his instructions from the Admiralty and the Royal Society – namely, with the avoidance of aggressive gunfire. As described on pages 126–130, Cook did not always find this policy easy to enforce.

As the ship rounded the North Cape in December 1769, the company celebrated Christmas Day. Goose pie was made from birds shot by Banks and he recorded that 'all the hands were as drunk as our forefathers'. It was a happier time on what had often been a difficult circumnavigation. Threatening behaviour from the Maori had taken on a new significance when some of the crew ventured on land and saw signs of cannibalism. 'The horror on the countenances of the seaman on hearing this discourse is better conceived than described,' wrote Banks.

Continuing the journey through the passage that they discovered separated the north and south islands of New Zealand, Lieutenant John Gore thought he saw land to the southeast. Cook, who had 'resolved that nobody should say he had left land behind unsought for', ordered the ship to be steered in that direction. He found nothing and therefore returned to New Zealand. Even Banks, one of only two remaining believers in the existence of a Great Southern Continent, gave up the idea of its discovery as the

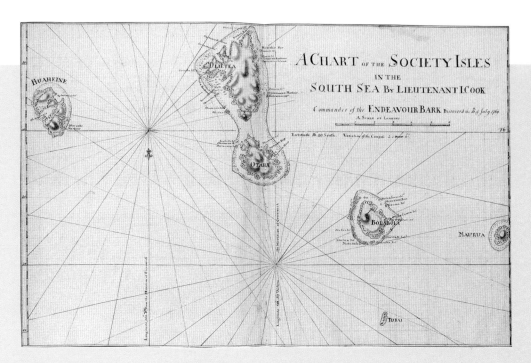

ABOVE: 'A Chart of the Society Isles' drawn by James Cook and his junior cartographer, Isaac Smith, in 1769. Although this island group had been sighted by the Dutch explorer Jacob Roggeveen in 1722, Cook was the first European to chart and explore its constituent islands of Moorea, Huahine, Raiatea, Tahaa, Bora Bora and Rurutu. During this part of his exploration of the South Seas, Cook was guided by Tupaia, who had exceptional skills in navigation.

RIGHT: 'A Chart of the East Coast of New Holland' drawn by James Cook and Isaac Smith between April and September 1770. This chart, and the feat of exploration and surveying that it represents, marks perhaps the greatest of Cook's achievements on the *Endeavour* voyage. It was also the most risky – a daring enterprise, outside his instructions from the Admiralty, that jeopardized his ship, the lives of his crew and the success of the entire voyage.

*Endeavour* rounded the tip of South Island 'to the total demolition of our aerial fabric called continent'. Perhaps it lay in higher latitudes further south. Although Cook believed it did not exist, he had not yet proved it. That task would have to wait for another voyage.

Admiralty Bay was the last stop in New Zealand, and here Cook was free to decide on his route home.

> To return by way of Cape Horn was what I most wished because by this route we should have been able to prove the existence or non-existence of a Southern Continent, which yet remains doubtful; but in order to ascertain this we must have kept in a high latitude in the very depth of winter but the condition of the ship in every respect is not thought sufficient for such an undertaking. For the same reason, the thoughts of proceeding directly to the Cape of Good Hope were laid aside, especially as no discovery of any moment could be hoped for in that route.

As a result, Cook settled on returning via the East Indies, first falling in with the 'undiscovered' east coast of New Holland, then considered a low priority for exploration among other European nations. To the ambitious Cook, however, the east coast offered a route home in warmer latitudes, as well as the promise of a new 'discovery'.

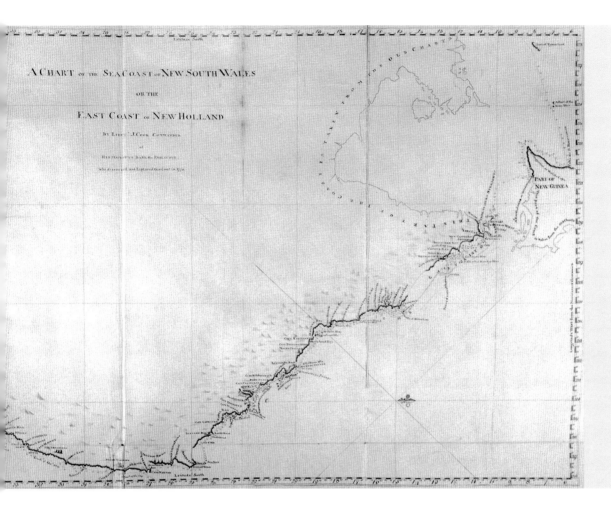

A Chart of the Sea Coast of New South Wales or the East Coast of New Holland By Lieut. J. Cook Commander of His Majesty's Bark the Endeavour who discovered and Explored this Coast in 1770

In the past, Cook had minimized the risk of crashing into unknown rocks and reefs in uncharted waters by either anchoring at night or sailing back and forth off the coast. In Australia, however, he did not have the luxury of time: his ship was in poor condition, his crew were longing for home, and his provisions were running low, so he accelerated the survey work by taking the extra risk of sailing at night. On 19 April 1770 Second Lieutenant Zachary Hicks sighted land, but Cook charted the coast for ten days before finding a suitable harbour in which to anchor. When he did, two Aborigines tried to prevent the shore party from landing by hurling darts and spears, so small shot was fired. The men fled when one of them was wounded, and thereafter the Aborigines at this landfall remained elusive, despite Cook's best efforts to 'form some connections' with them.

More successful was Banks's plant collecting, which inspired Cook to name the harbour Botany Bay rather than his first choice, Stingray's Harbour. From this point onwards, the coast was charted at the rate of 30 miles (50 km) a day, but despite frequent landings, the stresses of the long voyage were showing: there was violence and scurvy among the men, 60 fathoms (108 metres) of anchor cable were condemned as junk, and the topsail was 'wore to rags'. Arriving at Cape Grafton on 10 June 1770, the Australian leg of the voyage was almost over. Of course, no one yet knew this – or that there was worse to come.

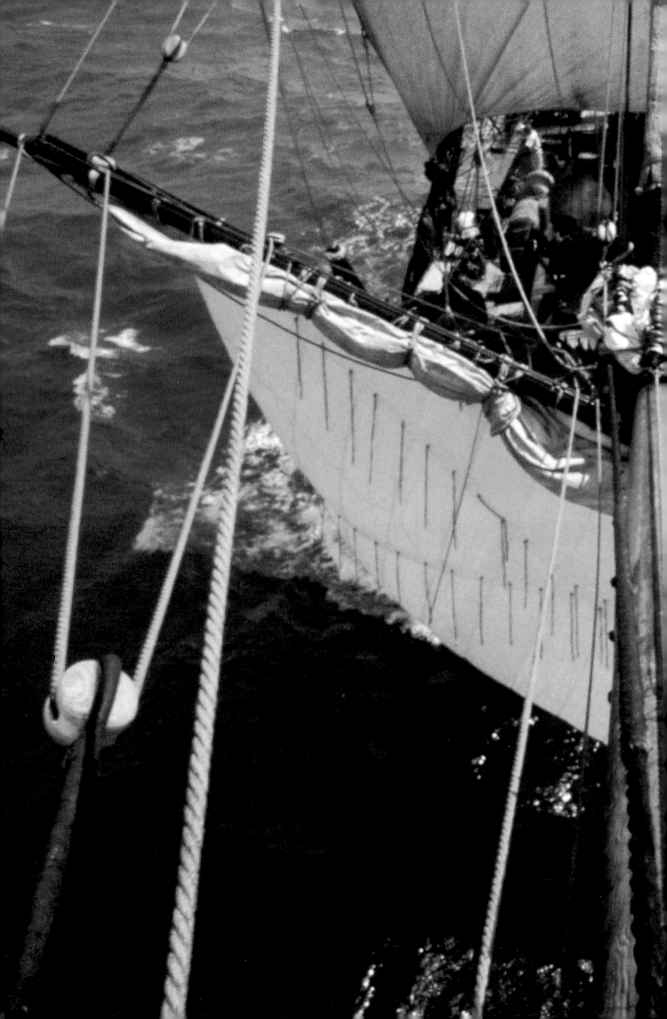

PART TWO
# Exploration

# Science

Although the first objective of the *Endeavour* voyage was the observation of the Transit of Venus, astronomy was not the only scientific pursuit of the expedition. Joseph Banks and Dr Solander were on board to learn more about the natural world through the new science of botany. While surveying a country's natural resources, 'the nature of the soil and the products thereof', formed part of Cook's official instructions for discovery and exploration, natural history, like astronomy, was also an end in itself. Banks and Solander explored foreign terrain, met with natural wonders never before seen by any European, collected exotic flowers, and even shot kangaroos. These experiences were not limited to scientists, but were shared by the whole crew, especially as some of these wonders of nature could be eaten. Botanical exploration also brought them into contact with the 'natives'.

Although the French botanist Philibert Commerson had sailed with Louis-Antoine de Bougainville a year before Cook's voyage, Banks was the first to assume that role on an official Royal Navy venture. However, he went much further than Commerson. The energy and enthusiasm that he brought to extending the boundaries of botany and

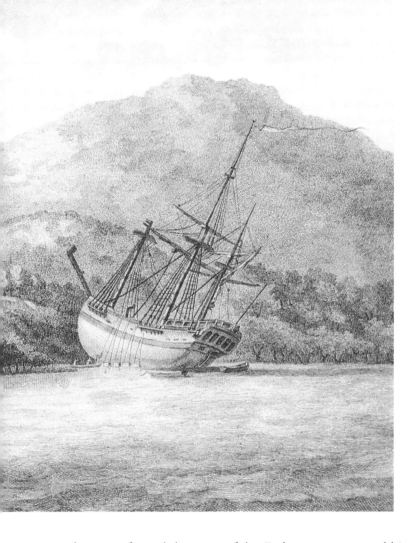

This engraving, made by Will Byrne in 1773 (probably after a lost drawing by Sydney Parkinson), shows how the *Endeavour* was beached for urgent repairs at Wahalumbaal Birri (which Cook named Endeavour River) after the ship had crashed on the Great Barrier Reef. The naturalists turned misfortune into success by 'discovering' many new species of plants and animals during their seven-week stay, and their scientific forays were shared, in different ways, by the entire crew.

zoology transformed the scope of the *Endeavour* voyage, and his work became the yardstick by which the scientific discoveries of subsequent voyages were measured. Later in his career, while helping to establish the Royal Botanic Gardens at Kew and then as president of the Royal Society, Banks would oversee the appointment of naturalists to numerous expeditions.

Our voyage in 2001 began at Cape Grafton, where Captain Cook had dropped anchor on 9 June 1770. Here he went ashore in search of 'fresh water and any other refreshment' while Banks and Solander went to look for new botanical specimens. While the source of water found by Cook proved 'too difficult to get at', the botanists were more successful in their quest, returning to the ship with 'a few plants which we had not before met with'.

Some 231 years later, the BBC volunteers trekked through the same woodland, mangroves and rainforest to join our ship at anchor where Cook's *Endeavour* had once moored. Among those tramping through the undergrowth were Tom Hoblyn and Lucy Smith, a botanist and a botanical artist from the Royal Botanic Gardens at Kew. Even before they had reached the ship's small boats, which they would have to row to the *Endeavour*, they too had begun collecting botanical specimens. Some were familiar,

having been chronicled by their eighteenth-century counterparts; others were more recent discoveries. When Banks and Solander were here, the science of botany was in its infancy. Although it is now far more advanced, there are still striking similarities between past and present in the techniques of collecting, preserving and depicting plant specimens. Treading in Banks's footsteps offered Tom and Lucy the chance to reassess the natural history achievements of Banks and his group from a twenty-first-century perspective. They would also be able to do what Banks could not, namely, learn more about the uses of the plants from the Aborigines.

## 'Increase of Knowledge'

The opportunity for new discoveries became apparent from the start of the voyage, even before the first landfall. Thousands of miles from the remote South Seas, Banks had already begun to use every opportunity to make new discoveries about the natural world from the ship. Just two weeks into the voyage, he spread his casting net and caught a salp. Although only a small catch, this jewel-like marine organism constituted the discovery of a new genus. Over the next three days he netted no fewer than six species of it and in his journal expressed his excitement.

> *6 SEPTEMBER 1769*
>
> It seems singular that no naturalist before this time should have taken notice of these animals as they abound so much where the ship now is, not twenty leagues from the coast of Spain; from hence, however, great hopes may be formed, that the inhabitants of the deep have been but little examined, and as Dr Solander and myself shall have probably greater opportunity in the course of this voyage than any one has had before us, it is a very encouraging circumstance to hope that so large a field of natural history has remained almost untrod, even till this time, and that we may be able from this circumstance alone (almost unthought of when we embarked in the undertaking) to add considerable light to the science which we so eagerly pursue.

In the weeks that followed he noted and described turtles, flying fish, marine spawns and new varieties of sea plants. Fish, algae, seaweed – no form of life was beneath his all-encompassing enthusiasm for the natural world. When the sea was sufficiently calm, he would go out in a small boat, rowed by his servants, and shoot unfamiliar species of bird. Even though still in European waters, everything Banks collected was new to science. No other naturalist had been that interested in the details of his immediate surroundings. If so many new discoveries might be made so close to home, how much more would be found in the unfamiliar and enigmatic South Pacific?

Once they had gathered botanical and zoological specimens – either on land or from the sea – Joseph Banks, Daniel Solander and their assistant, Herman Spöring, returned to the ship's Great Cabin and classified their specimens according to the new system of classification invented by the famous Swedish scientist Carolus Linnaeus. By adding their

newly found species to Linnaeus's system, Banks and Solander amplified and refined it. In this way, the influence of Linnaeus, under whom Dr Solander had studied, would be felt throughout the voyage. For example, a few weeks after the discovery of the salps, Banks wrote in his journal: 'About noon a young shark was seen from the Great Cabin windows following the ship, who immediately took a bait and was caught on board; he proved to be the *Squalus charcharias* of Linn[aeus] and assisted us in clearing up much confusion which almost all authors had made about that species.' Despite such breakthroughs, Banks and Solander still hoped to make their greatest natural history discoveries on land – indeed, were impatient for the opportunity to do so.

On 13 November the ship reached Rio de Janeiro, the *Endeavour*'s last major reprovisioning station before Tahiti. Here the local Portuguese viceroy was suspicious of the merchant collier that had just entered the port: surely this was not a king's ship, but a British smuggler in disguise? As a result, the viceroy forbade any of the officers or gentlemen, with the exception of the captain, from going ashore. So novel was the idea

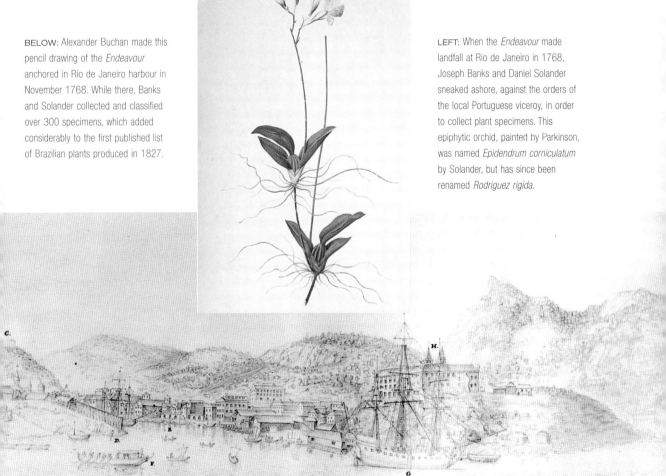

BELOW: Alexander Buchan made this pencil drawing of the *Endeavour* anchored in Rio de Janeiro harbour in November 1768. While there, Banks and Solander collected and classified over 300 specimens, which added considerably to the first published list of Brazilian plants produced in 1827.

LEFT: When the *Endeavour* made landfall at Rio de Janeiro in 1768, Joseph Banks and Daniel Solander sneaked ashore, against the orders of the local Portuguese viceroy, in order to collect plant specimens. This epiphytic orchid, painted by Parkinson, was named *Epidendrum corniculatum* by Solander, but has since been renamed *Rodriguez rigida*.

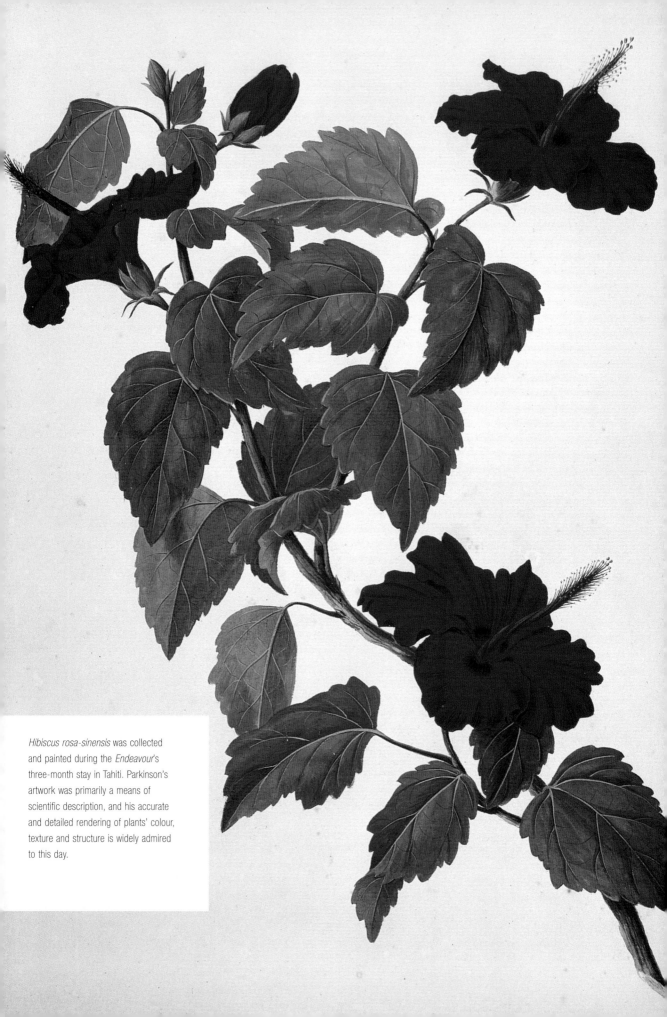

*Hibiscus rosa-sinensis* was collected and painted during the *Endeavour*'s three-month stay in Tahiti. Parkinson's artwork was primarily a means of scientific description, and his accurate and detailed rendering of plants' colour, texture and structure is widely admired to this day.

of a scientific expedition in the name of a king that the viceroy's fears of a more sinister purpose simply could not be allayed. The third lieutenant, John Gore, recorded in his journal: '…one suspicion of us among many others is that our ship is a trading spy and that Mr Banks and the Doctor are both supercargoes and engineers and not naturalists, for the business of such being so very abstruse and unprofitable that they cannot believe gentlemen would come so far as Brazil on that account only.'

Banks's enthusiasm to explore a new environment would not be extinguished by an overly cautious and obstructive local dignitary. One night, while the ship was anchored aimlessly in the harbour, Banks crept off under cover of darkness and conducted his plant gathering at first light. He returned in triumph and reported: 'The country where I saw it abounded with a vast variety of plants and animals, mostly such as have not been described by our naturalists as so few have had an opportunity of coming here.'

The importance of natural history on the voyage was apparent a few weeks later when the ship stopped at Tierra del Fuego on the southernmost tip of South America for the express purpose of plant collecting. Cook, perhaps not truly convinced of the necessity for stopping, later wrote: 'I sent a boat with an officer ashore to attend on Mr Banks and people who were very desirous of being ashore…while I kept plying as near the shore as possible with the ship. At 9 they returned on board, bringing with them several plants, flowers etc, most of them unknown in Europe and in that alone consisted their whole value.'

Cook would not again be quite so generous: in future, scientific collecting would have to coincide with the need for watering, wooding, provisioning and exploration.

In New Zealand, there was ample opportunity for collecting. At Mercury Bay, for example, Banks and Solander 'went ashore and botanized with our usual good success which could not be doubted in a country so totally new'. Banks had become so accustomed to making a wealth of new finds that at Poverty Bay, the ship's first landfall in New Zealand, he complained that he had found 'not above 40' noteworthy species in the one place. Once back on the ship, he was anxious to reach the next landfall, noting that 'the sea is certainly an excellent school for patience'. Nearly three weeks after leaving New Zealand the east coast of New Holland (present-day Australia) was sighted, but disappointment reared its head when the surf prevented the ship from landing at what appeared to be a very promising bay. 'We were obliged to content ourselves with gazing from the boat at the productions of nature which we so much wished to enjoy a nearer acquaintance with.'

When the botanists and artists did finally land, they were not disappointed. After five days of prolific collecting, Banks wrote:

Our collection of plants was now grown so immensely large that it was necessary that some extraordinary care should be taken of them lest they should spoil in the books. I therefore devoted this day to that business and carried all the drying paper, near 200 quires of which the larger part was full, ashore and spreading them upon a sail in the sun kept them in this

manner exposed the whole day, often turning them and sometimes turning the quires in which were plants inside out. By this means they came on board at night in very good condition.

On account of the vast number of plants collected, Cook named this landfall Botany Bay.

By the time the ship had reached Australia, Sydney Parkinson had a significant backlog of botanical drawing to tackle. Then, as now – despite the advent of photography – drawings were the most accurate means of describing plant specimens. They would also be evidence back in Europe of the many new species identified by Banks and Solander. The natural history painter had to work fast to keep up with the never-ending flow of specimens, committing them to paper before they faded and died. As the ship made its way up the coast of New Holland, Parkinson rarely left the ship. Even then, to cope with the workload, he had to abandon doing full drawings and content himself with sketches, noting each specimen's principal characteristics of colour and structure. During the three-year voyage, he produced an extraordinary 955 drawings, 280 of which were finished in every detail.

In the early days of the voyage, drawing and painting at sea could be frustrating occupations. On one occasion, during a squall that took the ship's company unawares, Parkinson's paint pots went flying, much to the amusement of his employer. However, five months into the voyage, Banks noted that the draughtsmen 'are now so used to the sea that it must blow a gale of wind before they leave off'. One other environmental problem proved harder to cope with. In Tahiti, Parkinson struggled on with his work, despite the pestering flies which 'ate the painter's colours off the paper as fast as they can be laid on'. Once in Australia, he worked through the backlog of specimens at a rate of knots: 'This evening we finished drawing the plants got in the last harbour which had been kept fresh till this time by means of tin chests and wet cloths. In 14 days just one draughtsman has made 94 sketch drawings, so quick a hand has he acquired by use.'

But even Parkinson was eventually to find leisure to disembark, though not in the circumstances he would have expected. On 10 June 1770, disaster struck. Banks recorded in his journal:

> [We] went to bed in perfect security, but scarce were we warm in our beds when we were called up with the alarming news of the ship being fast ashore upon a rock, which she in a few moments convinced us of by beating very violently against the rocks. Our situation became now greatly alarming: we had stood off shore 3 hours and a half with a pleasant breeze so knew we could not be very near it: we were little less than certain that we were upon sunken coral rocks, the most dreadful of all others on account of their sharp points and grinding quality which cut through a ship's bottom almost immediately.

Never before during the voyage had Cook and his company found themselves in such grave danger. Not only were all their lives at risk, but the fate of the entire project hung in the balance. What use would the voyage be if all the specimens, charts and logs so far

Revised for **Flora Malesiana**

_Dillenia alata_ (DC.) Martelli
**type.**

det. R. D. Hoogland I-1951.

NEW HOLLAND
BANKS & SOLANDER
1770
Wormia alata B
Illustr. Bot. Cook's Voyage, tab. *I* p.5

**Type Specimen**

The original specimen of _Dillenia alata_ collected by Banks and Solander at Endeavour River was brought back to London, where it is now stored in the Natural History Museum. Much of the work of classifying and organizing the 30,382 specimens collected during the voyage lay unfinished following the death of Dr Solander in 1782. It was as recently as 1988 that the full catalogue of the _Endeavour's_ botanical collection (the _Florilegium_) was finally completed. Some 1400 species of plant were new to European science.

collected perished with the crew and the ship itself? All spare hands manned the pumps to clear the water leaking in through the damaged hull. Banks panicked and began to pack his belongings, but later played his part in manning the pumps too. The next day, after lightening the ship by throwing out excess ballast, including six cannons and wasted stores, Cook made a bold decision. Having prepared the ship's anchors, he 'resolved to risk all and heave her off…and accordingly turned as many hands to the capstan and windlass as could be spared from the pumps and about 20 past 10 o'clock the ship floated'.

Luckily, the weather was calm, so the force of the water did not aggravate the damage to the hull. Also a piece of coral had blocked most of the hole, so the pumps did not have to work quite so hard. It was a junior officer who then came up with the idea that saved the ship. He suggested fothering the hull, which involved dragging a specially prepared sail around it like a bandage. The ploy worked, and, with another piece of extraordinary fortune, a suitable harbour was discovered nearby. Here, Cook and his crew could beach and then repair the ship.

Cook named this harbour Endeavour River. The ship remained here for seven weeks while repair work took place. First, a landing stage was assembled from some of the ship's topmast booms so that the crew and stores could be landed; the entire contents of the hold were cleared. Afterwards, using a pulley system of block and tackle and sheer manpower, the crew 'hauled the bow close ashore but kept her stern afloat'. The ship was then careened (set on its side) and the hull exposed. After tents were erected, Cook directed the hands to dig a well for fresh water. Meanwhile, the armourers set up a forge to make bolts and nails, and the carpenters began to repair the ship. Although many of the men's immediate thoughts were on survival, the naturalists saw this unplanned landfall as an extraordinary opportunity to botanize. Even before the ship had been properly beached, Banks and Solander had set off and begun gathering plants 'of which we had hopes of as many as we could muster during our stay'. Their sense of excitement in the first few days was marred only by the discovery that some of the specimens stored below had been damaged by the salt water that had flooded the hold.

The seven weeks at Endeavour River gave the botanists their most extensive field trip in New Holland. But their activities also benefited the crew as a whole because many of the species they collected or shot could be eaten.

## Foraging

Four days after beaching the ship, Cook's thoughts turned to gathering fresh provisions. It was not sensible simply to consume the ship's existing stores: these needed to be preserved for the onward journey to Batavia, which would take them along the remainder of this unknown and potentially dangerous coastline. To survive at Endeavour River over a sustained period of time, the ship's company would have to forage for fresh food. Cook therefore sent some able seamen out in small boats to catch fish, while others went 'into the country' to shoot for pigeons and, above all, to gather 'greens'. Although Third Lieutenant John Gore returned with 'a few palm cabbages and a bunch or two of wild plantains', much more was required.

Earlier in the voyage, Banks had shown how his botanical knowledge supported the use of wild greens with which Cook refreshed the ship's food supplies. At Tierra del Fuego in South America he had described the sustaining properties of scurvy grass (*Cardamine antiscorbutica*) and wild celery (*Apium antarcticum*): 'Both these herbs we used plentifully while we stayed here, putting them in our soup &c, and found the benefit from them which seamen in general find from a vegetable diet after having been long deprived of it.' Other members of the botanical team also made new contributions to the diet: they discovered taro and the burdekin plum.

Some of the gentlemen who had been out in the woods yesterday brought home the leaves of a plant which I took to be *Arum esculentum* [taro], the same I believe as is called coccos in the West Indies. In consequence of this I went to the place and found plenty; on trial,

however, the roots were found to be too acrid to be eat, [but] the leaves…when boiled were little inferior to spinach. In the same place grew…another fruit about as large as a small golden pippin but flatter, of a deep purple colour; these…were very hard and disagreeable but after being kept a few days became soft and tasted much like indifferent damsons.

Not for the first time, botanists had proved themselves useful beyond merely settling questions of natural history. As Banks recorded, '[We] resolved to content ourselves with the greens which are called in the West Indies Indian kale. I went with the seamen to show them the place and they gathered a large quantity.' This is one of many occasions when supernumeraries and seamen learnt from each other and shared their discoveries. On the ship, the seamen answered Banks's questions about marine life and the weather; on land they sought answers from him. Inevitably, there were many questions that could not be resolved because the plants and animals discovered were completely foreign to

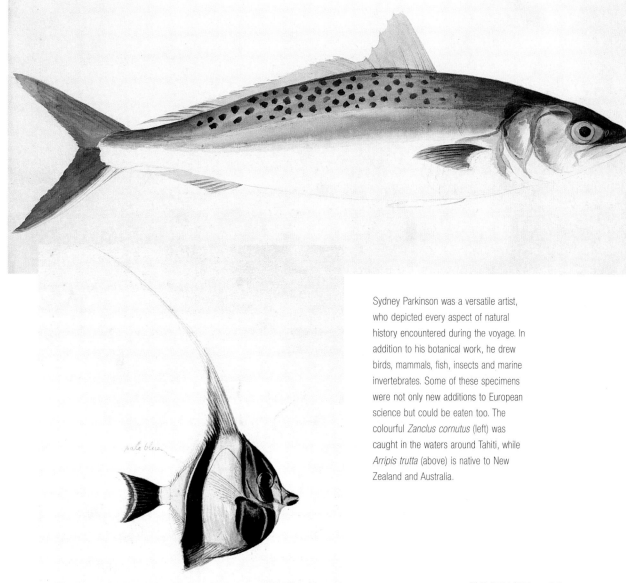

Sydney Parkinson was a versatile artist, who depicted every aspect of natural history encountered during the voyage. In addition to his botanical work, he drew birds, mammals, fish, insects and marine invertebrates. Some of these specimens were not only new additions to European science but could be eaten too. The colourful *Zanclus cornutus* (left) was caught in the waters around Tahiti, while *Arripis trutta* (above) is native to New Zealand and Australia.

everyone. The American midshipman James Magra spotted a dingo, but never having seen such an animal before, he described it to Banks as a wolf. Another man gave Banks a particularly colourful description of what turned out to be a large fruit-bat. 'A seaman who had been out in the woods brought home the description of an animal he had seen composed in so seaman-like a style that I cannot help mentioning it: it was (says he) about as large and much like a one gallon keg, as black as the Devil and had two horns on its head, it went but slowly but I dared not touch it.'

One animal in particular proved most beguiling. None of the ship's company had ever before seen anything like it, and they immediately brought news of it to Banks. The next day he saw the unusual creature for himself: 'In gathering plants today I myself had the good fortune to see the beast so much talked of, though but imperfectly; he was not only like a greyhound in size and running but had a long tail, as long as any greyhound's; what to liken him to I could not tell, nothing certainly that I have seen at all resembles him.' It was a young great grey kangaroo, the first ever recorded by a European. Three weeks later, the animal was successfully hunted by Lieutenant Gore; it was then brought back to the ship, where Cook and the naturalists examined and described the new discovery, and Parkinson drew a sketch of it. The creature was then prepared and eaten by

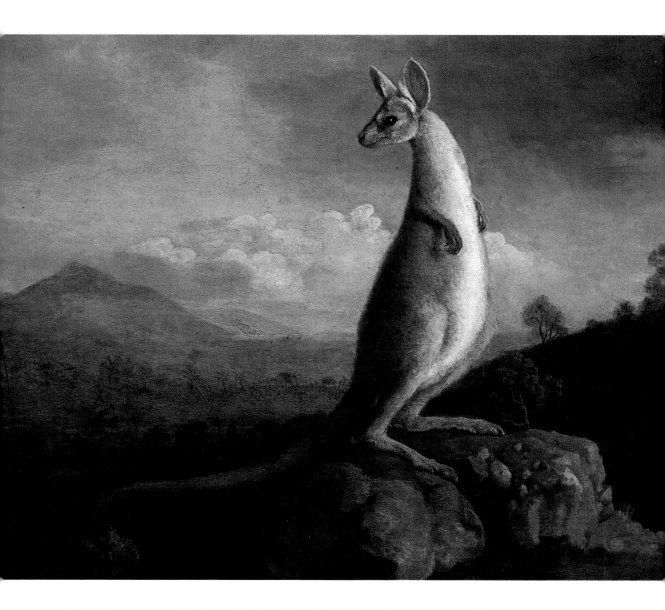

the ship's company, who deemed it 'excellent food'. At Endeavour River, perhaps more than at any other landfall during the voyage, the whole crew engaged in natural history, the benefits being both practical and scientific.

Foraging for food also led to discoveries being made at sea. One day Cook sent the master, Robert Molyneux, in the pinnace to search for a passage out of the reefs. Although he was unsuccessful in his mission, Molyneux discovered, wrote Banks, 'a dry reef where he found vast plenty of shell fish so that the boat was completely loaded, chiefly with a large kind of cockles (*Chama gigas*), one of which was more than two men could eat. Many indeed were larger; the cockswain of the boat, a little man, declared that he saw on the reef a dead shell of one so large that he got into it and it fairly held him.' A few days later Banks himself accompanied an officer to hunt for turtles on the reefs; while they failed to catch any, Banks took the opportunity to step on to the reef at low tide and gather 'many shells and sea productions'.

The pursuits of natural history at Endeavour River also contributed to the captain's work of exploration. Banks's scientific discoveries not only brought about an increase in knowledge for its own sake, but also formed the basis from which to make deductions about people, hydrography, even geography. When turtles were finally caught, they were opened up and inside was found not just what kind of 'turtle grass' the reptiles ate, but also 'an Indian peg' [hook or point of a spear] which, Banks said, suggested that the indigenous tribes did in fact have the means to go upon the water and hunt for reef food, contrary to what Cook believed. Similarly, pumice stones found by Banks 'in many parts of the inlet' and not geologically connected to the land indicated how far the tides reached inland. He also noticed barnacles on the husk of a coconut, as well as on other beached fruits, and he took this as 'a sure sign that they have come far by sea, and, as the trade wind blows almost right on shore, they must have come from some other country – probably that discovered by [Pedro Fernandez] de Quiros and called Terra del Espritu Santo [present-day Vanuatu] as the latitudes according to his own account agree pretty well'. Banks was absolutely right: although Cook had now shown geographically that de Quiros's discovery was separated from the coast of New Holland, Banks had found evidence to support this from natural history.

## New Encounters

The pursuit of natural history also brought the *Endeavour*'s company into contact with indigenous peoples. Their first discovery was that exploring a new environment on foot and in small groups presented a less threatening form of encounter between European and Tahitian, Society Islander, Maori or Aborigine than shore parties arriving en masse. The first landfalls attempted by Cook's crew in New Zealand and New Holland ended in their asserting superiority by musket fire when they met with resistance or attack, despite their insistence that they came in friendship.

Art and botany both offered opportunities for non-confrontational encounters; indeed, Parkinson and Banks successfully used them as ways of communicating with and seeking to understand indigenous societies. The life drawings executed by Sydney Parkinson, for example, brought him into amicable contact with his indigenous subjects. His brother wrote that he achieved this 'by the powers of his pencil, disarming them of their native ferocity and rendering them even serviceable to the great end of the voyage in cheerfully furnishing him with the choicest productions of the soil and the climate which neither force nor stratagem might otherwise have procured'. Establishing sympathetic relationships also gave Parkinson the opportunity to compile vocabulary lists of indigenous words, which were even more extensive than those compiled by Banks.

Exploring for botanical specimens also led to many friendly exchanges between Europeans and indigenous people. At Anaura Bay in New Zealand, for example, Banks and Solander 'ranged all about the bay and were well repaid by finding many plants and shooting some most beautiful birds; in doing this we visited several houses and saw a

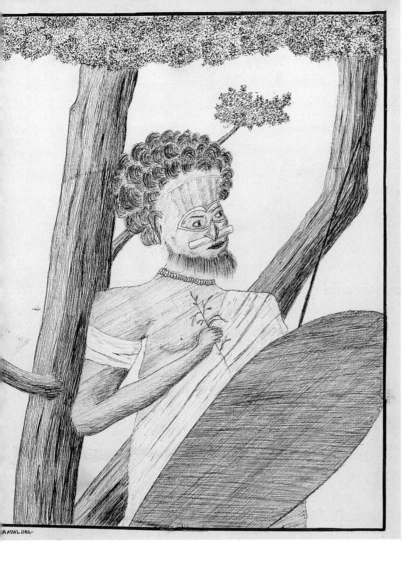

An Australian Aborigine drawn by Charles Praval, a seaman who joined the *Endeavour* at Batavia in Java. The drawing is thought to be a copy from a lost work by Sydney Parkinson, who took up the bulk of figure drawing after the artist Alexander Buchan died from an epileptic fit in Tahiti. The artistic and scientific pursuits of the *Endeavour*'s gentlemen allowed them to form non-confrontational relationships with indigenous peoples of the South Pacific, and encouraged the exchange of information and culture.

little of their customs, for they were not at all shy of showing us any thing we desired to see, nor did they on our account interrupt their meals, the only employment we saw them engaged in'.

Perhaps one of the most important aspects of these meetings was that they could learn more about the practical uses of plants that were new to them. This happened in Tahiti, where the *Endeavour*'s crew spent nearly three months. Banks records how on one occasion he had been able to learn, within the constraints of a limited vocabulary, a little about the medicinal herbs and plants used by the Tahitians.

> Vulnerary [healing] herbs they have many, nor do they seem at all nice in the choice of them, so they have plenty of such herbaceous plants as yield mild juices devoid of all acridity, such as chickweed, groundsel &c. in England. With these they make fomentations which they frequently apply to the wound, taking care to cleanse it as often as possible, the patient all the time observing great abstinence; by this method, if they have told us true, their wounds are cured in a very short time.

The ship's three-month stay in Tahiti allowed time for the language barrier to be at least

partially broken, and Banks in particular made many friends. The most influential of these was the high priest and navigator called Tupaia, originally from Raiatea. Banks invited Tupaia to join the ship not only so that he might show him off back in England, but also as a pilot in the explorations of the Pacific. Tupaia readily agreed. His role also expanded to translator and mediator in New Zealand when it was discovered that he and the Maori shared the same Polynesian language and could communicate. At Queen Charlotte's Sound, Cook wrote, 'Tupaia always accompanies us on every excursion we make and proves of infinite service.' Tupaia's presence led to an exchange of knowledge between the Europeans and Maori that would not otherwise have been possible.

[The Maori] showed us a great rarity of six plants of what they called Aouta from whence they made cloth like the Tahiti cloth; the plant proved exactly the same, as the name is the same, as is used in the Islands, *Morus papyrifera* of Linnaeus, the same plant as is used by the Chinese to make paper. Whether the climate does not well agree with it I do not know, but they seemed to value it very much and that it was very scarce among them I am inclined to believe, as we have not yet seen among them pieces large enough for any use but sticking into the holes of their ears.

LEFT: The *Endeavour's* naturalists caught this species of lobster (*Munida gregaria*) in casting nets near the tip of South America. A midshipman recorded how they saw so great a quantity that 'you could not tell the colour of the water they was so thick'. Banks and Solander called it *Cancer gregarius*.

BELOW: This green parakeet (*Cyanoramphus zealandicus*) was caught by Banks at Tahiti, where it is now extinct, the last recorded specimen being caught in 1844. Parkinson's drawing is unfinished, perhaps reflecting the pressure he was working under, but he had time to note that the bird's Tahitian name was *a'a*.

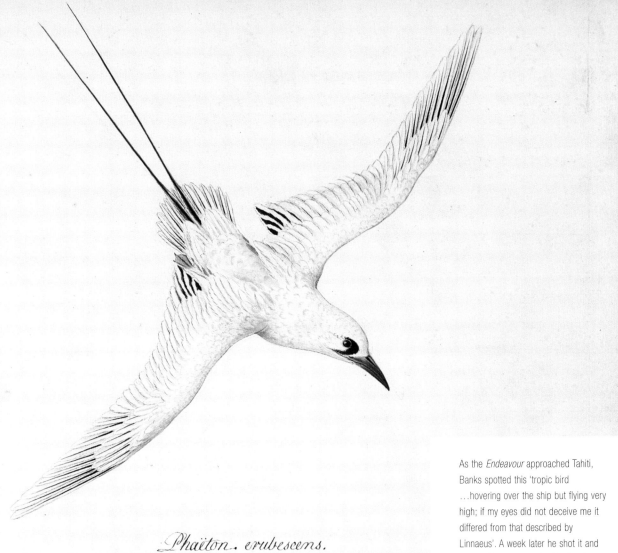

*Phaëton. erubescens.*

As the *Endeavour* approached Tahiti, Banks spotted this 'tropic bird …hovering over the ship but flying very high; if my eyes did not deceive me it differed from that described by Linnaeus'. A week later he shot it and Sydney Parkinson made this drawing. The specimen was one of 1000 animal specimens eventually brought back to England.

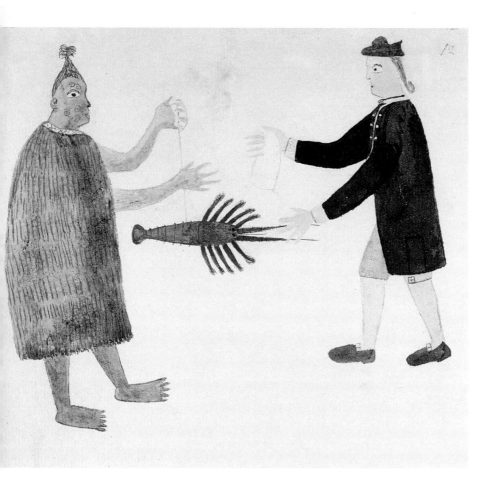

A moment of contact between European and Maori depicted by a Raiatean. Tupaia, who acted as Cook's translator and mediator during the ship's circumnavigation of New Zealand, painted this picture of an English naval officer bartering with a Maori for crayfish in 1769. Unfortunately, as Tupaia did not share a language with the Australian Aborigines, he and the naturalists met with less success in understanding the relationship between the Aborigines and the environment that they inhabited.

It had quickly became apparent that the scientific minds engaged in increasing knowledge of natural history were also ideally placed to acquire a greater understanding of the cultures they encountered along the way. At Endeavour River, however, they were to be disappointed because interaction with the locals failed to lead to enlightenment about the specific uses of local plant life. After leaving the mainland of New Holland, Banks confided to his journal the frustration he felt in not making greater botanical advances.

> Of plants in general the country afforded a far larger variety than its barren appearance seemed to promise. Many of these have no doubt properties which might be useful, but for physical and economical purposes which we were not able to investigate. Could we have understood the Indians or made them by any means our friends we might perchance have learnt some of these; for though their manner of life, but one degree removed from brutes, does not seem to promise much, yet they had a knowledge of plants as we plainly could perceive by their having names for them.

Throughout the *Endeavour*'s surveys of the east coast of New Holland, the Aborigines had kept their distance from the Europeans. Cook and the gentlemen could not 'prevail

upon them to come near us'; the natives 'made off as soon as they found they were discovered'. Fires were seen from afar, but these were warning signals between Aboriginal communities, alerting each other to the presence of foreigners in a strange ship. Although individuals had been spied from the decks of the ship at sea, none had displayed any curiosity about the visitors or their vessel, much to the frustration of Banks: 'not one was once observed to stop and look towards the ship; they pursued their way in all appearance entirely unmoved by the neighbourhood of so remarkable an object as a ship must necessarily be to people who have never seen one'.

Following a violent skirmish at Botany Bay, Banks seemed to give up the idea of making contact: 'Myself in the woods botanizing as usual, now quite void of fear as our neighbours have turned out such rank cowards.' When the ship approached Endeavour River a month later, however, his hopes were renewed: 'at night we observed a fire ashore …which made us hope that…our stay would give us an opportunity of being acquainted with the Indians who made it'. These hopes would soon be disappointed too. Three weeks into their stay, Banks made an excursion upriver with Lieutenant Gore 'to see if the country inland was different from that near the shore'. They were away for two days, camping at night in the bush. At the end of the second day:

> …we observed some smoke about a furlong from us: we did not doubt at all that the natives, whom we had so long had a curiosity to see well, were there, so three of us went immediately towards it hoping that the smallness of our numbers would induce them not to be afraid of us; when we came to the place, however, they were gone, probably upon having discovered us before we saw them.

Eric Deeral, an elder of one of the clan groups of the Guugu-Yimithirr nation, who inhabited the region then as today, has sought to explain this elusiveness from the Aboriginal point of view in an oral history that he has compiled. '[Our people] were very discreet because they needed to make sure just in case the visitors were reincarnations of *wawu-nhi*, spirits of our ancestors. Every effort was made to be tactful. Women were not allowed to approach the strangers.'

While natural history excursions were failing to provide points of contact, others foraging for food were having more luck. When out shooting on his own, Tupaia saw two people digging in the ground for some kind of roots. Although they ran off, this was the closest contact yet achieved. A few days later, the Aborigines approached the ship: the Europeans gave them a fish, and in return the Aborigines came back the next day and reciprocated the gift. Later they followed this up by giving Tupaia taro roots to eat. As the Aborigines grew in confidence, they allowed the Europeans to see their women, and on one day gave a demonstration of throwing a javelin, which impressed Banks.

Unfortunately, friendly relations soon broke down. During one of their visits to the ship the Aborigines had noticed some turtles lying on the deck and indicated several times that they wanted one of them. On being refused, they were offended. Eric Deeral

explains in his oral history that this misunderstanding stemmed from the initial exchange of fish: this 'would have been significant to the Aboriginals as they would have believed that Cook and his men understood their custom of reciprocal gift-giving'. As a result, in the eyes of the Aborigines, the Europeans had broken this code of ownership and sharing. In the hostility that ensued, the Aborigines disembarked and Banks recorded how they then tried to set fire to the camp around the beached ship.

> *19 JULY 1770*
>
> After meeting with so many repulses, all in an instant leaped into their canoe and went ashore where I had got before them just ready to set out plant gathering; they seized their arms in an instant, and taking fire from under a pitch kettle which was boiling they began to set fire to the grass to windward of the few things we had left ashore with surprising dexterity and quickness; the grass which was 4 or 5 feet high and as dry as stubble burnt with vast fury.

Although the damage was minimal, the risk to the ship and voyage had been great. The seine fishing net, a tent, some loaded muskets and even the ship itself were all unguarded: only the week before, the gunpowder had also been ashore, and that very morning the stores and the tents that housed the sick had been brought on board. Cook and Banks followed the Aborigines into the woods and succeeded in achieving a peaceful reconciliation. However, the trust had been broken and the Aborigines would not return to the ship again. Only a stray seaman foraging for food would make any further contact during their stay at Endeavour River. As Banks recorded:

> *22 JULY 1770*
>
> One of our people who had been sent out to gather Indian kale straying from his party met with three Indians, two men and a boy; he came upon them as they sat down among some long grass on a sudden and before he was aware of it. At first he was much afraid and offered them his knife, the only thing he had which he thought might be acceptable to them; they took it and after handing it from one to another returned it to him. They kept him about half an hour behaving most civilly to him, only satisfying their curiosity in examining his body, which done they made him signs that he might go away which he did very well pleased.

The windy and rainy weather that had marked the ship's entry into the harbour now began again, and it took some days before the conditions were right for the *Endeavour* to leave. The delay was frustrating; Banks continued to botanize, but he and Dr Solander 'had no wish to remain longer in the place, which we had pretty well exhausted even of its natural history. The Dr and me were obliged to go very far for any thing new; today we went several miles to a high hill where after sweating and broiling among the woods till night we were obliged to return almost empty.' Later he concluded, 'The plants were now entirely completed and nothing new remained to be found, so that sailing is all we wish for if the wind would but allow us.'

The first objective of the *Endeavour* voyage – the observation of the Transit of Venus to find the distance between the Earth and the sun – was undertaken in order to better understand the design of the universe and the Earth's place within it. The new science of botany conducted alongside this work also contributed to human understanding of the world. Both pursuits embodied the intellectual spirit of a new, secular age. By increasing, classifying and ordering knowledge, Europeans sought to understand creation; however, the very process of understanding empowered man and put him at the centre of his environment. As Banks wrote of the specimens he had collected earlier at Tierra del Fuego:

> Of plants here are many species and those truly the most extraordinary I can imagine; in stature and appearance they agree a good deal with the European ones only in general are less specious, white flowers being much more common among them than any other colours. But to speak of them botanically, probably no botanist has ever enjoyed more pleasure in the contemplation of his favourite pursuit than Dr Solander and myself among these plants; we have not yet examined many of them, but what we have have turned out in general so entirely different from any before described that we are never tired with wondering at the infinite variety of Creation, and admiring the infinite care with which providence has multiplied his productions suiting them no doubt to the various climates for which they were designed.

On the *Endeavour* voyage the pursuit of natural history was an end in itself, but also became a way of trying to understand the environments of the Pacific and the people who inhabited them. At Endeavour River the naturalist Banks was frustrated that he could not learn more. The conflict over the turtles was one of many occasions on which the Europeans failed to comprehend the Aborigines, their culture, their environment and the flora and fauna within it. On the BBC voyage of 2001 things would be quite different.

## Present Meets Past in Cooktown

On 27 August 2001 the BBC expedition weighed anchor off Cape Grafton and set sail for Endeavour River. In June and July of 1770, Cook spent seven weeks here repairing his ship and waiting for favourable winds so that the voyage could recommence. In the nineteenth century a colonial settlement called Cooktown would be established here.

Tom Hoblyn and Lucy Smith slept in the same cabins as Banks and Parkinson, and, like them, carried out their work in the Great Cabin. As we began the voyage, they recorded their first impressions of their surroundings. They, like Banks, found that opportunities for natural history presented themselves not just at landfalls but also at sea.

TOM'S JOURNAL – 28 August 2001

I am writing in my cabin at Banks's bureau. When you pull out the top drawer there is a lovely green baize desktop. Underneath, in the drawer below, is a vanity set – mirror, jewellery box, brush and comb – similar to one owned by Banks. It is great to be sailing finally to Cooktown, but it will be even better when

# Progress of the replica *Endeavour* between Cape Grafton and Cooktown, 25 August – 1 September 2001

Charts compiled by Jane Brooks, one of the volunteers on the BBC voyage of 2001 show stops made by the replica *Endeavour* as it travelled along the northeastern coast of Australia. We tried to follow Cook's route as closely as the winds and safety allowed between Queensland, Australia, and the island of Java in Indonesia.

North

South

Scale: Nautical miles

60
50
40
30
20
10
0

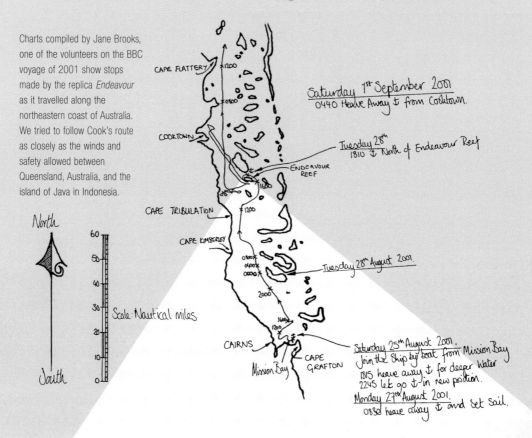

CAPE FLATTERY ✕1200

✕0800

COOKTOWN

Saturday 7ᵗʰ September 2001
0440 Heave Away ⊥ from Cooktown.

Tuesday 28ᵗʰ
1810 ⊥ North of Endeavour Reef

ENDEAVOUR REEF

CAPE TRIBULATION ✕1200

CAPE KIMBERLEY

0700✕
0500✕
0000✕

Tuesday 28ᵗʰ August 2001.

✕2000

1600✕
✕2200

CAIRNS

Mission Bay

CAPE GRAFTON

Saturday 25ᵗʰ August 2001.
Join the Ship by boat from Mission Bay
1815 heave away ⊥ for deeper Water
2245 let go ⊥ in new position.
Monday 27ᵗʰ August 2001.
0830 heave away ⊥ and Set Sail.

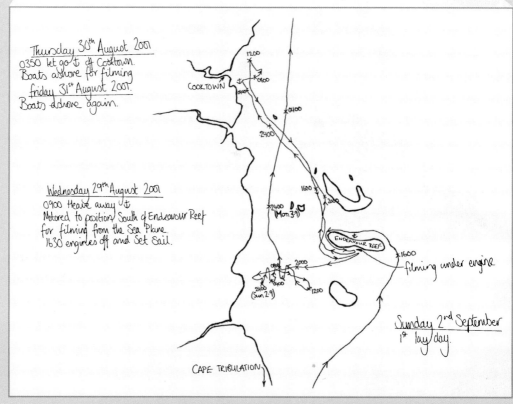

Thursday 30ᵗʰ August 2001
0350 let go ⊥ off Cooktown.
Boats ashore for filming
Friday 31ˢᵗ August 2001.
Boats ashore again.

✕1200
✕0800
COOKTOWN
0700✕
✕0400
2400✕

1600✕
✕2000

0400✕
2400 (Mon 3ᵗʰ)

ENDEAVOUR REEF

✕1600

filming under engine

Wednesday 29ᵗʰ August 2001
0900 Heave away ⊥
Motored to position South of Endeavour Reef
for filming from the Sea Plane.
1630 engines off and Set Sail.

0800✕
✕2000
2400 (Sun 2ᵗʰ)
✕1200

Sunday 2ⁿᵈ September
1ˢᵗ lay day.

CAPE TRIBULATION

we are actually there. Before I forget, I must list the birds we have seen so far. On the day we left Cape Grafton I saw a brahminy kite, which was beautiful. It was gliding up and down the beach as we left, looking for anything to scavenge. The next day I saw a satin flycatcher landing on the rigging. This morning I spotted a cormorant some way off. Then Torres Strait pigeon flocks flew past, migrating down south to feed on the ripening blue olive berries (*Elaeocarpus reticulatus*) which I saw when we walked through the mangroves to meet the ship's boats. Bruce, an Aboriginal politician from Cape York, who is one of the crew members on the ship, told me that his totem is the red-tailed black cockatoo and that he must treat it as a brother. Hopefully, we may see it before we leave Australia. We had a beautiful sunset this evening. I watched a white tern and a sooty tern fishing along the Great Barrier Reef.

### LUCY'S JOURNAL – 28 August 2001

The Great Cabin, I have to say, is magnificent! It's about twice as large as I had expected and full of glorious light and breeze which come from the four large stern windows and two quarter windows on the sides. It's not difficult to picture Banks, Solander and Parkinson sitting around the table with plants strewn all over the place, pipes being smoked, port drunk and much enthusiastic discussion taking place.

Tom and Lucy followed in Banks's footsteps around Cooktown, exploring the same environment, collecting the same plants, and sometimes even going in search of species recently discovered. Although their equipment was modern and their code of practice significantly different from that of the eighteenth century, they were surprised that the techniques of collecting, drying and drawing had remained fundamentally unchanged; even the Linnaean system of classification remains the basis of the modern-day system of ordering plants. Tom and Lucy's aim was to reassess the work of Banks, Solander and Parkinson, and to consider the contribution made by the then-new science of botany to the *Endeavour*'s voyage.

In 1770 the Guugu-Yimithirr nation inhabited Cape York in northeastern Australia. It was with their descendants, who still live there, that Tom and Lucy could achieve what Cook's company had not. They asked Eric and Henry Deeral, the elders of the Gamay Warra clan group, to accompany them on their field trip. Erica Deeral (Eric's daughter) and her colleague Carole Pierce also joined the group. By exchanging knowledge with their Aboriginal hosts, as well as with Diana Wood, the acting curator of the Cooktown Botanic Gardens, they would redress Banks's complaint – that he was unable to discover the uses of the plants he had found in that area.

### LUCY'S JOURNAL – 28 August 2001

I am really looking forward to collecting in the field at Cooktown, and also anxious about the bulk of illustrating work which will follow. I feel that the short walk to the ship and botanizing at Cape Grafton were a quick practice for the real thing tomorrow. My main concerns as a botanical artist are getting plenty of good flowering/fruiting/interesting plants; getting them back in one piece; and keeping them fresh and drawable for as long as possible. Which reminds me – must ask for more buckets for this purpose to cater for fresh plants here in the Great Cabin.

When Banks and Solander botanized at Endeavour River, they were the first European naturalists ever to explore the area. As the Aborigines initially decided against making contact, the botanists went where they liked and took what they wanted. On one occasion, Banks felled 'four or five trees' just to discover the source of a single fruit. When he and Solander failed to find it, Banks recorded the incident as 'the most vexatious imaginable'. Collecting today is approached very differently.

TOM'S JOURNAL – 29 August 2001

The process of preparing to collect plant specimens started months before I set off on this trip and requires lots of form-filling. Firstly, I needed approval from the Overseas Field Committee at Kew, to see if what I proposed to do followed the correct procedure. Next I had to see the Conventions and Policy section to talk through my proposal. After Kew had approved, I had to obtain permission from the Australian environmental agencies. As part of the process, permission also had to be sought from the traditional owners, e.g. the Gamay Warra people at Cooktown, as it is their land. Each one of these processes requires letters, forms, faxes, e-mails and telephone calls – very different from Banks's day! This evening I have been getting my equipment ready for the plant collecting at Cooktown. I must remember to inform the local ranger that I will be collecting there tomorrow.

The first day ashore finally arrived, and Tom and Lucy felt the sense of anticipation that their earlier counterparts had experienced.

TOM'S JOURNAL – 30 August 2001

Took the pinnace ashore to Cooktown. There was a good onshore breeze, so we sailed the whole way in. We arrived at about midday to be met by the Aboriginal elders from the Gamay Warra clan.

Eric had a frank and moving talk with us, saying that when the *Endeavour* replica first came here it was a sort of peace mission; now that we had come again it was time to put the past behind us and look to the future. He said that an institution like the Royal Botanic Gardens at Kew could help the Cooktown community by sharing information: the Aborigines have had names and uses for local plants for centuries, whereas botanists are still naming them. So let's swap information, he said. It was very touching for him to talk to us about something so major. Lucy and I could possibly help by suggesting some sort of liaison between Kew and Cooktown. Bruce wondered whether there would be a possibility of a grant for someone to come to Cooktown for a period of time and really learn about Aboriginal uses of plants.

Accompanied by Henry and Erica, our botanists first set off to explore the swathes of mangroves that line Endeavour River. Lucy, like Parkinson, began noting down the Aboriginal words they told her for some of the things they passed en route, including *burrii* (water), *waan* (crab), *walbulbul* (butterfly), *gujhu* (fish) and *barra barra* (mangrove).

TOM'S JOURNAL – 30 August 2001

We could see stingrays swimming beneath us, and a shoal of flying fish. I saw two sea eagles circling above us – the most magnificent birds we have seen so far… Great egret were feeding in the shallows at

BELOW: Botanist Tom Hoblyn and botanical artist Lucy Smith share information on the names and uses of plants with Bruce Gibson, one of their shipmates, at Cape Grafton. Here they are examining a specimen of *Dillenia alata*.

ABOVE: *Dillenia alata* painted by Lucy Smith in September 2001. The plant was named by Dr Solander in 1770, but it was only formally accepted and published as such in 1886.

low tide near the mangrove… I collected two specimens, *Avicennia marina* (grey mangrove) and *Osbornia octodonta* (myrtle mangrove). The first has pencil-size, peg-type roots; the leaves are glaucous beneath and have special glands for secreting excess salt – this is how they thrive in salt water. I tried to put the specimens immediately into my plant press but the wind made it too difficult, so I just tagged each specimen with a number and put them into a large polythene bag.

Noticing fires like the ones Banks had taken as signals, Tom was told that they have several purposes. In this case they were being used to clear the undergrowth so that new grass could grow for game.

After lunch, the group were joined by Eric and headed inland to explore the woodland on the banks of the river. Lucy noted 'some pandanus, *Grevillea* (*parallela* or perhaps *pteridifolia*) and occasional stretches of *Melaleuca viridiflora*'. When Banks was collecting here, he came across many new species that 'no European botanist had seen'. Nowadays, new species are very rare, but remote places sometimes yield exciting finds.

The first place we stopped off at was an area of swampy forest. The species diversity here is amazing – there was no one dominant species. However, one in particular caught my eye…*Livistona concinna*. Even though this palm has been seen many times, it was not until recently that people realized it was a new species. The main reason is that this is pretty inhospitable terrain; the palm only flowers in the wet season when there are many crocodiles beside the swamps and the river. The trouble is that you need to see the flowers in order to confirm that it is a new species.

Gaining access has always posed problems to botanists because exploration is often conducted on foot and certain plants can be found only in dangerous or inaccessible terrain. Today care must be taken to respect conservation and protection orders: obstructive trees and woodland cannot simply be cut down in order to reach a tantalizing specimen, which is what Banks and Solander would have done. Within these present-day constraints, Tom was particularly on the lookout for one species collected by Banks – the Barringtonia.

TOM'S JOURNAL – 30 August 2001

Erica kept on bringing different fruits to show us. One of them was egg-shaped, slightly blocky, with persistent calyces. I asked her where she got it from and she took me to the edge of the river…sure enough, there it was, the plant I had been looking for – *Barringtonia racemosa* (freshwater mangrove). Eric's name for this plant is 'gurrun'. I had to climb quite high to get the flower as, inevitably, the best flowers are always just out of reach. I had to be very careful because there are dangerous things, like ants and snakes, etc., and the river is full of crocodiles.

LUCY'S JOURNAL – 30 August 2001

Tom got to do some precarious tree climbing in order to retrieve the plant which he had been dying to see – a Barringtonia in flower (it's night-flowering but, hey, it was dusk by this stage). He shimmied up one tree and on to another, climbing to the extent of the Barringtonia, crossing over to a large tree about 14 feet [4 metres] off the ground by this stage, and then sliding fireman-style down the final tree, which enabled him to pluck a couple of lovely racemes with the very last of the buds hanging from the bottom having just burst into life.

TOM'S JOURNAL – 30 August 2001

This has to be one of the most beautiful [plants with]…long pendulous racemes of flowers. Each individual flower has four petals and hundreds of white stamens – those of the plant at Kew are pink. In the middle of the stamens is a pink style – when these flowers fall off, the style remains. They are night-flowering but since it was by now evening, we found some of them open. They are pollinated by bats and are therefore sickly sweet-smelling. The fruits can be used as a fish poison – a sort of soup is made and poured in the river. The poison paralyses the gills of the fish, so you can just pick the fish out of the water – back in fresh water they recover quickly. I think the plant is named after a keen amateur botanist Daines Barrington.

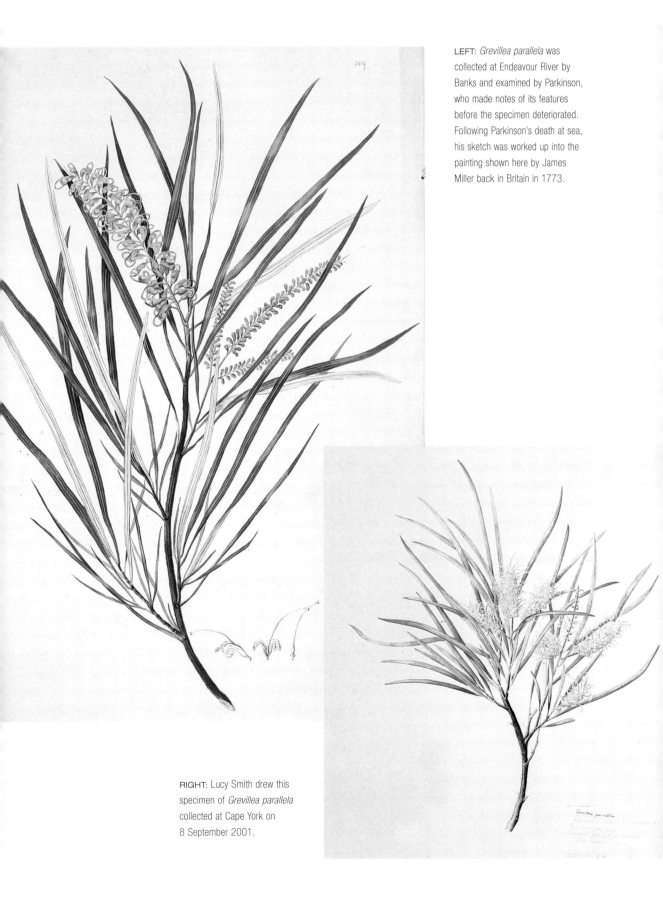

319

**LEFT:** *Grevillea parallela* was collected at Endeavour River by Banks and examined by Parkinson, who made notes of its features before the specimen deteriorated. Following Parkinson's death at sea, his sketch was worked up into the painting shown here by James Miller back in Britain in 1773.

**RIGHT:** Lucy Smith drew this specimen of *Grevillea parallela* collected at Cape York on 8 September 2001.

The work of Sydney Parkinson, the botanical artist on Cook's voyage, was to collect as much accurate information as possible about each specimen: only in this way could the plant be shown to be a new addition to European science. Sometimes the drawing had to be done urgently before the specimen died and lost its colour, structure and texture. This meant that work had to begin right away in the field, so Lucy followed Parkinson's example.

LUCY'S JOURNAL – 30 August 2001

As soon as Tom had collected the Barringtonia specimen, I had to sit down and try to draw the flower there and then in the middle of the bush because I could see that its fleshy petals and delicate anthers would wither very quickly. Night was coming on and the mosquitoes were fierce, so I sketched whatever the time and light allowed.

Before the group returned to the ship for the night, there were more new discoveries in store for Tom and Lucy, this time in the field of ethnobotany. The study of indigenous uses of plants in the local habitat is currently at the forefront of natural history, and Henry and Eric were generous in imparting their knowledge.

During the BBC voyage, Tom Hoblyn collected a specimen of *Barringtonia racemosa* at Endeavour River and Lucy Smith sketched it in the field before its condition deteriorated. She later painted it when back on the ship (see page 101).

Henry and Eric gave us a little taste of bush medicine. There was a green ants nest…made by glueing leaves together. If you disturb the nest, they come pouring out, sticking their bottoms in the air… Eric told us that the Aborigines eat these ants to cure them of colds, etc. I tried about a dozen…they taste sort of tangy lemony and weren't too bad.

The next day Tom and Lucy returned to Cooktown and picked up where they left off in learning Aboriginal uses for local plants. Diana, the acting curator of the Cooktown Botanic Gardens, kindly offered to be their guide for the day.

TOM'S JOURNAL – 31 August 2001

Diana and I drove up Grassy Hill, where Cook and Banks once walked to take a view on how best to escape the reefs. Here we collected *Eucalyptus intermedia*, which was collected by Banks, as well as *Exocarpos latifolius*, the 'native cherry', which has a multitude of uses in this area. The crushed leaves are used to treat sores, the smoke of the wood for insect repellent, the fruit for eating, and a special preparation is made as a contraceptive. From the top of the hill…the whole area appeared untouched and still very wild.

Another plant we collected today in Cooktown was *Morinda citrifolia*, known as cheesefruit or 'wuulabi' by the Gamay people. It has an ugly, potato-like fruit…an important crop [so] it is rare to find one. It can be made into a rather foul-tasting drink that is extremely good for you. Eric told me that he has a glass a day (he puts the fruit in a blender) and swears by it. But it has a brilliant side-effect: it makes alcohol taste awful and undrinkable. Eric would like to market this in order to help the alcohol problem in the area.

Banks tended to collect specimens individually, assessing them almost independently of their habitat. Parkinson's botanical paintings reflect this approach, showing specimens devoid of contextual detail. The current approach is to pay as much attention to the environment and ecosystem in which a plant lives as to the specimen itself.

TOM'S JOURNAL – 31 August 2001

The mountains, flatland bush and mangroves which surround Cooktown are all individual ecosystems but together they are an ecosystem too. Cooktown is built between the mountain (Grassy Hill) and the mangrove, so the wildlife chain is broken. 'Wildlife corridors' – i.e. spaces which mark out a continuation of the native flowers and plants – along the road verges would help solve this problem. I think that the flora here is so beautiful that I'd rather see native species along the streets than plain stretches of mown grass.

In the evening Diana drove us back to the wharf. On the way, she told me that the fact that we had approached the Aboriginal communities for assistance and permission to collect plants really pleased them… The Gungarde and Gamay communities were honoured that we did it this way as it acknowledged their importance in the community.

I had had such a fantastic two days – some of the botanically best days I have ever had.

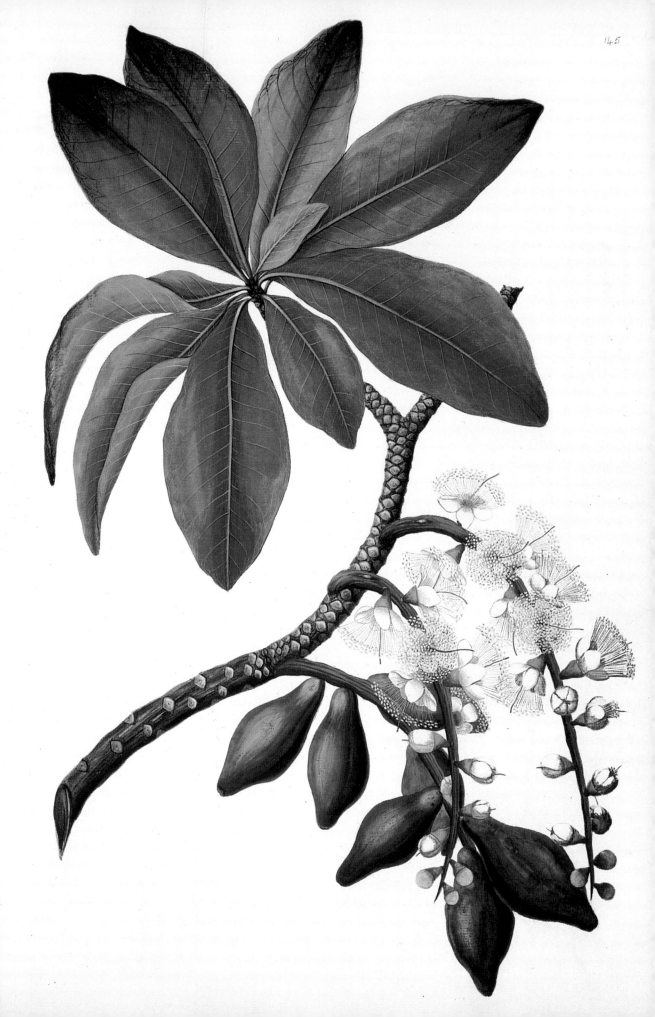

OPPOSITE: *Barringtonia calyptrata*, painted by Frederick Nodder in 1777 from an original sketch by Sydney Parkinson. This plant, native to the coastal region of northeastern Queensland, has toxic fruits that were once used by Australian Aborigines to paralyse fish, thus making them easier to catch. The plant was new to European botany when collected by the *Endeavour*'s naturalists, and was named after Daines Barrington, a botanist and friend of Joseph Banks.

RIGHT: Lucy Smith's painting of a *Barringtonia racemosa* specimen collected at Endeavour River in September 2001.

The next morning Lucy set about drawing the specimens that she and Tom had brought into the Great Cabin. Like Parkinson before her, she faced a backlog of artwork that needed to be completed before the specimens deteriorated. The one big difference was that Parkinson had been at sea for nearly two years by this stage in Cook's voyage, while Lucy had just started adjusting to the working conditions aboard the replica *Endeavour*.

LUCY'S JOURNAL – 3 September 2001

I think I am beginning to get used to painting on a surface which is moving up and down, and can't imagine what it will be like in really stormy weather/open sea. When drawing on deck I tied my pencil to a piece of tape and felt a lot more secure.

The last three days since Cooktown I have spent mostly on trying to draw all of the specimens now sitting in buckets in the Great Cabin. At the moment the order they are done is dictated by which plant is least likely to last the day, so that is keeping me on my toes. I am so grateful for the few sketches and colour notes I made in the bush (Barringtonia) and the Botanic Gardens (Dillenia, Pittosporum and

Cochlospermum) as these things so quickly deteriorated. The volume and pressure of work is giving me just the faintest idea of how Parkinson might have felt, although at two specimens a day, I'm hardly competing with his one-time total of 94 in 14 days! Am doing them in a little more detail, mind you. This is my system: get a complete pencil drawing on paper, with at least one of every relevant different part of the plant coloured, e.g. flowers, leaf upper, and underside, fruit, stalks, etc. I hope to be able to go back and finish them during the rest of the voyage. If I get them all done, that would be about 20 in total in the six weeks of this voyage.

To keep up, Lucy worked long hours and in circumstances remarkably similar to those in which Parkinson drew. Sometimes the conditions proved far from easy, especially when sailing outside the reef, where the seas changed dramatically.

LUCY'S JOURNAL – 4 September 2001

I decided to try drawing at night again. There is only one tiny battery-operated light in the Great Cabin. The Captain came in as I was wondering what to do, and suggested that I should try using candle lanterns as Parkinson would have done. Set up four in the navigators' room outside my cabin and did manage to draw the top half of *Dendrobium discolor* with much peering and squinting. Not an easy one –

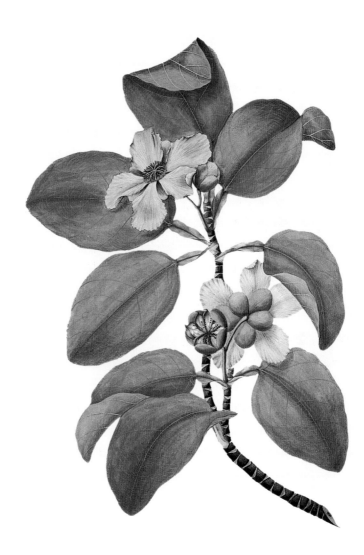

OPPOSITE: Working in the Great Cabin, as her eighteenth-century predecessors had done, Lucy found herself increasingly amazed at the quality and quantity of work they produced during the course of the voyage.

RIGHT: *Dillenia alata* painted by Frederick Nodder in 1778, based on a sketch drawn by Sydney Parkinson from the actual specimen shown on page 79. This plant is unique to the tropical region of northeastern Queensland and the coastal areas of Papua New Guinea.

BELOW: *Grevillea glauca* painted by Lucy Smith. This species, first seen by Europeans on Cook's *Endeavour*, is native to tropical Queensland, where today it is commonly known as bushman's clothes peg, after the use to which its seed capsules have been put.

the candles give off quite a lot of heat, so I didn't want the flowers to get too close. This morning the leaves were OK, but flowers – just terrible! Things grew worse when we left the reef today via Cook's passage: the seas swelled while I was drawing, only 3–6 feet [1–2 metres] apparently, but this was enough to get to me because we are so used to the calm waters inside the reef. I had to go up on deck and only then did I feel a bit better. This is just what I had feared might happen when working on the ship: with the stern going up and down, the last thing I wanted to feel was queasy and have to abandon my work – dammit!

While Lucy was busy drawing, Tom faced problems with preserving the specimens. One of the techniques used by Banks and Solander was to lay the specimens out in the sun on

paper, turning them regularly. On the ship, however, they dried the specimens between the two blotters of a plant press. This is how botanical specimens are dried today, although other methods may be used in 'emergencies'. In Queensland, for example, the humidity posed problems, so Tom resorted to drying his specimens in the engine room.

A week after leaving Cooktown, Lucy was taking stock and trying to get the measure of her eighteenth-century counterpart.

### LUCY'S JOURNAL – 6 September 2001

I was beginning to feel like Parkinson in that time pressures were big today…most of the fresh plants seem to feel like dying and dropping all their leaves at once. So by force of circumstance I have now gotten into a more comfortable drawing and colour-noting style after struggling a bit over the past few days – I am now drawing much more quickly, which is good and something I hoped would start to happen – no time to procrastinate, just plonk the thing down and draw away. Think I've now done about seven out of c.18 specimens, so still plenty to do.

I'm starting to understand why Parkinson didn't write very detailed journal entries about his shore activities – maybe he was just too busy stuck on board (or in camp at Cooktown) drawing! I imagine that Banks and Co had a lot more time to sit around, discuss and write about their adventures. Not surprising that Banks and maybe Parkinson and the Captain didn't suffer from nostalgia like all the sailors – they always had something to do and somewhere to be.

Banks took his specimens freely, transporting them between countries, and finally returning with them to Britain, where they are now stored in the Natural History Museum. Today, however, there are strict laws governing the collection and movement of plants. These were passed in order to respect each country's biological heritage and intellectual property. The introduction of new species into new habitats can also have disastrous consequences for the regulation of an ecosystem. As a result, Tom had to arrange for most of the specimens to be forwarded to Kew via an Australian counterpart. Some specimens were allowed to be kept on board for work to continue, but these were later destroyed before leaving Australian territory.

### TOM'S JOURNAL – 10 September 2001

At our last stop in Australia I had to get the new specimens packed up and sent off to James Cook University. I put the new specimens in newspaper and alcohol and wrapped them up well. However, I plan to throw all the remaining specimens overboard before we leave Australian waters as we do not have permission to 'export' these plants from the country. My permit states categorically that I can collect only in Australia and use the specimens for educational purposes only. They must now go to James Cook University in Townsville, Queensland, for processing. After being dried and sterilized, they will be sent to Kew. James Cook University is a licensed institution for the transporting of specimens.

As the voyage drew to a close and the ship approached Indonesia, Lucy and Tom reflected on what they had achieved in comparison with Parkinson and Banks.

There are lots of things I have learnt about drawing and painting under the conditions of the ship – one of them is that capturing habit and structure is as vital as colour, because many of our plants simply disintegrated after two or three days, the leaves dropping off when touched. I found that it was best to make quick colour studies in my sketchbook of flowers and fruits before beginning the final work, which I sometimes did not reach until days later. Notes were also really important to describe colours, which were forgotten later. It was strange how I found myself doing almost exactly what Parkinson did when he was working on this stretch of the voyage and he had a massive backlog of work to keep up with: outline drawings with colour on just the essential parts of the plant. I did my best to make the drawing a bit more complete, though.

Parkinson was extraordinarily prolific – on this voyage I have found out just what a feat his accomplishment of 955 drawings was. However, he was also a very fine artist, and looking at his non-botanical drawings reproduced in a book which we have in the Great Cabin has increased my respect for him: he was very good at producing landscapes and people with a one-off line.

Because it has also been necessary to paint the plants fairly quickly, therefore you can't always be as fussy and meticulous regarding technique as you would, say, in a studio situation. However, today drawing the Banksia which we collected all those weeks ago at Endeavour River, it has been very hard for me to cut corners as it is such an interesting plant with its complex flowering spike. I can see how Parkinson managed extraordinary detail despite the pressures he experienced: when I saw Parkinson's drawing of a Banksia at the Natural History Museum I remember noting the extra care he had used when drawing it. The paper was well handled and covered in more smudges and fingerprints than any of the others. The flowers had been drawn with considerable effort and extra detail. He must have found Banksia…especially intriguing and perhaps knew it was to become a special new genus.

Throughout this voyage I have been finding out more and more about Banks. I had an opinion of him at Kew, where he is held in the highest regard, which is different from what I now think. I always used to regard him as a scientist/plantsman, but now I don't think so. I have again read his journals and I am starting to get a good idea of what he was like.

Banks was by no means an academic – that was Solander's role. His devotion to natural history was an open-air devotion. He was well aware of what he was going to do when he got back to England and the uses which he would be able to make of his botanical discoveries.

This was why he was so frustrated that he could not learn more from the Aborigines during his time in New Holland. He wanted to find out from them in what ways their plants might be useful 'for Physical (i.e. medicinal) and economical (i.e. trading) purposes'. Although unformulated, his thoughts began to focus on the imperial uses which his botanical discoveries might be put towards. In his account of New Holland, Banks concluded the botanical section by saying: 'thus much for plants: I have been rather particular in mentioning those which we ate hoping that such a remembrance might be of use to someone or other into whose hands these papers may fall.'

The *Endeavour* voyage sowed the seeds of this new thinking: Banks was no longer the naive naturalist he was when he set out.

# Imperialism

As soon as Cook left Endeavour River, his ship was caught in the labyrinth of the Great Barrier Reef. It took him a whole week to travel the 55 nautical miles (100 km) to Lizard Island. En route he anchored every night and spent much of this time scouting in the pinnace for a way out of the shallow waters. When he finally reached Lizard Island, Cook climbed to the highest point and saw a way out into the open sea. Far from being the answer to his prayers, however, it presented him with a dilemma: should he sail inside or outside the reef?

Sailing outside the reef would be safer for his vessel, but would mean losing sight of the coast and therefore prevent him from completing his chart. Sailing inside the reef would allow him to finish his work, but it would also involve the risk of running aground again. This was a significant dilemma. Only by completing his chart would Cook be able to establish the geographical extent of the coast and thus lay claim to it in the name of King George III. This was the nature of discovery: you had to survey the land, chart your findings and publish them on your return.

The original *Endeavour* set out to make 'discoveries' in the South Pacific that, through trade, alliance and colonization, would extend Britain's burgeoning maritime empire ahead of its European rivals. After Britain lost its colonies in America in 1783, the government looked to the Pacific and the new possessions claimed there by Cook to restore its imperial ambitions. The culmination of Cook's survey of the east coast of Australia was a possession ceremony, marked on the ship by three volleys of musket fire.

However, charts were just one of many symbolic ways in which European voyagers took possession of a country of which they claimed to be the first discoverer. On the *Endeavour* voyage these symbols were 'rational' and 'enlightened', taking the form of 'scientific' surveys, descriptive accounts, drawings and possession ceremonies, these last being conducted after having at least sought the consent of the indigenous people. Taking possession through friendship, alliance and trade was one of Cook's many instructions from the Admiralty, which he followed to the letter. However, as described later in this chapter, the very act of landing and trying to establish contact sometimes ended in violence.

Cook's land claims on behalf of Britain led to his being hailed as a hero of discovery and exploration – a reputation sustained throughout the nineteenth and twentieth centuries, not least in the minds of the white settlers in New Zealand and Australia: Cook was their founding father. However, Cook is also seen a symbol of oppression by the indigenous societies of those countries most affected in the aftermath of his Pacific explorations. During the BBC voyage of 2001 we followed Cook's route from Cooktown to Lizard Island, and from there to Cape York and Possession Island, where Cook controversially laid claim to the east coast of Australia and named it New South Wales. It is impossible to look at such claims, or the significance of the *Endeavour* voyage, without

considering the views of those most directly affected. Chris Terrill, the producer of the television series, therefore invited the Aborigines Bruce Gibson, Bob Patterson and Rico Noble and the Maori Merata Kawharu, Curtis Bristowe and Mariao Hohaia to join the expedition. Their views would be very different from those held by others on board, and would lead Chris and the historians to re-evaluate Cook's legacy.

# Cartography

In coming to a decision about whether to sail inside or outside the reef, Cook had many things to bear in mind. First of these was that he hoped to claim the land he was surveying, so he had to discover its northernmost extent. In doing that, he also hoped to establish whether a passage existed between New Holland and New Guinea. This would not merely solve a long-standing dispute perpetuated by other people's maps, but also speed his onward journey to Batavia, where he was anxious to repair his leaky ship and take on fresh provisions.

Having weighed things up, Cook reluctantly decided to abandon charting the coastline. The risk to the ship and its crew was simply too great.

> *13 AUGUST 1770*
>
> After well considering both what I had seen myself and the report of the Master…I was pretty well convinced of myself that by keeping in with the main land we should be in continual danger besides the risk we should run of being locked in within the main reef at last and have to return back to seek a passage out; an accident of this kind or any other that might happen to the ship would infallibly lose our passage to the East Indies this season and might prove the ruin of the voyage, as we have now little more than three months provision on board and that allowance short in many articles. These reasons had the same weight with all the officers. I therefore resolved to weigh in the morning and endeavour to quit the coast altogether until we could approach it with less danger.

The next day Cook passed through a channel now known as Cook's Passage. Characteristically, he anticipated critics who would chide him for giving up his surveying work:

> *14 AUGUST 1770*
>
> It was with great regret I was obliged to quit this coast unexplored to its northern extremity which I think we were not far off, for I firmly believe that it doth not join New Guinea, however this I hope yet to clear up being resolved to get in with the land again as soon as I can do it with safety and the reasons I have before assigned will I presume be thought sufficient for my having left it at this time.

Cook's chart of eastern Australia shows the gap that resulted from this decision to quit the coast (see opposite). Clearly uncomfortable about his decision, he turned back to the

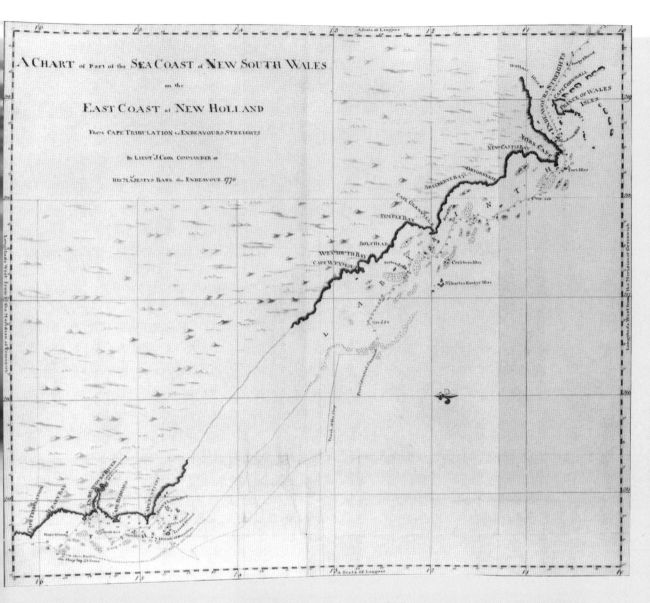

A CHART of Part of the SEA COAST of NEW SOUTH WALES

on the

EAST COAST of NEW HOLLAND

From CAPE TRIBULATION to ENDEAVOURS STREIGHTS

By LIEUT J. COOK COMMANDER of

HIS MAJESTYS BARK the ENDEAVOUR 1770

**ABOVE:** The labyrinth of the Great Barrier Reef forced Cook away from the east coast of New Holland, and the gap in the chart shows what he could not map. Banks described the open sea as the 'asylum we had long wished for'. Cook, however, was fearful of overshooting the supposed strait between New Holland and New Guinea, so he returned to the coastline two days after leaving it.

**RIGHT:** A view from Mount Cook on Lizard Island, the largest of the Islands of Direction. These were so named by Cook because they pointed the way out of the dangerous shoals of the Great Barrier Reef and into the open sea.

reef the very next day, fearful of 'overshooting the passage supposing there to be one between this land and New Guinea'. Unfortunately, he and the ship's company soon found themselves in even greater peril than previously.

As the *Endeavour* approached the reef, the winds dropped and the ship came to a halt. It was impossible to anchor in the deep sea, so the ship was at the mercy of the tide. 'All the dangers we had escaped were little in comparison of being thrown upon this reef where the ship must be dashed to pieces in a moment,' Cook wrote later. There was no way of controlling the ship except to tow it, so the pinnace, yawl and longboat were quickly manned and the ship was pulled out of danger. This success was only temporary, however. At one point the ship was dragged back by the tide and found itself terrifyingly close to the reef – less than 100 yards (90 metres) from destruction. Suddenly a breeze sprang up, a small breath of wind that in any other circumstances would not have been

'A View of the Land about Endeavour River...' drawn by Charles Praval in 1770, based on a drawing by Sydney Parkinson or Herman Spöring. Coastal views such as this were an important supplement to the cartographic charts produced on the voyage, and helped communicate as well as substantiate Cook's 'discovery'.

noticed. This, together with an ebb tide, gave the ship a brief respite from danger. Then there was an extraordinary bit of luck: a gap between two reefs, 'not more than a quarter of a mile broad', had opened up and the tide pulled the ship through to safety. Cook named this passage Providential Channel.

Weighing the demands of discovery against the need for safety was an agonizing dilemma for Cook: indeed, it provoked a rare personal outburst in an otherwise consciously restrained and public journal.

### 17 AUGUST 1770

Was it not for the pleasure which naturally results to a man from being the first discoverer, even were it no more than sands and shoals, this service would be insupportable especially in far distant parts, like this, short of provisions and almost every other necessity. The world will hardly admit of an excuse for a man leaving a coast unexplored he has once discovered; if dangers are his excuse he is then charged with *timorousness* and want of perseverance and at once pronounced the unfittest man in the world to be employed as a discoverer; if on the other hand he boldly encounters all the dangers and obstacles, he is then charged with *temerity* and want of conduct.

In fact, it was the prospect of 'pleasure' at being a first discoverer that had brought Cook to Australia. He set himself the task of mapping the continent's east coast even though he had completed his instructions from the Admiralty and his crew clearly wanted to get home. Ambition had brought him to the verge of his greatest discovery of the voyage, but also, for a second time, to its greatest danger. His journal entry on this episode ends with an admission and a justification of his actions, which crystallize the essence of discovery: 'I must own I have engaged more among the islands and shoals along this coast than may be thought with prudence I ought to have done with a single ship and everything considered, but if I had not we should not have been able to give any better account of the one half of it than if we had never seen it.'

Four days later Cook's gamble paid off. He had reached the end of the mainland and could see the Torres Strait that separated it from New Guinea. Going ashore at a small

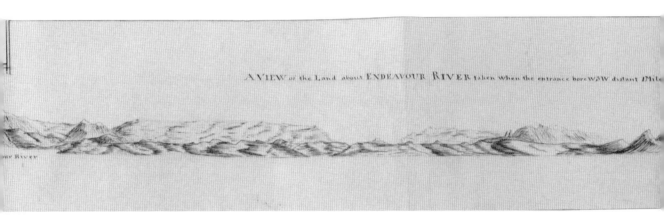

island near the tip of Cape York, he climbed to the top of a hill and there laid claim to the land he named New South Wales. Although it may seem odd that Cook should claim the territory from an island rather than the mainland, he did it advisedly. Only from here could he view the limits of the continent's east coast and simultaneously confirm the existence of the Torres Strait. The unwritten rules of discovery decreed that by defining the limits of a new-found land, a first discoverer distinguished his achievement from that of others and could thus claim possession.

*22 AUGUST 1770*

On the western side [of New Holland] I can make no new discovery, the honour of which belongs to the Dutch navigators, but the eastern coast from the latitude of 38 degrees south down to this place I am confident was never seen or visited by any Europeans before us and, notwithstanding [that] I had in the name of His Majesty taken possession of several places upon this coast, I now once more hoisted English colours and in the name of His Majesty George III took possession of the whole eastern coast from the above latitude down to this place by the name of New South Wales, together with all the bays, harbours, rivers and islands situated upon said coast.

As Parkinson recounted in his journal, the whole ship's company, on shore and off, took part in the ceremony of claiming that territory. 'The captain and some others…hoisted up a jack, and fired a volley, which was answered by the marines below, and the marines by three volleys from the ship, and three cheers from the main shrouds.'

Perhaps because so many of these ceremonies had been carried out during the course of the voyage, Banks did not even record this particular occasion in his journal. Like all discoverers, Cook did not know what would one day be of 'use' to his country, so he claimed everything he could, believing that if he didn't do so, others would. His claim to this part of New Holland would certainly thwart French ambitions. The explorer de Bougainville had made an attempt on New Holland only a year earlier, but had been deflected from reaching it by the dangerously shallow waters of the Great Barrier Reef.

The Admiralty had instructed Cook to take possession of a country 'with the consent of the natives' who inhabited it. The Royal Society also stipulated that 'no European has a right to occupy any part of their country or settle among them without their voluntary consent'. At Queen Charlotte's Sound in New Zealand Cook carried out the spirit of these instructions as best he could by winning consent from a small group of Maori to set up a 'mark upon the island in order to show any ship that might put into this place that we have been here before'. Afterwards he gave them presents of coins, nails and a bottle, before raising a flag and taking formal possession of the sound 'and the adjacent lands'. However, on Possession Island, as Cook named it, Sydney Parkinson recorded that 'we saw some of the natives stand gazing at us; but when the boat's company landed they immediately fled'. In direct contravention of the Royal Society's guidelines, no consent was sought or given. Flags, inscriptions and trinkets were left by way of staking a claim, and from such beginnings the British Empire of the nineteenth century grew.

After quitting each of the lands they had explored, Cook and Banks wrote lengthy accounts of the terrain and its people. These writings were quite separate from their daily journal entries and allowed them to order and assess their findings in science, botany and geography according to the rational spirit of the voyage. They also allowed them to strengthen their claim to the discoveries they described.

## Geography

In writing these reports Cook was doing no more than the Admiralty had asked him, but it was a daunting brief:

> …carefully observe the nature of the soil and the products thereof; the beasts and fowls that inhabit or frequent it; the fishes that are to be found in the rivers or upon the coast and in what plenty; and in case you find any mines, minerals or valuable stones, you are to bring home specimens of each, as also such of the seeds of trees, fruits and grains as you may be able to collect and transmit them to our secretary that we may cause proper examination and experiments to be made of them.

Painting of fruits and seeds collected during the BBC voyage of 2001 by Lucy Smith. Parkinson's botanical and zoological paintings, which Lucy greatly admired for their craft, were not simply works of art but a means of ordering the specimens and an aid to accurate observation and classification.

Cook also included assessments of the best harbours, noting where the water was deepest, so that future British ships would know how best to gain access.

In fulfilling the first part of the brief, Cook and Banks often began by assessing a country's agricultural potential. In Tahiti, for example, Banks recorded how the fruit trees grew with such ease that:

> ...scarcely can it be said that they earn their bread with the sweat of their brow when their chiefest sustenance bread fruit is procured with no more trouble than that of climbing a tree and pulling it down. Not that the trees grow here spontaneously but if a man should in the course of his life time plant ten such trees, which if well done might take the labour of an hour or thereabouts, he would as completely fulfil his duty to his own as well as future generations.

Similarly, of New Zealand Cook reported: 'It was the opinion of everybody on board that all sorts of European grain, fruits, plants etc. would thrive here. In short was this country

settled by an industrious people, they would very soon be supplied not only with the necessaries but many of the luxuries of life.' Australia also seemed promising – at first. Parkinson wrote, 'the country looked very pleasant and fertile; and the trees, quite free from underwood, appeared like plantations in a gentlemen's park'. On landing at Botany Bay, Cook's first impressions so supported this view that, he believed, 'the whole country or at least a great part of it might be cultivated without being obliged to cut down a single tree'. Although the soil was sandy, 'it produceth a quantity of good grass which grows in little tufts about as big as one can hold in one's hand'. Two days later, he and Solander explored the head of the bay. 'We found the land much richer, for instead of sand I found in many places deep black soil which we thought was capable of producing any kind of grain. At present it produces besides timber as fine meadow as ever was seen.'

However, as Cook historian Glyn Williams observes, Banks was not so impressed. He was collecting elsewhere in Botany Bay on the day that Cook discovered this rich soil, and he believed that the agricultural prospects were poor:

For the whole length of coast which we sailed along there was a sameness to be observed in the face of the country very uncommon… Water is here a scarce article or at least was so

OPPOSITE: While out botanizing at Tolaga Bay (Uawa), New Zealand, the gentlemen from the *Endeavour* saw a beautiful natural arch formed from a rock, prompting Banks to write later: 'so much is pure nature superior to art'. This pen and wash painting by Parkinson, a copy of an original drawing by Spöring, reflects how eighteenth-century Europeans applied their classical sensibility to the new landscapes they encountered.

BELOW: *Botany Bay: Sirius and Convoy Going In…* by William Bradley (1788). After Joseph Banks had recommended Botany Bay as an ideal site for a penal colony, the First Fleet from Britain made its way there using Cook's charts. On finding the site less than ideal, the fleet sailed further up the coast and eventually settled in the natural harbour, which Cook had sailed past and named Port Jackson. Today it is known as Sydney.

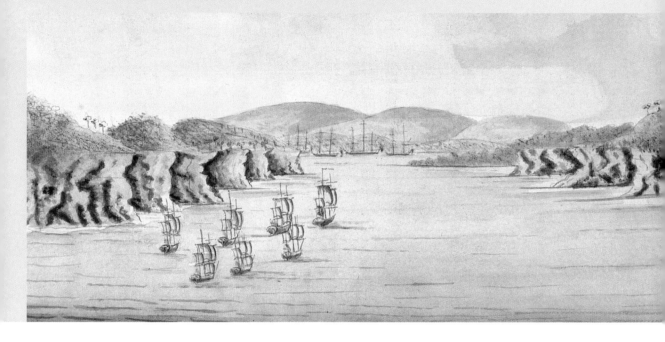

while we were there, which I believe to have been in the very height of the dry season; some places we were in where we saw not a drop, and at the two places where we filled for the ship's use it was done from pools not brooks. This drought is probably owing to the dryness of a soil almost entirely composed of sand in which high hills are scarce… A soil so barren and at the same time entirely void of the helps derived from cultivation could not be supposed to yield much towards the support of man.

This was not a ringing endorsement of New Holland as a suitable place for British colonization. Yet in 1785, when Banks was called upon to give evidence before the Beauchamp Committee, which was trying to decide upon a location for a convict settlement, he recommended Botany Bay rather than Tahiti or New Zealand. Fifteen years after the *Endeavour* had left Australia, Banks was reported as saying:

…the proportion of the rich soil was small in comparison to the barren but sufficient to support a large number of people…there were no beasts of prey but he did not doubt that our oxen or sheep, if carried there, would thrive and increase; there was great plenty of fish… The grass was long and luxuriant and there was some eatable vegetables, particularly a sort of wild

spinach; the country was well supplied with water; there was abundance of timber and fuel, sufficient for any number of buildings.

When the First Fleet carrying the colonists arrived at Botany Bay they searched in vain for Cook's rich black soil. Eventually, they gave up and moved a little further along the coast to Port Jackson, later renamed Sydney Harbour. Why, in the intervening years, had Banks changed his assessment of the land?

One possible explanation is that he assessed the site's suitability based on its emptiness rather than the quality of the land. In their journals Cook and Banks suggested that New Holland was virtually unpopulated. Undeniably, the Aborigines had largely avoided contact, which led Banks to conclude that 'this immense tract of land…considerably larger than all Europe, is thinly inhabited…at least that part of it that we saw: we never but once saw so many as thirty Indians together and that was a family, men, women and children, assembled upon a rock to see the ship pass by'. This supported Cook's early assessment at Botany Bay that 'the natives do not appear to be numerous, neither do they seem to live in large bodies but dispersed in small parties along by the waterside'. Their homes were makeshift and temporary; new homes would be made when 'wandering like the Arabs from place to place [they] set them up whenever they meet with one where sufficient supplies of food are to be met with'. From his observations of the nomadic and sparse Aborigines, Banks inferred that the continent was empty:

> What the immense tract of inland country may produce is to us totally unknown: we may have liberty to conjecture however that they are totally uninhabited. The sea has I believe been universally found to be the chief source of supplies to Indians ignorant of the arts of cultivation: the wild produce of the land alone seems scarce able to support them at all seasons, at least I do not remember to have read of any inland nation who did not cultivate the ground more or less, even the North Americans who were so well versed in hunting sowed their maize. But should a people live inland who supported themselves by cultivation these inhabitants of the sea coast must certainly have learned to imitate them in some degree at least, otherwise their reason must be supposed to hold a rank little superior to that of monkeys.

This information contributed to a picture of Australia as a *terra nullius*, a vast blank space of land belonging to and owned by no one. This impression was to have dramatic consequences: it contributed to Cook claiming the country at Possession Island and to the choice of New South Wales as the site for a penal colony. After all, how could such a scanty population, which had no property and did not cultivate the land (as Europeans recognized it), own the place? While there was no coherent imperial strategy in Cook's time, these early and ill-founded views had far-reaching consequences. The seeds of Aboriginal dispossession were sown with the ceremony on Possession Island: now they had taken root.

At the time of his survey, Banks probably had only a notion of the ways that his work might be used to further the cause of imperialism. In the years between quitting New Holland and making his submission to the Beauchamp Committee much had changed, not least Banks himself. He had joined the *Endeavour* as a young man of twenty-five with an enormous enthusiasm for natural history. Following his return to Britain in 1771, he was invited first to be master of George III's botanic gardens at Kew and then, in the 1780s, became president of the Royal Society, the most eminent scientific body in the country. Banks would only return to the field one more time: to Iceland in 1772. Otherwise, he remained in Britain as confidant of the King, and unofficial director, patron and promoter of scientific enterprises that related to voyages of discovery, including Cook's. Like everyone else who had been in contact with the *Endeavour*, he was changed by it for ever.

In his roles at Kew and the Royal Society Banks promoted botany as a valuable adjunct to imperialism by conducting experiments in transporting live plants and seeds across the globe. HMS *Bounty*'s attempted transfer of breadfruit plants from Tahiti to the West Indies is the most imaginative of the scientific voyages arranged by Banks. However, as maritime historian Nigel Rigby has shown, during the *Endeavour* voyage he was posing purely practical questions. One of the ways in which Cook and Banks explored the practicality of growing foreign plants was by establishing specially constructed gardens. Such experiments in growing plants far from their native habitats had already been conducted during the *Endeavour*'s three-month stay in Tahiti, as Banks recorded: 'This morn Captn Cook planted diverse seeds which he had brought with him in a spot of ground turned up for the purpose. They were all bought of Gordon at Mile End and sent in bottles sealed up, whether or not that method will succeed the event of this plantation will show.'

Banks conducted similar experiments himself, the purpose being to assess how well the seeds would grow and the best method of preserving them at sea. While both he and Cook knew that such scientific inquiry could be used for imperial purposes, such as expanding trade and settling new countries, the detail of these ambitions had not yet been worked out. The British Empire was to become the biggest in the world during the nineteenth century. The speculative work of explorers such as Cook was just the start.

## Ethnography

The writings of Cook and Banks described not only landscapes but also the people who inhabited them, their society and culture. As mentioned earlier, this was yet another part of Cook's instructions from the Admiralty: 'to carefully observe the genius, temper, disposition and number of the natives if there be any and endeavour by all proper means to cultivate a friendship and alliance with them, making them presents of such trifles as they may value, inviting them to traffic and showing them every civility and regard'. By establishing the disposition of the indigenous people – their amenability and willingness to trade, for example – Cook and Banks provided information that was vital to Britain's future plans in the Pacific.

At the time of the *Endeavour* voyage, however, this information sprang from practical questions, one of which occurred to Cook just after he had confirmed the existence of the Torres Strait. 'Another doubtful point I should like to have cleared up, although it is of very little if of any consequence, is whether the natives of New Holland and those of New Guinea are or were originally one people, which one might well suppose as these two countries lay so near to each other and the intermediate space is filled up with islands.'

This train of thought reflects how geography and ethnography were inextricably linked on the *Endeavour* voyage. Whether or not indigenous peoples come from one race was a question frequently raised by Cook and Banks: were the Society Islanders and the Maori of New Zealand, they wondered, formerly one race now divided among separate islands? In New Holland, the Aborigines were presumed to be one people because they inhabited a continuous stretch of land, the people of the north and south differing, according to Banks, only in the construction of their canoes. What the land could tell them about the people was just one of many lines of inquiry that made up their ethnographic accounts. By raising such questions, Cook and Banks compiled surveys that were as valuable for their anthropological content as they were for furthering British imperial prospects.

Just as Cook's explorations helped to map the South Seas, so the writings and pictures produced on his voyages helped to map mankind, making Europeans more aware of societies and cultures distant from their own. Cook and Banks sought to describe indigenous people and their societies rationally and objectively, in line with the scientific principles of the voyage. In the past, encounters with other peoples, such as the Incas of South America, had been treated as opportunities for conquest and subjugation. Banks distanced himself from such behaviour, writing that he hoped to avoid committing 'the cruelties which the Spaniards and most others who have been in these seas have often brought themselves under the dreadful necessity of being guilty of, for guilty I must call it'. By contrast, the interest that he and others took in the people with whom they came into contact has come to be understood as an early form of anthropology. They hoped that resolving anthropological questions would lead to imperial advancement. This was a new kind of exploration, and its exponents succeeded in welding together two, often contradictory, goals.

Writings about indigenous peoples covered a wide range of subjects, including physical appearance, clothes, adornments, behaviour and character, weapons and tools, boats, homes and furniture, sustenance – whether by hunting or cultivation – and language. These are surveys not of land but of human society.

As with the geographical reports, the ethnographic descriptions are ostensibly objective, first-hand accounts. The scientific and rational minds that sought to clear up confusions in botany and geography also illuminate these reports. For example, at the start of Banks's account of the New Hollanders, he is keen to contrast his impressions of the Aborigines with the random and inaccurate thoughts of them expressed by William Dampier, an English buccaneer who had visited the western coast of New Holland in

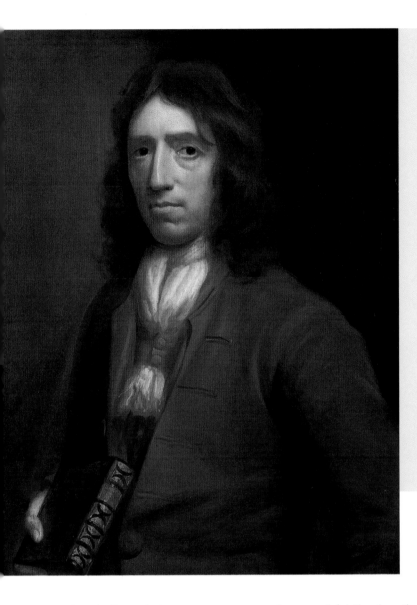

The buccaneer William Dampier, painted here by Thomas Murray (c. 1697), sailed around the world three times and was the first Englishman to reach New Holland (present-day Australia). He visited the northern and western coasts in 1688 and 1699. His unflattering account of the country and its resources contributed to the 'discovery' of its east coast becoming a low priority for European exploration. On the *Endeavour* voyage Dampier's account of Australian Aborigines influenced the journal writers' first impressions of the indigenous people, although these would change during the course of the ship's passage north.

1688–9. Dampier's account was not only untruthful (he described the Aborigines as 'coal black like…the Negroes of Guinea' and their hair to be 'short and curled like that of the negroes'), it was also a sweeping denigration of the people as a whole. By referring to the Aborigines as 'the miserablest people in the world', Dampier dismissed them as almost subhuman. The accounts written by Banks and Cook were infinitely more detailed and sympathetic, as we shall see later.

Although Cook and Banks did their best to write objectively, their accounts are necessarily subjective. Their observations about the peoples they encountered are arranged under subject headings, such as clothes and food, that reveal as much about their own priorities as what they are describing. They make generalizations based on specific incidents in which they and others were directly, and often violently, involved. Where evidence was scant, they simply relied on conjecture. Cook drew attention to this himself and prefaced his 'Account of New Zealand' with the following statement:

Before I quit this land altogether I shall give a short and general description of the country, its inhabitants, their manners, customs etc in which it is necessary to observe that many things are founded on conjecture for we were too short a time in any one place to learn much of their interior policy and therefore could only draw conclusions from what we saw at different times.

Banks also admitted that his ethnographic account of the Aborigines had no scientific basis. His observations came principally from encounters with the Guugu-Yimithirr nation at Endeavour River, which he said 'consisted of 21 people, 12 men, 7 women, a boy and a girl', although there could have been more. Perhaps conscious of other generalizations, he admitted that some conclusions were reached by observing from the ship using telescopes or 'glasses', which 'might deceive us in many things'. His account of New Holland ended with a list of Aboriginal words and their translations, but he again felt compelled to point out the potential for misunderstanding:

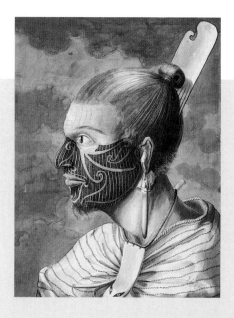

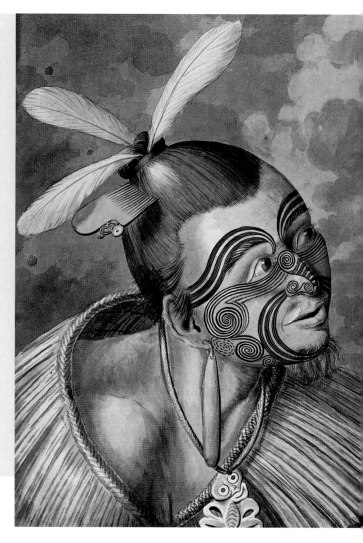

These two pen and wash drawings by Sydney Parkinson are the first visual representations of Maori warriors by Europeans. As such, they established archetypes that persist to this day. They contain a wealth of clear ethnographic detail, such as tattoos, clothes and ornaments, and did as much to help classification in this field as Parkinson's other drawings did in botany and zoology. Art historians Bernard Smith and Rüdiger Joppien have suggested that the European cast of the Maoris' features might have arisen from the neo-classical influence of William Hogarth's figure drawings in *The Analysis of Beauty*, a copy of which was on board the *Endeavour*.

Of their language I can say very little. Our acquaintance with them was of so short a duration that none of us attempted to use a single word of it to them, consequently the list of words I have given could be got by no other manner than by signs enquiring of them what in their language signified such a thing, a method obnoxious to many mistakes: for instance a man holds in his hand a stone and asks the name of [it]: the Indian may return him for answer either the real name of a stone, one of the properties of it as hardness, roughness, smoothness &c, one of its uses or the name peculiar to some particular species of stone, which name the enquirer immediately sets down as that of a stone.

This summed up the limitations of all the ethnographic accounts in the *Endeavour* journals. The observers' inability to understand the Aboriginal language was a real barrier to understanding indigenous customs and behaviour. Faced with the task of surveying societies highly different from their own, they attempted a scientific approach, which proved inadequate, so they resorted to conjecture and making contrasts with their own society to impose 'sense' on what they saw.

During his first days at Tahiti, for example, Banks drew on his classical education to find the terms to describe the place and the people. Not only were the chiefs Tubourai and Tuteha named Lycurgus and Hercules, after the Greek mythological figures, but Tahiti itself was the 'truest picture of an Arcadia of which we were going to be kings that the imagination can form'. It soon became clear, however, that other tools for understanding the new Pacific societies would have to be found.

Many of their observations were organized around the 'four-stage' theory of man, an anthropological scheme current at the time. This posited that human society passed from hunting to pastoralism, from pastoralism to cultivation and agriculture, and from there to commerce and trade. The organizing principle behind this scheme was the degree to which property was institutionalized. Property was deemed important because it indicated how far a society had progressed from its nomadic roots. According to anthropologist Nicholas Thomas, the use of the plough was 'seen as fundamental to the emergence of cooperative endeavour that led in turn to various forms of political union, civil regulation and institutionalized government'.

Applying this yardstick made the Aborigines of New Holland contrast unfavourably with the Maori of New Zealand. The latter, who had had 'so little or indeed no commerce with any others', were praised by Banks for their property rights and their 'excellent tillage' of the land. He took these as indicators of their political system and drew conclusions from them about many other things, such as the prevalence of fine clothes, boats, ornaments, affluence and even the 'king'. Banks could almost be describing his own country rather than New Zealand.

Throughout all this district the people seemed free from apprehension and as in a state of profound peace. Their cultivations were far more numerous and larger than we saw them any where else and they had a far greater quantity of fine boats, fine clothes, fine carved work; in

short the people were far more numerous, and lived in much greater affluence, than any others we saw. This seemed to be owing to their being joined together under one chief or king, so at least they always told us.

Banks was a wealthy landowner, so it is easy to understand the value he placed on property. But property was just one of many criteria that denoted civilization to Europeans: wherever they saw indigenous peoples displaying characteristics or habits that they too prized, they considered the people more sophisticated for it. The Tahitians, for example, were praised for their 'curiosity', a characteristic abundant in the observers. The Tahitian chief, Amo, was deemed by Banks a very sensible man for his 'shrewd questions about England, its manners and customs etc'. Correspondingly, the Aborigines, who showed not the slightest curiosity about the ship, were referred to as 'the most uncivilized savages perhaps in the world'. The Maori were commended for their cultivation and weaving – 'the arts of peace' – but were also admired for their war-like qualities. (These would naturally be prized by a martial nation that had recently and successfully concluded the Seven Years War against France.) The Maori canoes, too, were a match even for the *Endeavour*; the fine craftsmanship of their carvings left Banks unusually incapable of finding the words to describe them. By contrast, the Aborigines' canoes were 'exceedingly bad'.

It might be expected that the cultures observed would come off the worse under analysis from the European point of view. Interestingly, however, the descriptions are often sympathetic and even idealized against the European commercial world. The most stark instance of such a subjective response can be seen in the conclusion to Cook's assessment of the Aboriginal way of life in New Holland.

> From what I have said of the natives of New Holland they may appear to some to be the most wretched people upon Earth, but in reality they are far more happier than we Europeans; being wholly unacquainted not only with the superfluous but the necessary conveniences so much sought after in Europe, they are happy in not knowing the use of them. They live in a tranquillity which is not disturbed by the inequality of condition: the earth and sea of their own accord furnishes them with all things necessary for life, they covet not magnificent houses, household stuff etc, they live in a warm and fine climate and enjoy a very wholesome air, so that they have very little need of clothing and this they seem to be fully sensible of… In short they seemed to set no value upon any thing we gave them, nor would they ever part with any thing of their own for any one article we could offer them; this in my opinion argues that they think themselves provided with all the necessaries of life and that they have no superfluities.

The insight that Cook expresses here is extraordinary. Both he and Banks had been baffled by the Aborigines, who, to their minds, had shown only a fragile interest in contact, exchange or trade; their language was unintelligible to them; they were naked

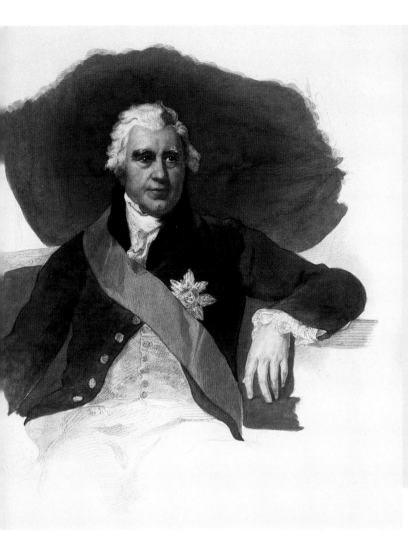

Joseph Banks in old age, a colour engraving after Sir Thomas Lawrence (1810). Banks's later career saw him transform Kew Gardens into a world centre of botanical science, become president of the Royal Society and an influential adviser to government ministers. His high standing in international scientific circles led him to promote many voyages and projects that sought to further British imperial expansion during the late eighteenth and early nineteenth centuries.

and dirty; their crude canoes were 'as mean as can be conceived', their homes 'small hovels', and their weapons and tools rudimentary. Such a society left the Europeans perplexed, yet they were able to sympathize with the Aborigines' way of life and contrast it favourably with their own. To conclude that the Aborigines might in fact be 'happier than we Europeans' was indicative of how exploration had changed in the eighteenth century. It very much accorded with popular philosophical views being expressed in the increasingly industrial world of Europe about the desirability of a simple life.

Banks too went beyond his first reactions and favourably compared the values of Aboriginal society with those of his own. His response is more specific about the elements of European society which were being re-evaluated.

From [the Aborigines] appear how small are the real wants of human nature, which we Europeans have increased to an excess which would certainly appear incredible to these people could they be told it. Nor shall we cease to increase them as long as luxuries can be invented and riches found for the purchase of them; and how soon these luxuries degenerate into

necessaries may be sufficiently evinced by the universal use of strong liquors, tobacco, spices, tea &c. &c. In this instance again providence seems to act the part of a leveller, doing much towards putting all ranks into an equal state of wants and consequently of real poverty: the great and magnificent want as much and maybe more than the middling: they again in proportion [want] more than the inferior: each rank still looking higher than his station but confining itself to a certain point above which it knows not how to wish, not knowing at least perfectly what is there enjoyed.

The focus on luxury reflects concerns about European society at the time. Contact with the indigenous peoples of the Pacific ultimately confirmed European superiority. However, in the late eighteenth century this contact also contributed to theories by philosophers such as Denis Diderot and Jean Jacques Rousseau about the innocence of less commercial societies. This led to comparisons with the acquisitive and increasingly industrial nature of European cities where opulence and luxury (resulting from the stream of new goods from new markets) were also deemed corrupting influences. The picture of the 'noble savage', for example, was derived by Diderot from the experiences of Cook and de Bougainville with the Tahitians. Banks thought in similar terms: the wants of European society, he concluded, counterbalanced its riches. This put the Europeans on an equal, not superior, level with more 'innocent' societies, whose riches were not great but neither were their wants.

The analyses of Banks and Cook pose uneasy questions about the impact of the *Endeavour*'s arrival in the Pacific. If the Aborigines might be said to be as happy if not 'happier than we Europeans', what possible benefit would future connections with Britain and Europe bring? These new contacts, in this period of the early British Empire, were justified in terms of mutual improvement through trade. Gaining the 'friendship' of indigenous peoples is a phrase often used by Cook and Banks. But in reality, the *Endeavour*'s surveys of coastlines and societies were unambiguously exercises in prospecting for places to colonize and from which to trade. Perhaps conscious of this, Cook suggests, albeit indirectly, that contact with Europeans will not lead to an improvement in life for the Aborigines.

After returning to England, Cook wrote two letters to his friend and former employer John Walker. These are perhaps his most personal and revealing accounts of the *Endeavour*'s voyage since he could write free of official constraints. In the second letter he picks up his train of thought on leaving New Holland and expands on what he has said previously.

It is said of our first parents that after they had eaten of the forbidden fruit they saw themselves naked and were ashamed; these people are naked and are not ashamed; they live chiefly on fish and wild fowl and such other articles as the land naturally produces for they do not cultivate one foot of it. These people may truly be said to be in the pure state of nature… They covet not magnificent houses, household stuff etc; they sleep as sound in a small hovel or even in the open as the King in his palace on a bed of down.

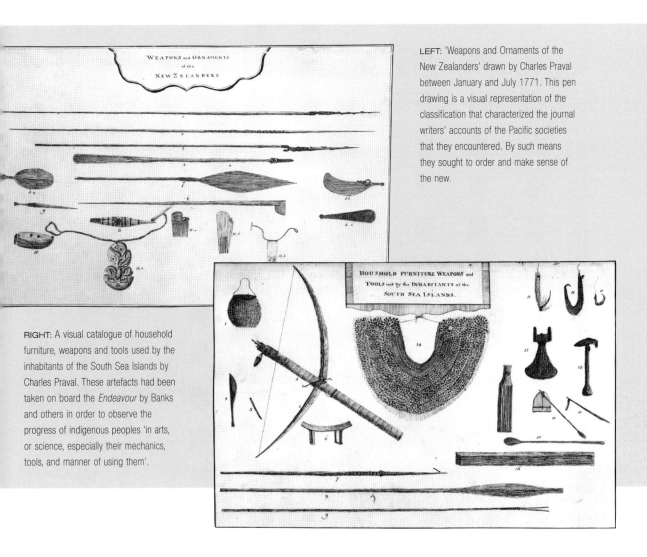

LEFT: 'Weapons and Ornaments of the New Zealanders' drawn by Charles Praval between January and July 1771. This pen drawing is a visual representation of the classification that characterized the journal writers' accounts of the Pacific societies that they encountered. By such means they sought to order and make sense of the new.

RIGHT: A visual catalogue of household furniture, weapons and tools used by the inhabitants of the South Sea Islands by Charles Praval. These artefacts had been taken on board the *Endeavour* by Banks and others in order to observe the progress of indigenous peoples 'in arts, or science, especially their mechanics, tools, and manner of using them'.

The final reference to King George, who had personally funded the *Endeavour*'s voyage and in whose name the new territories of the Pacific had been claimed, suggests an ambivalence in Cook about the impact of European contact with this fragile society.

While ostensibly rational, the Accounts written by Cook and Banks are, then, also highly subjective. Nonetheless, they could also write with clear-eyed detachment when describing new places and societies. Indeed, none of the journal writers were afraid to describe aspects of indigenous life that dismayed them. During their time in Tahiti, for example, the Europeans had many artefacts stolen. Dr Solander's watch went missing after their first banquet with the Tahitians, and Banks's cloak was later taken during his journey round the island. Most serious, however, was the theft of the astronomical quadrant with which Cook and Green were due to observe the Transit of Venus. All these objects were eventually returned, in some cases by force.

Cook's journal also included Third Lieutenant John Gore's observations on Tahiti as they provided an interesting perspective. This officer had visited the island two years earlier in the *Dolphin* and he noticed on this return trip that internal political strife had

taken its toll on the community. Gore recorded how he went into 'the woods [groves of fruit trees] where almost everywhere was altered for the worse since I was here on the *Dolphin*… In several places where there had been fine houses, we found a field of the cloth plant, and in others nothing but grass and some of the pillars of the houses remaining.' Cook remarked in his journal that fresh meat was also scarce. During his three-month stay, he saw no more than three dozen chickens on the whole island and concluded that there were only enough pigs to allow the ship's company one or two fresh meals a week.

On the same day that Cook held divine service, he and his crew witnessed an unusual public event.

> This day closed with an odd scene at the gate of the fort where a young fellow above 6 feet [180 cm] high lay with a little girl about 10 or 12 years of age publicly before some of our people and a number of natives. What makes me mention this is because it appeared to be done more from custom than lewdness for there were several women present [who]…were so far from showing the least disapprobation that they instructed the girl how she should act her part, who young as she was, did not seem to want it.

What is interesting is the detachment with which Cook observes the scene. Far from being shocked or expressing moral outrage, he records it as he sees it.

The rational values of the Enlightenment informed the standards in botany, geography, cartography and ethnography. However, they also led to a reassessment in European thought, which followed from exposure to the 'early' societies of the Pacific. Through published narratives of the voyage, paintings and popular cartoons, the *Endeavour* voyage was associated with cultural contact between Europeans and the Society Islanders, Maori and Aborigines, and this became a central influence in these changes of eighteenth-century thought.

## Violence and Friendship

Cook's secret instructions from the Admiralty required him to seek 'alliance and friendship' with the indigenous peoples whom he encountered in the hope of promoting trade and exchange that would be of mutual benefit. Claims to land, he was further instructed, were to be made with the 'consent of the natives'. To help achieve these aims, the Royal Society's president, Lord Morton, compiled some unofficial guidelines entitled 'Hints'. These were for 'the consideration of Captain Cook, Mr Banks, Dr Solander, and the other gentlemen who go upon the expedition on board the *Endeavour*'. These hints emphasized the importance of patience and forbearance in dealing with the new people encountered, as well as the need for respect: 'They are human creatures, the work of the same omnipotent Author, equally under his care with the most polished European.' Cook was advised to 'restrain the wanton use of firearms'; even if the indigenous people

opposed his landing, 'this would hardly justify firing among them'. Above all, Morton suggested, there were many ways in which to convince the natives of Europeans' 'superiority' without resorting to violence. Although conscious that these were the standards by which he and his expedition would be judged, Cook nonetheless saw violence erupt time and again.

At Tahiti, Cook noted the welcome that he and his men received: 'Not one of the natives made the least opposition at our landing, but came to us with all imaginable marks of friendship and submission.' This owed much to the actions of HMS *Dolphin* in 1767, when, desperate to reprovision and take on fresh water, the captain and crew of the ship opened fire on the orchestrated and hostile approach of 600 Tahitian canoes, which, in the Europeans' eyes, were determined to prevent their landing. Thereafter, the Tahitians engaged rather differently with the visitors, showing them the utmost hospitality. This attitude characterized all their future contact with Europeans, but the day after the *Endeavour*'s arrival, a violent incident nonetheless occurred. Banks recorded it in his journal:

> ...on our return, we found that an Indian had snatched a sentry's musket from him unawares and run off; the midshipman (maybe) imprudently ordered the marines to fire. They did fire into the thickest of the flying crowd some hundreds in number, several shot, and pursuing the man who stole the musket, killed him dead. But whether any others were killed or hurt, no-one could tell.

Parkinson, the ship's artist, also witnessed the scene, and was more damning in his judgement of events:

> A boy, a midshipman [Jonathan Monkhouse], was the commanding officer, and giving orders to fire, they obeyed with the greatest glee imaginable, as if they had been shooting at wild ducks, killed one stout man and wounded many others. What a pity that such brutality should be exercised by civilized people upon unarmed ignorant Indians! When Mr Banks heard of the affair he was highly displeased, saying, 'If we quarrelled with those Indians, we should not agree with angels.'

Banks concluded, as he and Cook often did, that the *Endeavour*'s crew had been 'forced' to take this action. However, he was not above questioning whether the events leading up to such action really merited the outcome. En route to Tahiti, for example, the ship passed a small island that Banks deemed 'too trifling to be worth taking possession of; had we therefore, out of mere curiosity, hoisted out a boat, and the natives, by attacking us, obliged us to destroy them, the only reason we could give for it would be the desire of satisfying a useless curiosity'.

On the same day, Banks also foresaw that the services of an interpreter might help avoid potential conflict:

We shall soon by our connections with the inhabitants of [Tahiti] gain some knowledge of the customs of these savages, or possibly persuade one of them to come with us who will serve as an interpreter and give us an opportunity hereafter of landing wherever we please without running the risk of being obliged to commit the cruelties which…most others who have been in these seas…[were] guilty of…

By the end of their stay at Tahiti, Banks had invited on board Tupaia, a high priest from the island of Raiatea, whose knowledge of navigation and the Polynesian islands he thought might be useful. Indeed, during the ship's exploration of the Society Islands, Tupaia regularly guided Cook to the best harbours and never allowed the ship to pass over the reefs hidden in shallow water. In New Zealand, however, Tupaia's role became even more wide-ranging and important. Sharing the same language as the Maori, he assumed the role of mediator and diplomat, attempting to resolve violent encounters between them and the Europeans. Nonetheless, violence did erupt at Poverty Bay, the ship's first landfall. Banks was among the party that first went ashore to take on water. While looking for it, some Maori attacked the 'four young boys' guarding the yawl. Cook recorded how 'the Coxswain of the pinnace, who had the charge of the boats, seeing this, fired two muskets over their heads. The first made them stop and look around them, but the second they took no notice of, upon which a third was fired, and killed one of them on the spot, just as he was going to dart his spear at the boat.'

The death of this man meant that securing the friendship of the Maori at Poverty Bay became all the harder. The next day, Cook sought to land again and 'establish a communication with them', so Tupaia attempted to explain why they were coming ashore. When one of the Maori tried to steal a short sword from the astronomer, Charles Green, Cook and Banks agreed that the man should be fired at, and he was 'wounded in such a manner that he died soon after'. Both parties retreated.

Cook then decided to approach a different part of the bay and to 'surprise some of the natives and take them on board, and by good treatment and presents, endeavour to gain their friendship'. An opportunity to put this plan into action came when a canoe full of Maori paddled away at their approach.

I ordered a musket to be fired over their heads, thinking that this would either make them surrender or jump overboard but here I was mistaken, for they immediately took to their arms, or whatever they had in the boat and began to attack us. This obliged us to fire upon them, and, unfortunately, either two or three were killed, and one wounded, and three jumped overboard. These last, we took up and brought on board, where they were clothed and treated with all imaginable kindness and, to the surprise of everyone, became at once as cheerful and merry as if they had been with their own friends.

The violent encounters at Poverty Bay cast a shadow over the remainder of the voyage, but Cook penned the following in his defence:

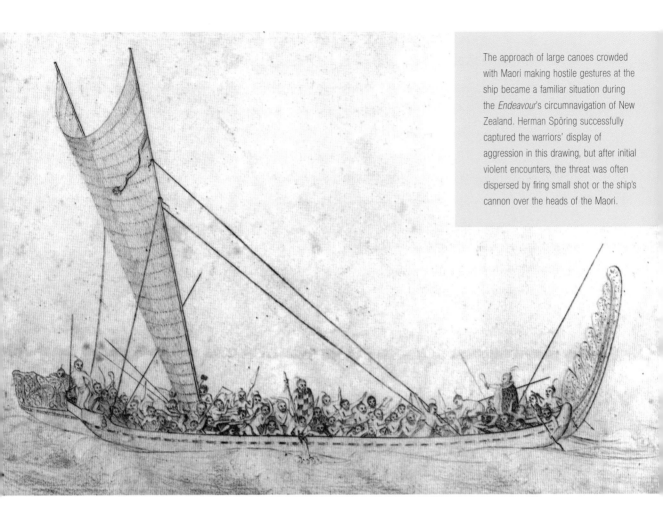

The approach of large canoes crowded with Maori making hostile gestures at the ship became a familiar situation during the *Endeavour*'s circumnavigation of New Zealand. Herman Spöring successfully captured the warriors' display of aggression in this drawing, but after initial violent encounters, the threat was often dispersed by firing small shot or the ship's cannon over the heads of the Maori.

I am aware that most humane men, who have not experienced things of this nature, will censure my conduct in firing upon the people in this boat. Nor do I myself think that the reason I had for seizing upon her will at all justify me. And, had I thought that they would have made the least resistance, I would not have come near them. But as they did, I was not to stand still and suffer either myself or those that were with me to be knocked on the head.

Of this episode Banks wrote, 'Thus ended the most disagreeable day my life has yet seen.' Despite this crisis of conscience, however, he did not abandon the hope of making contact, even if violently. A few days after the disaster of Poverty Bay (present-day Gisborne), he concluded that until 'these warlike people have severely felt our superiority in the art of war, they will never behave to us in a friendly manner'. It is hard to reconcile this statement with the advice in Lord Morton's 'Hints'.

Although Tupaia himself became involved in the violence to the extent of firing a musket at Poverty Bay, he more often acted as appeaser. At Hawke's Bay, for example, several armed canoes, each carrying as many as 150 men, approached the ship in a highly threatening manner. Tupaia talked to them from the stern of the *Endeavour* and 'they came into a better temper and answered his questions relating to the names of the

countries, kings etc very civilly. He desired them to sing and dance and they did so.' Even though there were further deaths, Tupaia's influence undoubtedly helped minimize the violence between Europeans and Maori.

When a Maori at Mercury Bay attempted to take a piece of cloth without giving something in exchange, Third Lieutenant John Gore opened fire and killed him. Cook was not present, but he was displeased to hear of the incident. The report of what happened 'did not meet with my approbation because I thought the punishment a little too severe for the crime and we had been long enough acquainted with these people to know how to chastise trifling faults like this without taking away their lives'. Cook believed that he had found a pragmatic way of managing encounters, namely, warning with the cannons and wounding with small shot rather than shooting to kill. However, given that Gore's safety had been in no way threatened by the Maori's attempted theft, his killing of the man fell far short of both the advice in Morton's 'Hints' and Cook's interpretation of it.

In New Holland Cook used small shot in self-defence to land at Botany Bay and curtail an attack by two Aborigines, who opposed the landing with stones and darts. However, a month later, at Endeavour River, Cook used different tactics when some Aborigines tried to set fire to the camp and the ship. He and Banks followed those who had run away into the woods and sought a reconciliation with them. At their head was a *walmba maalin*, or Aboriginal elder and spokesman.

> The little old man now came forward to us carrying in his hand a lance without a point. He halted several times and as he stood employed himself in collecting the moisture from under his arm pit with his finger which he every time drew through his mouth. We beckoned to him to come: he then spoke to the others who all laid their lances against a tree and leaving them came forwards likewise and soon came quite to us. They had with them it seems 3 strangers who wanted to see the ship but the man who was shot at and the boy were gone, so our troop now consisted of 11. The strangers were presented to us by name and we gave them such trinkets as we had about us; then we all proceeded towards the ship, they making signs as they came along that they would not set fire to the grass again and we distributing musket balls among them and by our signs explaining their effect.

Eric Deeral in his oral history of the Guugu-Yimithirr nation has explained that the elder 'took his sweat for protection and said, "*Nganhthaan gadaai thawun maa naa thi nu*" – We come to make friends.'

The ship, at this point, had been repaired and the crew were preparing to leave Endeavour River. Cook was under no pressure to make amends to the Aborigines, but he did so nonetheless. Perhaps, nearing the end of his discoveries, he wanted to record some success in measuring up to the standards set out in Morton's 'Hints' before sending off the ship's journals to the Admiralty in London from Batavia. Perhaps, more simply, he did not want to leave on bad terms.

# Possession and Dispossession

On the BBC voyage of 2001, the ship set sail north from Endeavour River, passed in and out of the Great Barrier Reef and anchored off Possession Island near the northernmost tip of Cape York. This is one of the most controversial sites of Cook's exploration of the east coast of Australia because it was here that he claimed the eastern seaboard for the British Crown and named it New South Wales. Although in 1770 it was unclear to Cook what use the new possession would be to Britain, the impact of this territorial claim throughout the nineteenth and twentieth centuries would be enormous. As Britain became the possessor, so the Aboriginal people were effectively dispossessed.

In 1788, only seventeen years after the *Endeavour* arrived back in England, Australia became the site for British settlement on the evidence given by Joseph Banks that Botany Bay would make a suitable site for a penal colony. From the earliest days of white settlement, atrocities were perpetrated against the Aboriginal people. They were forced off their traditional hunting and fishing grounds by farmers, gold-diggers and pearl fishermen. When they tried to repulse the settlers, the reprisals were brutal. 'Uncivilized' Aborigines were resettled by force into reserves, and stories of murder and violent displacement have been handed down through the generations. Little wonder then that Cook and the *Endeavour*, whose voyage led to white settlement of Australia, are seen by Aborigines as symbols of the destruction that followed in their wake.

Chris Terrill, the producer of the television series, saw the BBC voyage of 2001 as a chance to look afresh at the achievements of Cook and his ship. To this end he invited three Maori and three Aborigines to join the expedition and tell us how their peoples had been changed by white settlement. He had met Curtis Bristowe and Mariao Hohaia in London, where they run a Maori cultural group called Ngati Ranana; Merata Kawharu, a Maori anthropologist from the University of Auckland, had met Chris in Brisbane; Bruce Gibson, a young Aboriginal politician, was asked to come on the voyage as far as Cape York, where he is head of the Injinoo Land Trust; finally, Bob Patterson and Rico Noble from the Aboriginal community of Yarrabah and elders of the Gurugulu Gunggandji and Gurrgiya Gunggandji clans respectively would complete the group.

During a stop at Cooktown we would also meet Eric Deeral, a local elder and the first Aboriginal member of a state parliament. From him we would learn how oral history of the area has been compiled and used to further the Aboriginal cause. Perhaps surprisingly, we would also find out how the *Endeavour* journals too have contributed to this end. Both at Cooktown and on the ship many of us would learn more about land ownership in Australia, and discover how sensitive and highly disputed an issue it is today.

We hoped to begin our voyage from Mission Bay in the shelter of Cape Grafton, a region traditionally owned by the clan groups that make up the Yarrabah community. Antonia Macarthur of the Endeavour Foundation had put a request to them in writing months earlier on behalf of the BBC. However, it was also necessary to seek permission from the elders in person. At a gathering in the community centre Chris Terrill and

captain Chris Blake explained that the replica ship was intended to act as a bridge towards reconciliation between white Australians and the Aboriginal people. The television series would reflect Aboriginal attitudes to Cook as well as their understanding of the history being explored from the ship. The sensitivity of the project quickly became apparent when one of the community members objected in principle and walked out. Bob and Rico, however, conferred with the other elders and agreed to allow us to begin the BBC voyage from their community.

On a subsequent visit, Bob and Rico showed us not only where their oral history says Cook had anchored, but also where he, Banks and their landing party had come ashore. On another occasion Bob took us to a cave high in the hills where early Aboriginal paintings of the *Endeavour* and its small boats were depicted on the ceiling. All these places are considered to be sacred sites inhabited by the spirits of Aboriginal ancestors, and as we approached them, Bob asked permission of the spirits for all of us to enter. We were extremely pleased when Bob and Rico agreed to participate in the project. They would be valuable members of the crew, and volunteers and historians alike would learn a great deal from them and the others during their time on the ship.

### CHRIS'S JOURNAL – 25 August 2001

As we trekked through the mangrove swamp and rainforest, I was very excited and incredibly moved by the fact that Bob, an Aboriginal elder, was leading the way – showing us the route to the beach from where we were going to row out to the *Endeavour*. Bob has elected to join us for the part of the voyage from Cape Grafton to Cooktown. This is typical of his big-hearted attitude to history, the present and the future. He sees this not as selling out to the white man, as some of his community do, but as a way forward in the reconciliation process between white Australians and Aborigines. I believe that Bob is a very courageous man for participating.

### VANESSA'S JOURNAL – 25 August 2001

Once on the beach, there was a long wait for the pinnace and yawl. I talked to old Bob about his involvement in the project. His misgivings, along with those of the community, are outweighed by the potential boons of media exposure and the opportunity for furthering the Aboriginal cause. Although he didn't say as much, it's also possible that financial incentives will compensate for any political objections to re-enactment. This is surely a mark of the times: before land rights legislation and reconciliation it would have been a rare Aboriginal elder who saw participation in a series about invasion as an opportunity.

# Progress of the replica *Endeavour* between Cooktown and Possession Island, 1–10 September 2001

friday 7ᵗʰ September 2001
1245 Stb. bower ‡ let go off Mt. Adolphus Island.
All hands ashore for a BBQ on the beach.
Saturday 8ᵗʰ September
0700 ‡ Aweigh Sailed to Cape York.
1030 let go Stb. bower ‡ off Pajinka.
Boats ashore, Welcomed by Dancers then
BBQ at Pajinka.
Sunday 9ᵗʰ September
0910 Weighed ‡ Set Sail
1200 Pinnace and Yawl let go and Sail to Possession Island.
1510 let go ‡ Boats ashore to Possession Island. While anchoring
Broke Stock on the Port bower ‡.
Monday 10ᵗʰ September
Delayed lay day.
1535 heave away ‡

North

South

Scale: Nautical miles
60 50 40 30 20 10 0

Coral Sea

PROVIDENTIAL CHANNEL (Capt. Cook 1770)

✻2000
✻1600
✻1200
✻0800
✻0400
✻2400 (Wed. 5·9)
✻2000
✻1600 — Cook's passage

Wednesday 5ᵗʰ September
Passed back through the Reef at 2245
through Second Three Mile Passage

Tuesday 4ᵗʰ September 2001
Rescue Boat ashore, Historians walk up Mt Cook to view Reef.
1210 Anchor Away
1510 Endeavour Passes through Cook's Passage out of the Reef.

Monday 3ʳᵈ September 2001
1730 let go ‡ off Lizard Island
Boat out to look for Turtles, – no luck

Saturday 1ˢᵗ September 2001
0440 Heave Away ‡ from Cooktown.

CAPE MELVILLE

E LIZARD ISLAND ✻1600

LOOKOUT Pt.

CAPE FLATTERY ✻1200

✻0800

COOKTOWN

As the volunteers rowed their way out to the ship, we were paid an unexpected visit which would underline how the ship is seen by some as a negative symbol of oppression.

As we rowed out to the *Endeavour* in our pinnace towards almost the same anchoring point that Cook used, and whilst looking at a coastline virtually unchanged since he and his crew first saw it in 1770, the twenty-first century called us back in a sobering but fascinating way. A modern motor cruiser came out to the ship and started to circle it. From its mast flew the distinctive flag of the Aboriginal people – the boat was making a protest at the presence of the *Endeavour* in their waters, or at least, waters close to their sacred land and their settlement of Yarrabah, visible from our anchoring point. It brought it home forcibly to all of us that the same history can take on many different shapes, depending on your viewpoint.

Afterwards I spoke to Bob about the protest and he was remarkably philosophical. He admitted that he had had to search deep into his soul before agreeing to join us on the ship but realized that he and all Aborigines have to stop looking back into the past and look forward. He said that he thought if he followed in the footsteps of the first Europeans to come to this part of Australia, he might gain a fresh understanding of their motives and therefore a new insight into the mind of the white man. 'If we refuse to understand each other,' he said, 'there is no hope for the future.'

As a mark of respect, and in an attempt to foster understanding on board, Chris decided to add a new flag to those normally hoisted on the replica *Endeavour*.

I learnt a valuable lesson today. I had decided that the proper thing to do after the protest by the Aborigines the other day would be to hoist an Aboriginal flag as a courtesy flag on the ship. I managed to get hold of one yesterday when I went ashore to do the helicopter filming of the ship under sail. So this morning, after breakfast, I asked Alex Cook and Cyril O'Neil, who were on helm duty, to hoist the flag, but then along came Rico, Bruce and Bob who immediately took over. 'It's our flag, so we must hoist it,' they said gently but firmly. 'Of course,' I said, feeling like an idiot for not asking them in the first place. They hoisted the flag with a few well-chosen words about the plight of the Aboriginal people in history, but also calling for reconciliation between themselves and white people.

Afterwards, when they had gone below, Cyril and Alex were visibly moved by the event. Cyril, an American from LA, said to me, 'I don't really understand yet exactly what their grievances are, but now I really want to. The way they raised that flag was really poignant.' And Alex, himself an Australian, said, 'It is so important we have Aborigines on board so that we can learn from them.'

In the course of our voyage to Cooktown and beyond both the Maori and Aborigines on board did indeed share their views with others in the crew. We discussed land title claims, the effect of government subsidies on communities, the benefits and flaws of Aboriginal work programmes, the prejudices that still remain today, the loss of Aboriginal language and culture, and the importance of reviving Aboriginal pride in themselves and their long

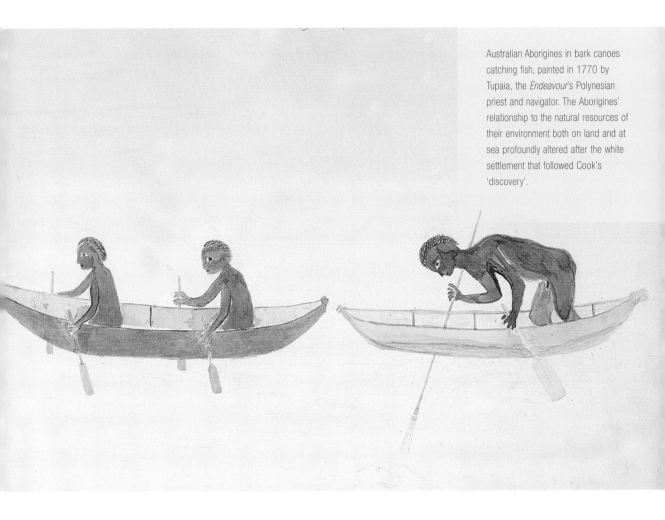

Australian Aborigines in bark canoes catching fish, painted in 1770 by Tupaia, the *Endeavour*'s Polynesian priest and navigator. The Aborigines' relationship to the natural resources of their environment both on land and at sea profoundly altered after the white settlement that followed Cook's 'discovery'.

history. However, it was stories from their own experience and family history that made the greatest impression.

### MERATA'S JOURNAL – 29 August 2001

I've learnt from one of the Americans that 'yawl' is both a boat and people (you all). Maori words including 'kai' (food), 'ka pai' (good), 'moe' (sleep), 'puku' (stomach) and others have found currency in daily speak on the ship. Micky likes moe and his new name is Micky Moe. 'Yabba', Aboriginal for 'brother', is also commonly spoken, particularly between Mariao, Curtis, Rico and Bruce. They call me sister!

In comparing Maori and Aboriginal cultures my mind travels home through the old 'waiata' or song which Curtis, Mariao and I would sing in between scrubbing and cleaning the lower deck.

I talked with Rico about customary Aboriginal social organization, which consisted of tribes and smaller clans, the total of which was a nation. The nation itself would be further divided into two moieties, which were important where marriage was concerned. Individuals would marry across moieties, not within them. Of course, this system, as Rico was taught, no longer operates following systematic wipe-outs of communities and government policies. I cannot help but be horrified by these stories; Rico and Bruce tell us of people being taken away not 150 years ago, but only two generations ago.

It is terrifying the tales that Rico and Bruce tell us about the seizure of Aboriginal children, which was often accompanied, especially in the earliest examples, by the slaughter of the parents. Rico says that one of his older relatives saw his mother axed through the head, and will never forgive the white Australians for what they have done. What a lot of demons perched on settler shoulders here.

MERATA'S JOURNAL – 29 August 2001

In New Zealand we have common issues of how to turn around community apathy and suspicion which resulted from the systematic mistreatment of indigenous peoples to good ideas and how to empower others to get involved in collective development. There are no simple answers. What a place to reflect on the questions!

Chris also learnt about the more subtle, but no less destructive, spiritual dispossession from the natural environment.

CHRIS'S JOURNAL – 29 August 2001

Eric Deeral has described the Aboriginal belief system as being based upon 'a powerful spiritual link between the land and its people. The words binga (old, grey-headed) and thawuun (friend) show that we are part of everything around us; we are joined to the earth, rocks and trees, birds and animals through another powerful concept. This is binaar (love). For all bama (our people) thawuun and binaar are the most important foundations of our well-being. They are the life force that joins us to all creation.'

Bob too told us how, in the Aboriginal myth of the Dreamtime, the actions of their ancestors were related to natural features of the land and sea. This connection between the people and their environment was in large part destroyed by white settlement.

CHRIS'S JOURNAL – 29 August 2001

I was talking to Curtis, Mariao, Bob and Bruce on the quarterdeck this evening. Bruce said something really interesting about the nature of empire-building in the late eighteenth century. He pointed out that it was not only a matter of simple possession by force, but that it was more a case of possession by knowledge.

His point was that it was the botanists with their plant presses more than the marines with their guns that led to the taking of Australia for the British Crown. By 'discovering' new flora (and fauna) in Australia, and then labelling and classifying it, Banks *et al.* were effectively laying claim to it. These plants were emotionally and spiritually the property of the indigenous people, but British botany prevailed and Anglified the very plants through scholarship – Banksias are an obvious example, although they were named much later of course.

Another example was the practice of naming places on the newly drawn maps – reefs, rivers, settlements, mountains and capes, etc. by Cook himself, i.e. Cape Bedford, Cape Tribulation, places which we have sailed past in the ship. In the Age of Enlightenment science was new and found itself marching together with exploration and discovery in the burgeoning imperial adventure. To the Aborigines looking

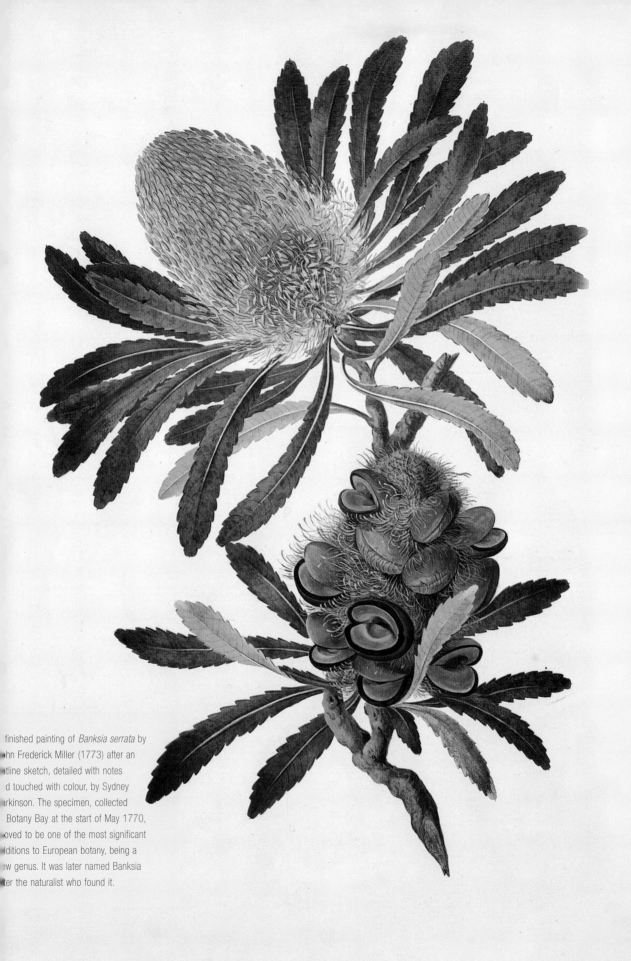

finished painting of *Banksia serrata* by
hn Frederick Miller (1773) after an
tline sketch, detailed with notes
d touched with colour, by Sydney
rkinson. The specimen, collected
Botany Bay at the start of May 1770,
oved to be one of the most significant
ditions to European botany, being a
w genus. It was later named Banksia
er the naturalist who found it.

on, the intimate relationship which they had with their own environment was effectively usurped by the white scientists. Knowledge was not only power – knowledge was possession.

The historians went ashore at Cooktown, where Cook had his most sustained contact with the Aborigines during his whole exploration of the east coast of New Holland. Today Cooktown is one of the key Cook tourist sites in Australia. However, the white settlement here did not come about because of Cook: Cooktown was so named when, in 1873 – long after the explorer had left – gold was discovered nearby.

Here Bob disembarked: he was needed back in Yarrabah to attend native title hearings. Before he left, however, he greeted his relation Eric Deeral, an elder of the Gamay Warra clan group, and introduced him to Tom and Lucy. The next day the historians also met Eric.

### IAIN'S JOURNAL – 31 August 2001

It turned out to be a wonderful day, largely thanks to the tribal elders there and family of Bob, one of our indigenous mess mates. Eric proved to be an extraordinary man with a kindly, rather gentle face, very dark, and slightly myopic in the way he peered out from behind dark glasses. He, his daughter Erica and her husband Jim – a huge man with the look of a bushman – greeted us at the landing kiosk in Cooktown. Eric reminded me somewhat of Nelson Mandela; politically he was moderate but trenchant, prepared to view the *Endeavour* as a potentially positive symbol as well as a generally negative one. Eric spoke movingly about the way that the first sight of the *Endeavour* replica in the mouth of the river had been painful and overpowering. He felt a direct frisson of empathy with his ancestors across the centuries as they had stood on a grassy knoll and seen the strange spectacle of the three-masted bark.

Eric has written: 'The Guugu-Yimithirr people are unique in that we have survived invasion and settlement of our lands with our language and culture damaged but alive.' This is reflected in – and has been helped by – the oral histories of the region that Eric has compiled.

### IAIN'S JOURNAL – 31 August 2001

He and his clan group, the Gamay Warra are part of the black cockatoo totem, and a subset of the Guugu-Yimithirr people. He had assembled an extremely painstaking set of portfolios concerned with forwarding their land rights claim to the surrounding district of Cooktown. Eric spoke gently and firmly about the oral tradition, placing the local information and topographical investigations side by side with research done on Western lines in order to provide an empirically based record of the long-term presence of this tribe and clan in the district.

In June 1992 the concept of Australia as a *terra nullius* (an empty land belonging to no one) was finally overturned in the Mabo case: the High Court recognized that the Merriam tribe were the traditional owners of Murray Island (Mer in the indigenous language). Ironically, the *Endeavour* journals, which had contributed to the picture of

a *terra nullius* in the first place, had been used in the court case as evidence of 'continuous presence': they attested to the fact that the Merriam had had an association with the land since the time when Cook was in these waters.

The ruling had a huge effect on Aboriginal land claims all over Australia, not least on the land around Cooktown. In 1997 the Guugu-Yimithirr of Hopevale were the first Aboriginal people to be given legal recognition and ownership of their lands under the new Native Title Act that followed from the Mabo case.

The shore party moved inland along the banks of the river. Here, in the place where the *Endeavour* is believed to have been beached, were monuments to Cook. At the base of a statue was inscribed the legend, 'He left nothing unattempted.' Close by, however, was a memorial to the Aboriginal people. The stories they symbolized told a very different history.

CHRIS'S JOURNAL – 31 August 2001

Cooktown provides a curious link-up with the past: my first impression was of all the usual touristy stuff regarding Cook: the 'Cook's Landing' food kiosk, 'Captain Cook Cruises', 'Cook's Emporium – for all your souvenirs and novelties', and, of course, the Captain Cook statue down by the harbour.

However, right opposite Cook's statue – imperious, heroic and slightly enigmatic – is a mosaic monument dedicated to the Aboriginal people. It tells the story from their point of view and, not surprisingly, ideas of brave discovery, startling achievements in navigation, amazing botanical achievements and the defeat of scurvy are not so much as mentioned. The multicoloured mosaic rather tells the story of a frightening arrival of 'ghost people' (white and apparition-like), 'fire sticks' (guns) and aggression. It also tells the subsequent story of dispossession, forced resettlement and genocide. It is a mosaic of tragedy – the decline of an entire people.

I was with Bob, Bruce and Rico, and also with Merata, Mariao and Curtis. Erica (the daughter of Eric Deeral, the head elder of the people around here) described the mosaic and we were all affected by what she told us. This was not just dry, descriptive history of an imperial adventure over 200 years ago – this was history that lived on and was told from the heart. She spoke very fluently and energetically at first, but as she started to describe the consequences of colonialism to her people, tears were running down her cheeks and she apologized for her emotion.

Our ship continued its journey northwards to reach Cape York, the point where Cook's ambition had driven him to take great risks. Once again inside the reef, he wrote, 'Let the consequence be what it will.' Now at the northernmost tip of Australia, Bruce and Rico left us with a final comment.

CHRIS'S JOURNAL – 8 September 2001

Bruce, along with Rico, is getting off the ship today in Pajinka. He has to return to his people – the Guarang Guarang – as one of their most energetic and far-sighted young 'elders'. He is a politician and wants to lead his people into a brighter and better future but he knows too that he still has to help break down white prejudice. He pointed out that the Endeavour Foundation uses the ship as a floating museum and claims it is a means of learning that provides a bridge to understanding between cultures. Now, he

said, he realized this was not strictly true – in fact it was a fiction. 'The *Endeavour* is a proud symbol for white Australia, but for most Aborigines it is an insulting thing – a painful reminder of our tragic history as well as our present, languishing condition as a people in modern Australia.'

The next morning we sailed on to Possession Island, where Cook staked his claim to the east coast in the name of King George III. The landfall provoked reflections on the controversial act of taking possession.

CHRIS'S JOURNAL – 9 September 2001

What a desolate place is Possession Island – deserted, rocky, dry, burnt and infested with spiders and bats. But here it was that James Cook planted the British flag, fired three token rounds of muskets as a salute and claimed the east coast of Australia for the Crown from 10°S – the latitude of Possession Island – to 38°S – the latitude of Point Hicks where New Holland was first seen by the *Endeavour*'s second lieutenant.

VANESSA'S JOURNAL – 9 September 2001

Cook's account of the possession ceremony is one of the most significant passages in the annals of Australian history. However, it is fraught with tensions and contradictions and reveals the problematic status of possession even for those who practised it. Cook's instructions, like those of the British explorers Byron and Wallis before him, explicitly stated that possession had to be accomplished with the 'consent' of the indigenous people. The Crown could not be perceived to have 'stolen' land or appropriated it through force. Cook observed that they saw 'smokes', evidence that he was aware the land was inhabited. However, neither here nor anywhere else does he record efforts made to elicit indigenous consent: there are no treaties, no purchasing of land for the proverbial handful of beads or fistful of dollars. The absence of this gesture suggests that only a consenting party could grant 'consent'. That the Aborigines ran away left Cook in 'peaceable possession'. Possession was claimed by default.

CHRIS'S JOURNAL – 9 September 2001

I noticed Alex, a young Australian historian, hanging back. He looked distressed, so I went over to him. 'What's wrong, Alex?' I said. He was fighting back the tears, so he looked out to sea to regain composure before he replied. 'I've been thinking of my country. Australia has its faults but it is an essentially good country and I am proud of it. But standing here in this place where it was effectively born as a modern nation state, I feel remorse. I know, deep down, that it was taken under false pretences from the people who were already there.'

Possession Island was our last stop in Australia. During the stretch from Cape Grafton to this island, Cook had risked the ship, his crew and the success of the entire voyage for the sake of a 'discovery' that the Admiralty had not even instructed him to make. Having followed Cook's dangerous route in and out of the reef, Vanessa and Jonathan reflected on what had motivated the man to make the claim that, as history later showed, would affect the Aboriginal people so dramatically.

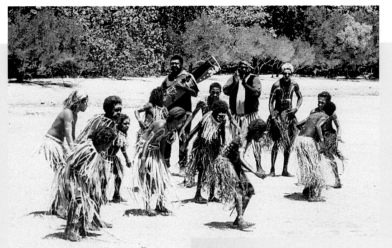

LEFT: The last landfall on the mainland of Australia during the BBC voyage was at Pajinka, the northernmost tip of Cape York in Queensland. The ship's company was welcomed ashore with a traditional Aboriginal dance. From here the ship had only a short distance to sail to Possession Island.

RIGHT: Curtis Bristowe and Mariao Hohaia greeting the Aboriginal dancers with a traditional Maori *hongi* (touching of noses and the joining of spirits symbolized by their breaths). Having been welcomed with a display of indigenous culture, Curtis and Mariao wished to reciprocate.

### VANESSA'S JOURNAL – 10 September 2001

Jonathan has been musing about Cook's statement that 'was it not for the pleasure which naturally results to a man from being the first discoverer, even was it nothing more than sands and shoals, this service would be insupportable'. What exactly is this pleasure? Is it purely personal? Or is Cook referring to the pleasure of approbation back in London? I had never considered the question of Cook writing for an audience other than the Admiralty, or thought about his individual aims. I've always regarded Cook as a long arm of the state, and his personality, his private anguishes and triumphs, as subordinate to the larger enterprise. Here, though, the journal introduces a level of subjectivity that is otherwise absent.

### JONATHAN'S JOURNAL – 10 September 2001

Did Cook risk his ship, the lives of all his men, solely for the 'pleasure' of being the one to claim, unasked, this unsought-after piece of land for the British? Leaving Endeavour River, Cook faced a dilemma: was he to sail within or without the reef? Map the unmapped coastline, or save his ship? In the process, he showed himself as a lucky and very competent seaman, as well as a brilliant hydrographer; but someone who was taking risks and could easily have come to grief. In the process, he defines his own interests as only loosely in line with those of the navy, the Royal Society, even his own crew. Those interests centre in that mysterious 'pleasure' he says is the sole consolation of the lonely navigator and 'first discoverer'.

# Navigation

When Captain Cook finally left behind the northeastern tip of New Holland, he steered the *Endeavour* to Batavia, present-day Jakarta, on the island of Java. Once again, he and his crew were in waters that had already been explored by the Dutch and the Spanish in the sixteenth and seventeenth centuries. Although their charts of the area were inaccurate, Cook had copies of them on board the *Endeavour*. Batavia itself was then a key Dutch colony and Cook planned to have the ship properly repaired and refitted there before attempting the return route to England via the Cape of Good Hope. Nearly three weeks into their passage to Batavia, an extraordinary sight was observed in the sky. Sydney Parkinson wrote about it in his journal:

*16 SEPTEMBER 1770*

In the night, between ten and eleven o'clock before the moon was up, we saw a remarkable phenomenon which appeared in the fourth quarter, extending one point west and two east and was about twenty degrees high, like a glow of red rising from fire, striped with white,

On the *Endeavour* voyage astronomy not only helped to advance knowledge of the solar system: it was also the key to accurately locating the ship's position on the face of the Earth. Measuring the sun's height above the horizon at noon provided the ship's latitude, but observations of the angle of the moon against the sun or another star could also solve the greatest challenge faced by navigators of the period: finding the ship's longitude at sea. The newly advanced techniques of astronavigation practised on board the *Endeavour* would, under Cook's methodical rule, redefine the standards and nature of exploration.

which shot up from the horizon in a perpendicular direction, alternately appearing and disappearing.

It is appropriate that the phenomenon, now known as the aurora australis, should be recorded in the *Endeavour* journals, as observations of the heavens formed a major part of Cook's voyage. Indeed, they were essential to the tasks of navigation and surveying.

Since the mid-fifteenth century, explorers had used navigational methods that relied on observations of the height of the sun or a star above the horizon. However, by 1768, when the *Endeavour* set sail, the techniques for navigating by the stars had reached new levels of sophistication. Not only were instruments more advanced, but astronomical tables had been devised and simplified, allowing longitude to be calculated at sea. The ship's two astronomers – Charles Green, a former assistant at the Royal Observatory at Greenwich, and Captain Cook himself – were the first to adopt as routine these new advances. The accuracy with which they determined the position of the ship and the lands of the Pacific would transform the nature of exploration, establishing it on a new, 'scientific' basis.

On the BBC voyage of 2001, we too sailed west from Australia, heading for Jakarta through the Arafura and Timor seas. It was early September, and until this point in our

journey the ship had been hugging the coastline. We had been constantly stopping and starting, weighing and dropping anchor as we followed Cook's tortuous route through the Great Barrier Reef. Now, as we left Cape York, we sailed into open seas, watching the land disappear behind us.

Since our longitude would be changing dramatically from day to day, the producer invited our navigating team, consisting of John Jeffrey, John Gilbert and astronomer David Floyd, to replicate the astronavigation techniques used on the *Endeavour* 231 years previously. Although they shared a broad knowledge of the stars and a wealth of experience in navigating by them, they had never used Cook's methods. Now they planned to resurrect the lunar distance method of calculating longitude and test its accuracy. From Cape York to Indonesia they would steer the ship using only this technique and see if they could match the proficiency of their eighteenth-century counterparts. Although the captain would monitor our actual position by geopositional satellite (GPS), the navigators would not have access to that information. It promised to be an interesting experiment.

## Longitude

For centuries all voyages of exploration were hazardous and imprecise because it was impossible to calculate accurately a ship's position at sea. Working out the latitude, the ship's location on the north-south axis of the globe, was relatively easy: using a backstaff (a basic instrument for measuring angles), you simply measured the height of the sun above the horizon at noon each day. Later the more sophisticated quadrant took the place of the backstaff.

Finding the longitude, the ship's position on the east-west axis, was a different matter altogether. The principle of calculating it had been understood since classical times: you simply needed to know the time at the point of departure and the time where the ship actually was at any given moment. The rotation of the Earth was known to be 360 degrees in a day, 15 degrees in an hour, so the difference between the two times could give you the difference in degrees and thus the ship's longitude. When Greenwich time began to be used and accepted as the prime meridian in the 1770s, longitude was calculated as the number of degrees from Greenwich by navigators from Britain, France and other countries. Before this time, however, even though the principle of longitude was clear enough, there was neither the method nor the technology to put it into practice.

As a result, navigators on voyages of exploration worked out their longitude by estimation: they consulted a record of the courses steered by the compass, and the speed of the ship as measured by the log-line. (The latter was a knotted rope streamed out from the stern over a half-minute period.) Adjustments were then made for the effects of winds, tides and currents. This process of estimation was known as 'dead reckoning'. The estimation of latitude could be checked by measuring the sun's altitude at midday if the skies were clear and then adjusted according to the sun's height above the horizon.

However, there was no way of verifying the estimated longitude. As a result, errors in navigation would accumulate each day over long distances, which could prove detrimental to the well-being and safety of ship and crew.

In 1707, for example, five British ships returning from Gibraltar crashed on the rocks of the Scilly Isles, believing that they were safely at the western mouth of the English Channel. Two thousand men were lost and the news shocked the British public. Although poor charts were as much to blame as misleading estimates, it was decided that an accurate method of calculating longitude should be found as a matter of urgency. Petitions were made asking Parliament to act. In 1714 a reward of £20,000 was offered – the equivalent of millions of pounds in today's terms – and a Board of Longitude was established to assess the proposals put forward.

It was to be many years and many ideas later before a solution was found. In 1735 John Harrison, a carpenter and self-taught clockmaker from Yorkshire, produced his first chronometer, a clock designed specifically to function at sea. This prototype, built to withstand the effects of temperature and motion, needed considerable refinement before it met the Board's rigorous tests. The fourth model, a large silver watch, eventually won Harrison the £20,000 prize in 1773.

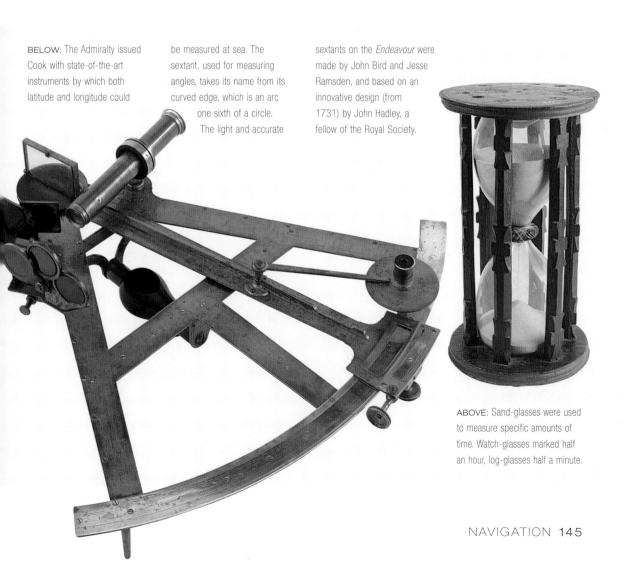

BELOW: The Admiralty issued Cook with state-of-the-art instruments by which both latitude and longitude could be measured at sea. The sextant, used for measuring angles, takes its name from its curved edge, which is an arc one sixth of a circle. The light and accurate sextants on the *Endeavour* were made by John Bird and Jesse Ramsden, and based on an innovative design (from 1731) by John Hadley, a fellow of the Royal Society.

ABOVE: Sand-glasses were used to measure specific amounts of time. Watch-glasses marked half an hour, log-glasses half a minute.

On behalf of the Royal Navy, James Cook tested this timepiece and its accuracy in calculating longitude on his second and third voyages. It passed, and the chronometer lit the way for finding longitude at sea in the future. The glory was Harrison's, but another, more complex, technique, called the lunar distance method, had in fact offered another solution to the problem years earlier.

## Lunar Distance Method

This method relied not on man-made timepieces but on what the motion of the moon and the stars could tell the navigator. The basic principle is as follows: the comparatively fast movement of the moon against the stars acts like the hand of a clock against a dial. The changing angles (or 'lunar distances') between the moon – as it made its way across the sky – and other stars is an index of the time at the place from which they are observed. If these angles, measured, for example, from Greenwich, could be predicted and tabulated into an almanac, it would be possible to observe any one of them from any part of the world, then look in the almanac to find the time they took place at Greenwich. (The ship's local time was kept by a watch set at noon at the moment when the sun was

LEFT: The chronometer, a timepiece made by John Harrison, represented a huge leap forward in navigation, as it allowed longitude to be calculated at sea other than by the lunar distance method (provided the chronometer's error is known or can be estimated). The device took Harrison, a self-taught clockmaker, over fifty years to perfect. Cook and his officers tested a copy of the device on a second voyage to the South Seas. It performed successfully, keeping good time despite the movement of the ship and variations in temperature, humidity and air pressure. For his remarkable work, Harrison was awarded the £20,000 Longitude Prize.

RIGHT: Cook's 'testimony' to the Admiralty, dated July 1775, reported on the chronometer's performance. Although the timepiece lit the way for longitude to be calculated in the future, Cook and subsequent mariners well into the nineteenth century still had to correct errors of the chronometer by the lunar distance method.

highest in the sky.) By comparing the local time of the astronomical phenomenon with the Greenwich time given by the almanac it was possible for a navigator to calculate the number of degrees in longitude he was from Greenwich.

The idea for the lunar distance method had been proposed as early as 1514 by Johann Werner, but the movement of the moon and the exact positions of the stars were not adequately known. King Charles II founded the Royal Observatory at Greenwich in 1675 with a view to shedding some light on these matters specifically to benefit navigation. At the King's request, it was John Flamsteed, the first Astronomer Royal, who applied 'himself with the utmost care and diligence to rectifying the tables of the motions of the heavens and the places of the fixed stars so as to find out the so much to be desired longitude of places for perfecting the art of navigation'. His almanac of star movements was published after his death in 1725.

This success was followed in 1731 by the invention of an instrument capable of measuring astronomical angles at sea with extraordinary accuracy. John Hadley, a fellow of the Royal Society, produced a double-reflecting quadrant, which counterbalanced the motion of the ship by allowing the navigator to look through one eye-piece and see the sun and the horizon at the same time. By eliminating the errors caused by the rocking of the ship, this new instrument immediately resulted in more correct readings of the altitude of the sun against the horizon. These in turn produced more accurate calculations of local time.

However, in finding longitude by the lunar distance method, it is not the altitude of the sun that the navigator measures, but the angles between the moon and some prominent nearby star or the sun. Hadley was confident that when the tables predicting the moon's motion became available, his instrument would help in popularizing the lunar distance method: the double-reflecting quadrant could bring together not just the sun and the horizon, but also the moon and the star against which its position was being measured.

The next task in perfecting the lunar distance method was to compile a catalogue of the moon's movements, which Tobias Mayer, a German professor of geography, did in 1755. These tables were tested at the Royal Observatory by the Astronomer Royal and proved sufficiently accurate to become the basis for a series of tests aimed at successfully calculating longitude at sea. Mayer was posthumously awarded £3000 by the Board of Longitude.

## Improving the System

All the pieces of the puzzle were now in place, but navigating by the lunar distance method remained highly complex. The task of simplifying it for ordinary seamen was undertaken by the mathematician, later Astronomer Royal, Nevil Maskelyne. Following successful experiments on a voyage to St Helena in 1761, Maskelyne published *The British Mariner's Guide*, which explained the lunar distance method in simple terms. His subsequent publication, the *Nautical Almanac* (1767), improved things even further by containing a significant part of the calculations required to find longitude. Two further

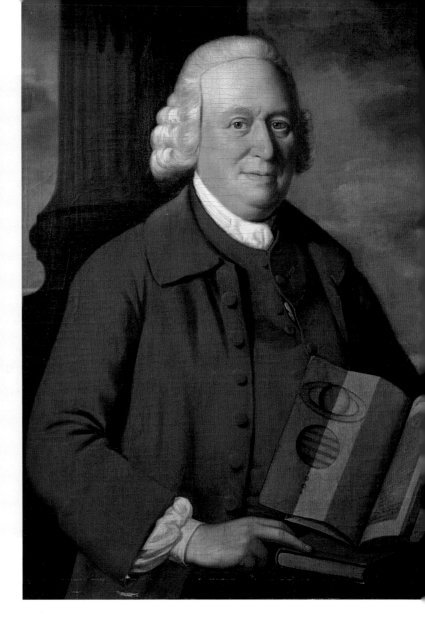

Nevil Maskelyne, Astronomer Royal from 1765 to 1811, produced tables of star and planetary movements especially for use on the *Endeavour* voyage. This information, published as the *Nautical Almanac*, simplified the lunar distance method of navigation and contributed to solving the problem of finding longitude at sea.

volumes were produced for the years 1768 and 1769, and copies of these accompanied Cook on his *Endeavour* voyage.

Four years later, Maskelyne, who served *ex officio* on the Board of Longitude, vigorously opposed awarding the prize-money to John Harrison for his chronometer. He believed that the lunar distance method was the rightful winner of the Longitude Prize. Vilified for this stance in times past and present, he and the method he championed were belittled as outmoded, but the significance of both should not be underestimated. Certainly Harrison's chronometer was to become the way longitude at sea would be calculated in the future, but the lunar distance method greatly helped voyages of exploration before and even after the chronometer came into use. Some mariners continued to believe that the stars would always be more reliable than a man-made timepiece.

In the early days of the chronometer its ability to keep accurate Greenwich time needed to be constantly checked. Ironically, this was done against longitude readings calculated by the lunar distance method. As chronometers were highly fragile

instruments, it was common practice on the first voyages for ships to travel with more than one chronometer on board. However, it was impossible to correct one against another because nobody knew which one was right. The lunar distance method therefore remained an important adjunct to the new technology.

Given the expense of chronometers, which were laboriously made by hand, few mariners could afford them, so the lunar distance method of necessity had many adherents. In fact, its use continued into the early twentieth century, but ended with the arrival of radio signals. The last *Nautical Almanac* to include lunar distances was published in 1906.

## Navigation on the Endeavour

On the course from New Holland towards Timor, the *Endeavour* was back in the known world, sailing through regions explored by previous European voyagers. Since there were few, if any, new discoveries to be made, Cook began to ponder in his journal on the expedition's achievements and to anticipate their impact in Britain. Among the topics he considered was the lunar distance method.

Cook was not the first to use Maskelyne's publication explaining the method. Captain Wallis, Cook's immediate predecessor in the Pacific and the first European explorer to visit and claim possession of Tahiti, carried with him an astronomer about whom little is known. It was he who calculated the island's longitude using Maskelyne's method. Captain Wallis admitted that he personally had no understanding of the method, and that only a few calculations had been made with it. By contrast, Cook carried out a systematic trial both on land and at sea, and was so impressed by its accuracy that he advocated it as a system of navigation that could become standard. On 23 August 1770 he wrote: 'The [lunar distance method] we have generally found may be depended upon to within half a degree, which is a degree of accuracy more than sufficient for all nautical purposes.'

This standard of accuracy had helped Cook to navigate his ship directly to Tahiti, a small island in the vast and uncharted Pacific. Although Wallis had already given him the longitude of his destination, Cook used Maskelyne's *Nautical Almanac* to navigate the straightest course. Later in the voyage, when the almanac's information for 1768 and 1769 became out of date, Cook and Green worked directly from Mayer's tables. Although the calculations took four hours rather than one, the results were equally accurate.

Also successful was the extent to which the officers on board the *Endeavour* learnt how to use the lunar distance method – something that critics had predicted would be far too difficult.

*28 AUGUST 1770*

By [Mr Green's] instructions, several of the petty officers can make and calculate these observations almost as well as himself; it is only by such means that this [lunar distance]

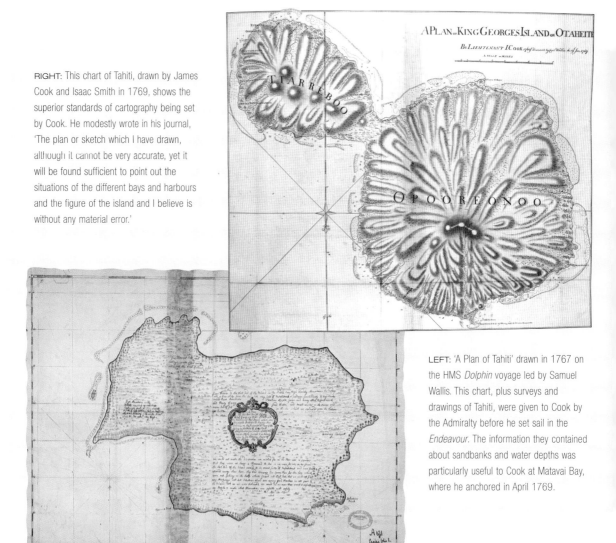

RIGHT: This chart of Tahiti, drawn by James Cook and Isaac Smith in 1769, shows the superior standards of cartography being set by Cook. He modestly wrote in his journal, 'The plan or sketch which I have drawn, although it cannot be very accurate, yet it will be found sufficient to point out the situations of the different bays and harbours and the figure of the island and I believe is without any material error.'

LEFT: 'A Plan of Tahiti' drawn in 1767 on the HMS *Dolphin* voyage led by Samuel Wallis. This chart, plus surveys and drawings of Tahiti, were given to Cook by the Admiralty before he set sail in the *Endeavour*. The information they contained about sandbanks and water depths was particularly useful to Cook at Matavai Bay, where he anchored in April 1769.

method of finding the longitude at sea can be put into universal practice… Would sea officers apply themselves to the making and calculating of these observations, they would not find them so very difficult as they at first imagine, especially with the assistance of the Nautical Almanac and the Astronomical Ephemeris, by the help of which the calculations for finding the longitude takes up but little more time than of an azimuth for finding the variation of the compass.

Green himself recorded the highs and lows of teaching the junior officers to use the lunar distance method. Off the North Cape of New Zealand he wrote:

*23 DECEMBER 1769*
After I had done observing I lent my quadrant to Mr Clerk, Mr Saunders, and Monkhouse, and they each took a set, alternately taking the altitude for each other and brought me the results…differing only from the mean of my three sets [by] 4'. This is the first attempt of the kind these hopeful youths have made and I wish they may not grow worse instead of better.

However, worse some of them did grow, as Green also noted in his journal: 'The observations of this day are pretty good, the air being very clear, but might have been more and better if proper assistance could have been had from the young gentlemen on board with pleasure to themselves; or otherwise their observations cannot be depended upon when made a fatigue instead of a pleasure.'

Despite the astronomer's criticisms, Cook deemed the officers' grasp of the lunar distance to be sound. His journal sent a clear message to the Lords of the Admiralty in London: Maskelyne's method worked to a sufficient degree of accuracy and ordinary sea officers could be taught it. Therefore this method might be employed as the principal means of navigation on all naval ships embarking on long voyages.

This news was a considerable breakthrough for future exploration. Being able to calculate longitude accurately not only made long voyages safer, but also more efficient. Ships could now avoid spending time 'lost' at sea, wasting their valuable supplies of food and water. The longer provisions lasted, the longer the crew would stay healthy. The longer the crew stayed healthy, the longer the voyages they could undertake. In this way Britain established better connections with distant trading ports and the colonies of her burgeoning commercial empire. A new era of 'scientific voyaging' was beginning.

## Surveying

Cook's success with the lunar distance method was not confined merely to navigating. It also had a huge impact on his maps, charts and surveys.

As soon as he reached Batavia in October 1770, he sent a letter with journals and charts to the Admiralty in London, describing the cartographic achievements of the voyage. 'The charts and plans I have drawn of the places we have been at were made with all the care and accuracy that time and circumstances would admit of. Thus far I am certain that the latitude and longitude of few parts of the world are better settled than these.'

In describing his chart of New Holland, Cook went into more detail: 'The latitude and longitude of all or most of the principal headlands, bays etc may be relied on for we seldom failed of getting an observation everyday to correct our latitude by, and the observations for settling the longitude were no less numerous and made as often as the sun and moon came in play.'

Cook's surveys fall into two categories: the large-scale charts of principal headlands, inlets, harbours and islands, and the small-scale surveys of coastlines such as those of New Zealand and eastern New Holland. In the former Cook and his officers would go ashore, which allowed them to use more precise surveying methods. For the latter Cook surveyed the coastline from the ship. These 'running surveys' benefited from corrections for latitude and now, with the assistance of the lunar distance method, for longitude. As a result, Cook's charts became accurate to an unprecedented degree. Those of New Zealand, for example, set new standards and remained in use for the next hundred years.

Cook's surveying methods have been fully described and explained by Andrew David, a historian of hydrography. The point to be made here is that accurate latitude and longitude allowed the surveyor to plot more precisely the positions or 'ship's stations' from which the running survey was structured. Field data gathered from these stations included compass bearings of the prominent coastal features, the angles between these features, the depth of the water and the distance between the stations. The data were then assembled into a chart depicting the geographical features of the coast on a scale previously calculated by plotting the longitude and latitude observed by Green.

All Cook's charts were calibrated to grades of longitude and latitude in degrees west from Greenwich because Maskelyne's *Nautical Almanac* calculated the lunar angles from that position. Many other navigators from different countries also began to use

LEFT: A plan of Endeavour River drawn by Richard Pickersgill, master's mate, in 1770. Pickersgill was only nineteen at the start of the voyage and had already produced charts for Wallis in the *Dolphin*. Large-scale surveys such as this complemented the small-scale charts of long stretches of coastline, and benefited from the more accurate surveying techniques afforded by being on land. Pickersgill also gathered data at sea, such as the depth of the water, by taking soundings (marked on the chart) from the ship's small boats.

RIGHT: 'A Chart of New Zealand' drawn by James Cook and Isaac Smith between October 1769 and April 1770. Cook's great cartographic achievement of the *Endeavour* voyage was to make the first chart of New Zealand. As remarkable as its accuracy is that it was achieved in just six months.

Maskelyne's almanac in the latter part of the eighteenth century, so their calculations were also calibrated to Greenwich. Map publishers all over the world therefore had no choice but to produce their charts on the same basis. However, it was not until 1884, at the International Meridian Conference in Washington, that Greenwich was officially adopted as the prime meridian for longitude and time. By then three-quarters of the world's shipping tonnage had long grown used to it.

## Getting Things Right

On the voyage between New Holland and Batavia, Cook used charts produced by European mapmakers, such as Robert de Vaugondy, who compiled the discoveries and charts of explorers who had gone before him. We know this from Cook's journal entry in which he explains why he is abandoning the idea of charting southern New Guinea before reaching Batavia. Cook, Banks and their usual landing party had gone ashore on a part of New Guinea northwest of Cape York; however, they were frightened back to ship by an attack from the indigenous people. As the *Endeavour* could not come close enough to shore to protect the men with her guns, Cook deemed landing again too dangerous. He therefore left the coastline and pressed on for Batavia.

*3 SEPTEMBER 1770*

No new discovery can be expected to be made in those seas which the Dutch have, I believe, long ago narrowly examined as appears from the three maps bound up with the French History of Voyages to the *Terra Australis*, published in 1756, which maps I do suppose by some means have been got from the Dutch as we find the names of many of the places are in that language. It should likewise seem from the same maps that the Spaniards and the Dutch have at one time or another circumnavigated the whole island of New Guinea as most of the names are in those two languages.

After New Guinea, the *Endeavour* passed the island groups of Aru, Tanimbar and Timor. De Vaugondy's charts allowed Cook to compare the published longitudes and latitudes of these islands with his own calculations, but time and again he had to correct the inaccuracies of earlier explorers and the charts that their voyages produced.

*5 SEPTEMBER 1770*

These islands have no place in the charts unless they are the Arow [Aru] Isles, which if they are, they are laid down much too far from New Guinea…

A chart of Australia produced by the French Geographer Royal, Robert de Vaugondy, in 1756. Cook used this chart, in addition to a larger scale chart by the Frenchman, as the *Endeavour* sailed west for Batavia, correcting their inaccuracies en route. The navigating team on the BBC voyage of 2001 also used both charts to guide them as they attempted to navigate the ship towards the southern tip of Timor using only eighteenth-century navigational techniques.

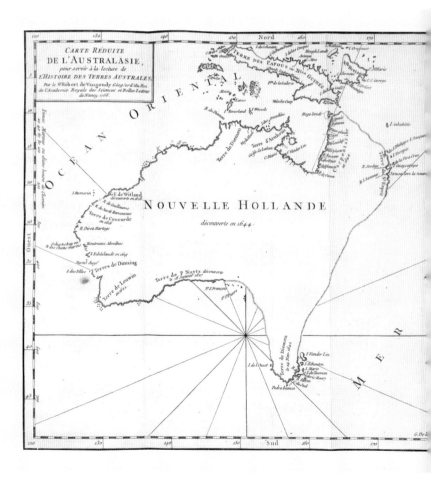

*6 SEPTEMBER 1770*

This land…ought to be part of the Arow [Aru] Isles, but it lays a degree further to the south than any of these islands are laid down in the charts…

*11 SEPTEMBER 1770*

We were now well assured that this was part of the island of Timor in consequence of which the last island we saw must have been Timorland [Tanimbar] the south part of which lies in the latitude of 8° 15' S, longitude 228° 10' west, whereas in the charts the south point is laid down in latitude 9° 30'.

Putting matters of cartography right was one of Cook's main preoccupations throughout his passage to Batavia. So many were the inaccuracies in the published charts that he was moved to a rare personal outburst. Information relating to exploration, he wrote, had been compiled through the ages in a haphazard way. Allowing for the fact that previous navigators lacked the sophisticated tools in his possession, he wrote: '…it is not they that are wholly to blame for the faultiness of the charts, but the compilers and publishers who publish to the world the rude sketches of the navigator as accurate surveys without telling what authority they have for so doing…'

However, in an attempt to be even-handed, he said that seamen too must shoulder the blame:

I have known them lay down the line of a coast they have never seen and put soundings where they have never sounded, and after all, are so fond of their performances as to pass the whole off as sterling under the title of a 'Survey, Plan, etc'. These things must in time be attended with bad consequences and cannot fail of bringing the whole of their works into disrepute.

Cook acknowledged that even were seamen to concede where their chart was defective, publishers would still not publish this information because it would adversely affect the sale of the chart. The result was inaccurate and unscientific material being published as if it were true. It was not until 1795 that an official publisher of naval charts, the Hydrographic Department, was established, thus ending the Admiralty's dependence on commercial producers of maps. In the meantime, Cook concluded, the only way to know that your chart was accurate was to go and prove it yourself.

Cook's ambition as an explorer – to set navigational and cartographic information on an authoritative, empirical footing – could hardly be expressed more clearly. In another journal entry he returned to the issue of the strait between New Holland and New Guinea:

*3 SEPTEMBER 1770*

I always understood before I had sight of these maps [by de Vaugondy] that it was unknown whether or not New Holland and New Guinea was not one continued land and so it is said in

the very History of Voyages these maps are bound up in: however we have now put this wholly out of dispute. But, as I believe it was known before, though not publicly, I claim no other merit than the clearing up of a doubtful point.

Settling 'doubtful' geographical questions not only defines Cook's aims – it also describes the nature of being an explorer in the eighteenth century. By the 1760s the world had become largely 'discovered': Europe, Asia, Africa, North America and South America were all on the map in forms that we would recognize today. Even the greater part of New Holland had been charted by the Dutch. Alexander Dalrymple, the Royal Society's first candidate to head the *Endeavour* voyage, felt that he lived in the shadow of past European explorers and that there now remained no significant discoveries to match those of Magellan and Columbus. The achievements of those great men, he said, 'precluded all competition in the honour of sublime discovery'.

Cook, on the other hand, made a virtue of exploring in the wake of others. He was conscious of setting his work apart from that of his predecessors by systematically filling in cartographic gaps and extending geographical knowledge. On the *Endeavour* voyage this took the form of producing authoritative charts of New Zealand and the east coast of New Holland. However, his work of 'clearing up doubtful points' also meant revealing what did not exist. On his first voyage Cook showed that there was, in fact, no land connecting New Guinea and New Holland. On his second voyage he completed the work of his first and proved that the Great Southern Continent did not exist. On his third and final voyage he dispelled once and for all the notion that the Northwest Passage between America and Asia could be a viable trading route. While his explorations disproved certain theories about the geography of the world, they simultaneously established many truths and did much to increase European awareness of previously unknown lands and peoples.

Cook's achievements in navigation and surveying are a way of looking at and understanding the *Endeavour* journey as a whole. The naturalists and artists on board shared the same scientific, rational and empirical approach to work that Cook did. Whether engaged in astronomy, botany, ethnography or navigation, they all sought to order or classify information. This systematic approach established the *Endeavour* voyage as one of the key explorations of the Enlightenment. As a final thought, however, the tradition of Western scientific knowledge was not the only one on board the *Endeavour*. When Tupaia joined the ship he brought with him Polynesian practices relating to navigation and geography. He came from a Raiatean family noted for its skills in navigation and these guided Cook successfully around the Society Islands. As he noted in his journal, Cook loosely understood that Polynesians navigated with the 'sun serving them for a compass by day and the moon and stars by night', but no closer understanding of the differences between European and Polynesian practices was achieved. The chart that Cook asked Tupaia to draw of the Society Islands shows the Polynesian navigator's extensive knowledge depicted within the Western framework mastered by Cook.

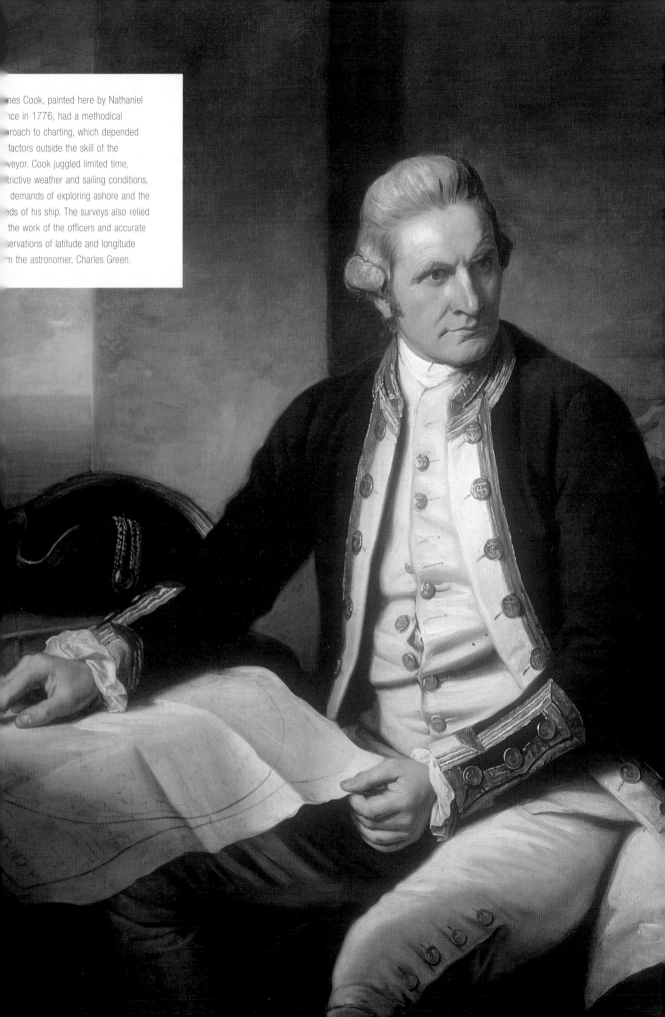

nes Cook, painted here by Nathaniel
ce in 1776, had a methodical
roach to charting, which depended
factors outside the skill of the
veyor. Cook juggled limited time,
trictive weather and sailing conditions,
demands of exploring ashore and the
ds of his ship. The surveys also relied
the work of the officers and accurate
servations of latitude and longitude
m the astronomer, Charles Green.

The map contains the following handwritten notes:

PANTAR
RAWILLA
ALOR
WETAR
KISAR
MOA
BABAR
YAMDENA

Sunday 16th
Lay day:

TIMOR

Sunday 23rd September
Lay day, voyage destination
Changed to Bali due to political
unrest in Jakarta

(Wed 26.9)  (Tues 25.9)
0000 2000 1600 0800  2000
1200  KUPANG

ROTI

1200

Monday 24th September
7.20 Came alongside at Tenau (Nr Kupang)
to clear Indonesian Customs.
18.30 let go Tenau (after Clocks back
1 hr) Sailing for Savu, with 3
Indonesians on board.

Saturday 22nd September
Captain's rounds in the
morning.
1600 Swimming in 1300 meters
of water.
'Blackbeard' Showing on
'Endeavour Screen 1.'
Quarterdeck.

'Oil rig'

Friday 21st September
0700 ships boat sent
to trade for fish -
2 Swordfish and a
Small hammerhead
Shark.

TIMOR SEA

Wednesday 19th September
0915 Man over board exercise
during which Port Stunsail
boom broken in half.

(Mon. 17.9)  (Sun 16.9)
0800 0000 1600  1600 1200 0800 0800 1600 1200

Monday 17th September
Morning tacking and wearing pra
Botany lecture from Lucy

DARWIN

# Astronavigation in 2001

During the BBC voyage of 2001, the producer of the series invited the navigating team
to sail the ship using the lunar distance method. It was agreed that John Jeffrey, John
Gilbert and David Floyd would take over the navigation of the ship from the captain
between Australia and Indonesia using only the tools, techniques and charts that had been
available to Cook. The aim of this exercise was to reassess the contribution that advances
in astronavigation had made to the *Endeavour* voyage and to those that followed. We also
hoped to acquire a better understanding of Cook's achievement and the new 'scientific'
values under which he was working.

In order to replicate Cook's testing of the lunar distance method, our team had to
take observations and make calculations using a sextant, a compass, a watch and a
telescope which were comparable in accuracy to those used by Cook. They were also
supplied with sand-glasses for measuring specific periods of time, a log-line for measuring
speed and a lead-line for measuring the depth of the water.

Last, but not least, they needed a copy of Maskelyne's *Nautical Almanac*, but this had
not been published for nearly a hundred years. The BBC therefore approached Catherine

Various handwritten journal annotations on the map:

...ay 14th September
...back 1 hour
...cation lecture on
Quarterdeck.

IRIAN JAYA

false Cape

PAPUA NEW GUINEA

Tuesday 11th September 2001
0950 Man overboard
exercise.
Night watches split into
A's and B's.

0000 (Fri 14.9)   1700   1200   0800   2400 (Thurs 13.9)   1800   1200

0800   0400 (Wed 12.9)   2000   1600   1200   0800   0400 (Tue 11.9)   2000

...day 15th September
...ns rounds in the morning
Quiz night in the (18)

Thursday 13th September
Afternoon Stunsails were
Set on the foremast.
Smoke float set off by a fish that didn't
want to be caught!

Wednesday 12th September
1110 Memorial Service on the
quarterdeck for the victims
of the American Terrorist
attack

...RA SEA

TORRES STRAIT

man over
board exercise

NORTH

PAJINKA

CORAL SEA

GREAT BARRIER REEF

60
30
0
Scale: Nautical Miles

Progress of the replica *Endeavour* between Possession
Island and Timor, 11–24 September 2001

Hohenkerk at the National Almanac Office and asked if she and her colleagues could update Maskelyne's tables for the six-week period we would be at sea in 2001. They kindly obliged and two months later the updated information was duly made available.

John Jeffrey, the most experienced of the three navigators, began preparations for the project long before he boarded the ship. In his journal he set out his goals for the trip.

### JOHN'S JOURNAL – 15 August 2001

It's been hectic. I have spent most waking hours producing a 'worksheet' for the lunar distance calculations we shall be undertaking on the *Endeavour* voyage. I have based the worksheet on an 18th-century example, but modified it to make it easier for me and my team to follow.

The basic idea behind the calculations I shall be doing is simple enough – the moon moves more quickly across the sky than the sun, stars and planets do, so the angle (or lunar distance) between it and any other astronomical body is changing all the time but in a predictable way. Measure that angle, look up the figures for the same angle in the tables of the *Nautical Almanac*, and you'll know the time in Greenwich.

As well as finding the Greenwich time when we're at sea, we also have to find the local time because it's the difference between the two that defines the longitude. We shall be estimating local time by measuring the height of the sun in the early morning or late afternoon, then doing some more calculations.

Well, that's the big picture. But if it were that easy, people would still be doing it today. As it is, three pages of calculations of spherical trigonometry and mental arithmetic are needed to turn a few sextant measurements into a longitude and a latitude. A competent mathematician, apparently, should be able to work through it in less than an hour, given a bit of practice. I know the theory but I have never actually used it. So it seems a useful idea to set out the sequence of steps on a worksheet that we can all use and which will make it easier to check for errors.

As the crew began their voyage and sailed the *Endeavour* north along the coast of Queensland, John and his team practised the observations and calculations required by the lunar distance method, even though the longitude on this course changed very little. Some of these 'dry runs' were more successful than others: they forecast the kind of difficulty the team would have when they navigated the ship in earnest from Australia to Timor.

JOHN'S JOURNAL – 29 August 2001

I always knew that it wasn't going to be easy. Sextants were designed originally to measure angles upwards, between the sun and the horizon. For longitude you have to use the sextant in a different way – you have to tilt it to measure angles diagonally between two objects in different parts of the sky. Tonight I tried to bring the image of the star of Fomalhaut into contact with the edge of the moon by looking through the eyepiece of my sextant. I eventually managed it by lying back against a shipmate's knees and holding the sextant upside down over my head. My shipmate kept her dignity, but I must have looked plain daft.

JOHN'S JOURNAL – 30 August 2001

I have found the process of calculating Greenwich time from the lunar distances measured not as bad as I had expected. It has taken me about an hour to work through all three pages of the worksheet. One problem is that there are dozens of intermediate steps, at none of which is there any clue as to whether the 'answer so far' is reasonable – rather like a maze, you have to press on all the way to the end before knowing if you've taken all the right turns.

Eventually I reached an answer just three miles different from Cook's own record of his position at the same point in the journey and felt a child-like delight at this unexpected beginner's luck.

JOHN'S JOURNAL – 31 August 2001

I have been calculating the angle or lunar distance between the moon and Mars this time, however my results are worse than before. I am not sure why, but part of the problem no doubt has come from the difficulty in measuring the heights of the moon and Mars at the same time of day. Here's the snag; we can't measure the lunar distance until Mars is visible, so we have to wait until dusk for the sky to darken. But that means the horizon is beginning to fade, so it's difficult to measure the heights of the two bodies. (We need this information to feed into the calculations.) Well, nobody said it was going to be easy. I am looking forward to the moon getting closer to the sun, so we can measure the distance between these two in daylight, and the height problem will be solved because the horizon will then be much clearer.

The trial period was over, and on 10 September we set sail for Timor. Our team of navigators duly took over the ship from the captain, Chris Blake, and agreed a plan with him. While he kept a close eye on the position of the ship using GPS readings and up-to-date charts, the navigators would rely solely on the lunar distance method, Cook's instruments and copies of the charts he had used.

JOHN'S JOURNAL – 10 September 2001

So far, we've been following the coast of Queensland more or less visually. Now that we're going to head for the first time out into the open sea, we have been handed photocopies of 17th- and 18th-century charts which Cook had with him. Probably the best are the French ones produced by de Vaugondy, French Royal Geographer in the 1770s. His charts were based on information from many sources, including the adventurous Dutch and Spanish, who were in these waters well before Cook's visit. The charts are good for their day, but poor by the standards which Cook set and absolutely hopeless by modern standards. Not only are islands and coastlines shown in the wrong place, with some islands missing altogether, but also there are no indications of depths, and no hint of the reefs which in fact litter this area.

For the sake of safety, it was agreed that only when the navigators directed the ship into danger would the captain take charge and change course accordingly.

JOHN'S JOURNAL – 10 September 2001

Cook sailed directly through some very shallow waters and was lucky not to have grounded more than once. Prudence won't let Captain Chris Blake take this *Endeavour* over the same path, so the deal we have struck is that I'll give him my best estimates of the direction to steer, but he reserves the right to ignore me. Seems fair! The anchor came up just before 4 p.m. and we set off to the SW along the channel which we saw from Possession Island yesterday. A strong current and a brisk SE wind soon sped us towards what looked like open sea. This was excellent. My plan is to turn to the NW as soon as we pass the last large island on our right and can see that there is a passage, so it's good that we'll reach the turning point in daylight. I've taken sailing boats to all sorts of places around the world, but always with better information available than I have now today; so it's an exhilarating feeling to be directing this magnificent ship into truly unknown waters.

[Later] The captain sprang the first of what could be many changes of plan. His modern charts show that there's a long sandbar in the direction I wanted to go, invisible but dangerously close to the surface. Cook went over it by the skin of his teeth; we are not going to take that kind of risk, and the furthest I have been allowed to turn is due west.

Balked already, I have decided to revise the plan. The captain has assured me we'll be clear of the sandbar by midnight, so I will estimate where we'll be by then and recalculate the course from that spot.

The navigating team soon became frustrated by the inaccurate eighteenth-century charts of the explorers who sailed before Cook through these same waters. They hoped to see the coast of New Guinea soon, just as Cook did, and thus be able to correct the contemporary maps according to their actual observations.

For the first time on this voyage I didn't sleep soundly last night. The challenge of trying to navigate with so few of the resources I'm used to is exactly why I came along on this trip, but it has undeniably been keeping me keyed up.

We should have passed Isla Santa Clara around 10 p.m. last night, and the south coast of Papua New Guinea should now be close on our starboard. In fact, our 'dead reckoning' position put us inland on the chart we're using, when in actuality there was no land in sight. I put this down to the inaccuracy of the map rather than of our estimated position.

We heaved the lead and found no bottom at 15 fathoms [30 metres], so the captain agreed to my request to turn northwards towards where I think the coast is; but on this course the wind began to bend the upper part of the masts. The captain offered me a choice: turn away from the land to sail slightly off the wind, or take down the t'gallants [small, square sails at the top of each mast], which would have involved a lot of effort. Cook would have been in no doubt – use the crew to take down the overpressed sails. I was in a different position, and agreed to a compromise course of 340°, in the direction NNW.

The navigating team's persistence in trying to find the coast brought them towards the same shallow waters that prevented Cook from surveying the coast of New Guinea.

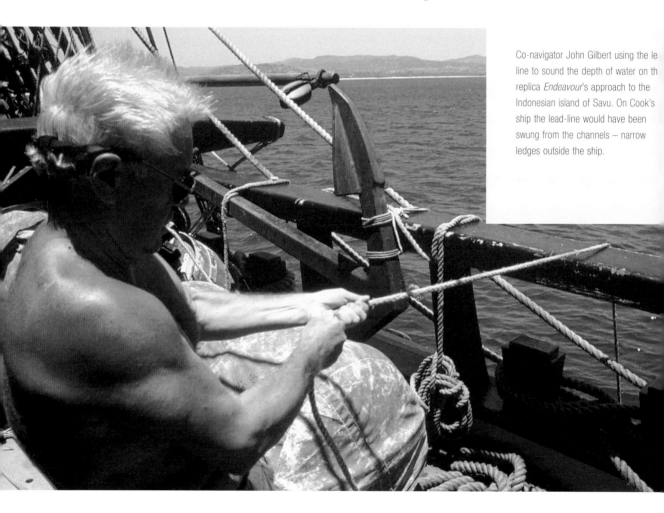

Co-navigator John Gilbert using the le line to sound the depth of water on th replica *Endeavour*'s approach to the Indonesian island of Savu. On Cook's ship the lead-line would have been swung from the channels – narrow ledges outside the ship.

Although no land was in sight, certain signs in the weather and the water suggested to the team that it was in fact close by.

JOHN'S JOURNAL – 12 September 2001

Although I can't trust the longitudes in the charts we have, I have more faith in their latitudes. By noon we are at the same latitude – given by the charts – as 'False Cape' on the southwest coast of New Guinea, and heading into the shallow bay to its east. It's obvious we are getting close to land; there was an extra swell clearly being reflected from coastline somewhere nearby; there were also cumulus clouds to the north, of the sort typically triggered by land heating up, and we began to see land birds too. To cap it all, we spotted a most unseaworthy small fishing boat which surely can't have come far. But these waters are shallow, as we saw from the change in sea colour to a lighter, brighter blue, and the captain was keen not to enter the bay with the wind behind him, so we turned away.

This was tantalizing stuff. I was anxious that in the poor visibility we wouldn't be close enough to the coast to see the land before we set course for our long passage to Timor. At last, however, just before 4 p.m., there was a hint of a smudge on the horizon to the north. I climbed the rigging to the main topsail yard to peer below the t'gallant and there, sure enough, was land. What's more, it was the right shape for the 'False Cape' of New Guinea. My relief at finding it was enormous – we are on the right track.

However, John's excitement was short-lived. He and his team had by no means cracked the lunar distance observations.

JOHN'S JOURNAL – 13 September 2001

My biggest disappointment today was that we still couldn't measure the distance between the moon and the sun. We've been looking forward to having them both in the sky together, but now that they are, the sunlight is so bright that the pale moon is almost invisible. Hadn't foreseen this problem when I was practising successfully back in UK. How on earth did Cook manage in these circumstances?

With a little guidance from the captain, the navigators succeeded in directing the ship south along the Aru group of islands, which Cook himself passed on his journey to Timor. Five days into the experiment, John and his team were now beginning to find their feet.

JOHN'S JOURNAL – 15 September 2001

Just before dawn I woke the team and together we observed the angle between the moon and Jupiter. After one disruption or another, it was 12 hours before David and I were finally able to compute the results. We agreed on a longitude which puts us about 50 miles [80 km] further west than we thought we were. This is not a bad level of accuracy: Maskelyne promised results to 'within a degree', which we've certainly beaten on this occasion. If, as I suspect, there's a west-going current in these parts, then the longitude we've just measured is probably even closer to the truth. Tonight I began to feel a bit more confident; I reflected on the fact that Cook had been practising for a couple of years by the time he had got this far in the journey.

If conditions are cloudy or if the moon is in certain positions, then observations for both latitude and longitude are not possible. As a result, eighteenth-century navigators often relied on estimating their position by dead reckoning – keeping notes of the direction sailed by the ship with a compass and its speed measured by a rudimentary instrument called a log-line. Once they were in a position to take observations again with their sextants, they were able to correct their dead reckoning position against their new readings for latitude and longitude. As our navigating team now found out, however, the estimated position can be wildly in error if the tides or currents are also affecting the ship's course.

JOHN'S JOURNAL – 17 September 2001

Today the moon was so new that it almost coincided with the sun. As a result, it was impossible to measure the angle between them with the sextant. All I had to rely on was estimation. At noon, our position by dead reckoning was 9° 49' south, 130° 50' east. This takes no account of the current which I am certain must exist. Our longitude by lunar distance from two days ago suggested that we were almost a degree further west, but (unlike Cook) we are not confident enough of the technique to make such a radical change to our estimated position.

JOHN'S JOURNAL – 19 September 2001

Even when lunar distances are impossible to observe, as they were today, I can still take measurements for latitude. At noon the latitude showed that we were well south of our dead reckoning position for the second day in succession after days of no error. This was an exciting breakthrough. The southerly trend of our course can only have been caused by a west-going ocean current, which was now being deflected by the coast of Timor. By some simple geometry and a few assumptions, I deduced that the current here was about 1 knot. I then recalculated our position since our last lunar distance measurement for longitude four days ago – we are now probably nearly 2° further west than we had thought.

This puts us encouragingly much closer to the southern tip of Timor. However, by the team's estimates we are also around 10° south of the Equator now. Tonight I told the captain that if we go much further, we'll miss our destination – the southern end of Timor. I felt relieved when he agreed to turn due west.

On course for their first destination reached by using the lunar distance method, the navigating team now came up against an unexpected hurdle – a massive drop in the winds. The ship found itself becalmed in almost exactly the same part of the sea as the original *Endeavour*.

JOHN'S JOURNAL – 20 September 2001

It is fascinating to compare our winds with those of Cook's voyage. He was here at almost exactly the same time of year, and experienced a very similar pattern of weather. In particular, fresh E/SE trades for the first few days after leaving New Guinea, then lighter and more variable. His daily progress, like ours, dropped from around 150 miles [240 km] to under 50 miles [80 km], with the west-going ocean current being vital to him – and us – helping the ship along in these near-windless conditions. The difference is

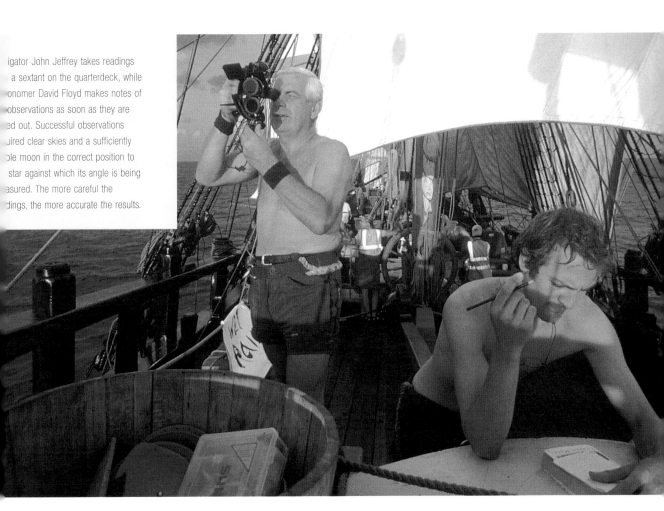

that Cook was further north, closer to the chain of island groups, and so he experienced even more variability as sea and land-breezes affected the general flow.

When Cook finally reached Timor, he sailed close into its shore and tacked along its southern coast: only this way would he know when he had reached its end and that he was thus closer to Java. To avoid the time-consuming process of tacking back and forth along the coast, the BBC navigating team gambled on a slightly different course: their plan was to sail due west in lower latitudes and aim straight for the southern tip of the island. To help them, the conditions for observing lunar distances were at last perfect.

### JOHN'S JOURNAL – 22 September 2001

Today at last we could measure the lunar distance of the moon's angle against the sun with a good clear horizon all around us. However, it was still not entirely simple because the sun and moon were so far apart. David had to take his sextant and go to the bow of the ship to find a horizon below the sun, while John was at the other end of the ship on the quarterdeck doing the same for the moon. With such a distance between my colleagues, I had to bellow 'NOW!' whenever I brought the sun and moon together into the eyepiece of the sextant from my undignified position lying flat on my back. David had to run back

to the quarterdeck to deliver his sextant reading, then off to the bow again to make ready for the next shot. What a performance it all was. But will it produce the best result yet?

JOHN'S JOURNAL – 23 September 2001

No it didn't – or apparently not. The graphs looked promising but the result showed us 1° west of the dead reckoning position. This is possible, but not likely, because we would then be in sight of Timor. I went up the mast at dawn in case sunlight illuminated any distant mountains but nothing was visible except a smudge to the north, which could be anything, including my imagination. Still, there is very little wind, so this seems like another drifty day during which the wind and current conspire to take us well south of our target.

However it was not long before the navigating team's patience paid off – with a little help from the captain. Land was finally in sight.

JOHN'S JOURNAL – 24 September 2001

Around midnight the captain, of his own accord, altered our course to the north. As the wind began to pick up, the team estimated that we would be in sight of Timor at first light. At 4 a.m. I was on deck and

John Gilbert making calculations in the wardroom, where Cook's officers would have worked on their navigational and surveying tasks, as well as their journals. With the *Nautical Almanac*, the complex calculations for longitude took approximately one hour for Charles Green to work out, but three hours more when the almanac became out of date. His modern-day counterparts were in awe of his abilities and diligence, which would have helped Cook not just in navigating the ship, but also in making accurate charts of the places they visited.

sure enough, even before sunrise, mountains appeared ahead, right on cue. We bore away and followed the remainder of the coast.

With the ship reaching Timor, the navigating team had succeeded in their first challenge. Here the ship moored and the whole crew were cleared through Indonesian customs.

JOHN'S JOURNAL – 25 September 2001

So we have reached the southern tip of Timor. It is now time for a change and I will invite John and Dave to take over the lunar distance measurements while I do some of the easier jobs. It has been fun and exhausting. We still have a way to go yet, but I am glad that we have reached our first significant destination with the lunar distance method.

## Reflections

It quickly became evident that the lunar distance method stretched the abilities of the modern navigators to the limit. Did they find their experiences with it useful and relevant? John Jeffrey summed up on behalf of the team.

JOHN'S JOURNAL – 5 October 2001

There is an impression around that mariners were completely without hope until Harrison produced his superb sea-going chronometers, and that Maskelyne was some kind of villain who tried to sabotage Harrison's efforts. But this trip has highlighted, at least for me, that the lunar distance method was a viable means of navigating in its own right and that Maskelyne showed technical brilliance in simplifying the method and making it workable. The resulting technique was adopted as routine on the *Endeavour* voyage and proved a major contribution to Cook's success.

What I've discovered on this trip is that a reasonably numerate sailor who was prepared to be highly methodical could, in the eighteenth century, use the lunar distance method to find longitude with the kind of accuracy that Maskelyne promised. This is a very satisfying discovery. By following its guidance, we too have been able to estimate our longitude, most of the time, within a degree or so of our true position; sometimes better, sometimes worse. That may not sound brilliant by modern standards, but it was a lifesaver in Cook's time.

Most of all, though, I've discovered the truth of what before I'd only believed: that James Cook was a master of navigation. His successes in navigating the *Endeavour* were not all dependent on Maskelyne's lunar distance method. Rather, he took the best of what was available to him – in men, equipment, new techniques and knowledge of the sea – and used them brilliantly. Navigators today tend to rely on only one source of information: their satellite position or GPS. However, this project has encouraged me to try and emulate Cook and use all the information available to the navigator: not just the information from the sextant observations and calculations, but also what the whole sailing environment tells you – the waves, the clouds, the birds, the colour of the water.

With all our advantages, we didn't match Cook's achievements. But we didn't do badly; and it was a privilege, and an adventure, to be given the chance to try.

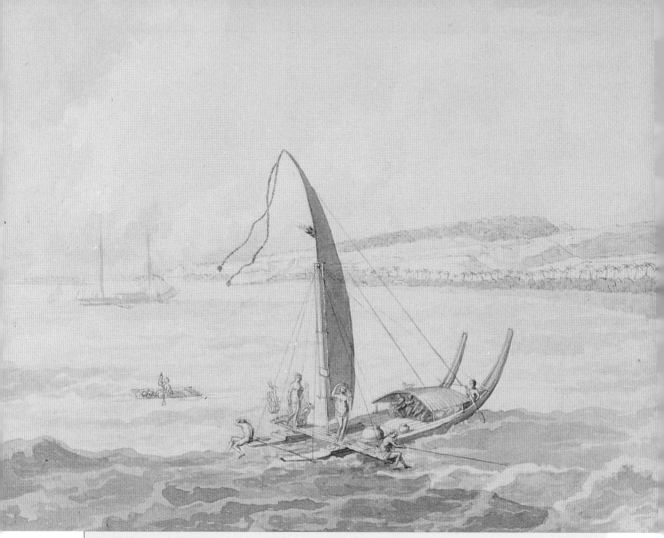

# Land and Sea

Soon after the *Endeavour* had sailed past the southwestern coast of Timor, Captain Cook was surprised by the sight of a small island not described on the charts. 'We now steered directly for it and by 10 o'clock were close in with the north side where we saw houses, coconut trees and flocks of cattle grazing. These were temptations hardly to be withstood by people in our situation, especially such as were in a very indifferent state of health and I may say mind too.'

By this time the ship's company had been at sea for over two years. Since they had left New Holland, the crew were reported in the journals as suffering from 'a disease under the name of nostalgia' and longing for both land and home. Morale had further deteriorated after Cook had refused his officers their request to land for refreshments at New Guinea and Timor. Now the attractive and unexpected island seemed to offer bountiful, unguarded provisions and made Cook 'think it a new discovery, but in this I was mistaken'.

As the ship had approached one of the harbours, Cook ordered the Union flag to be raised. In response, 'to our no small surprise, the Dutch Colours were hoisted in the

town and three guns fired'. The *Endeavour* had in fact reached Savu, a secretly guarded Dutch possession.

One can imagine Cook's disappointment on seeing the Dutch flag. No doubt he hoped that the island would offer the chance to reprovision, and perhaps be a base he could claim for the Crown, and at which other British ships in the future might take on fresh supplies.

However, islands such as Savu offered more than fresh food: they also offered the prospect of new and intense experiences. During their time on the *Endeavour* expedition, the ship's company had met with a variety of extraordinary encounters in Tahiti, the Society Islands, New Zealand and Australia, which contrasted with the routine life on board ship. Speculation and excitement about new places began long before landing. Once ashore, gentlemen, officers and even sailors and marines found occasions to be at liberty — to meet new people, find new 'wives', eat strange food and engage in alien customs.

Unlike Cook, who landed at Savu by 'mere chance, not by design', the replica *Endeavour* deliberately followed his route to this tiny Indonesian island. After two and a half weeks of shipboard confinement, we were overwhelmed by the experience of coming ashore — by the bright, pale beach, by mopeds and animals, by neat inland streets tranquil with palms, pink-flowered trees and lots of delicate light.

Since our stores of fruit and vegetables had been exhausted, we decided to get fresh supplies at the local market the day after we arrived. While Caroline, the ship's cook, bought as many greens as she could, other members of the shore party sought out the fruits, spices and palm sap that Banks had described in such detail.

The islanders welcomed us with traditional dancing and songs, and we tried an array of intoxicating local delicacies, which Cook and his landing party had tasted when they visited the island. In fact, we were amazed to find how many aspects of local life had a direct continuity with the past. What did these experiences tell us about long-distance voyaging in the eighteenth century? What was it about life on board ship that made Cook describe the sights of Savu as 'temptations' not to be resisted? For us and for Cook's crew the previous weeks spent at sea seemed to make experiences on land more intense. However, the experiences ashore were not only vivid in contrast to the wooden world. Landfalls over the three years of the *Endeavour* voyage brought the ship's company into contact with things that were new in themselves, ways of life that they had never seen before and would probably never see again.

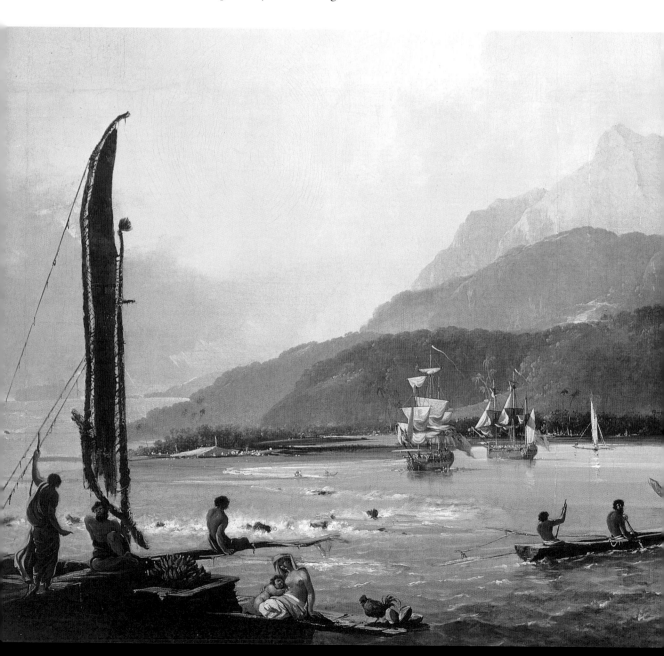

# Health and sickness

On their passage to Batavia from New Holland, Cook's crew were suffering. The demands of being at sea for two years were now showing both mentally and physically.

## Nostalgia

Banks reported that after the ship's failure to land at New Guinea, 'the sick' and 'the melancholy' were cheered by the prospect of finally leaving the Pacific behind.

> *3 SEPTEMBER 1770*
>
> The greatest part of [the ship's company] were now pretty far gone with the longing for home which the physicians have gone so far as to esteem a disease under the name of Nostalgia; indeed I can find hardly any body in the ship clear of its effects but the Captain, Dr Solander and myself; indeed we three have pretty constant employment for our minds which I believe to be the best if not the only remedy for it.

This scene of Matavai Bay, Tahiti, was painted by William Hodges *c.* 1775. On this occasion, two British naval ships – the *Resolution* and the *Adventure* – anchored in the bay among the small Tahitian fishing boats, where the *Endeavour* had dropped anchor four years earlier.

The men struggled to 'keep life and soul together': the 'melancholy ones…croakers… [and] old unbelievers' were all finding new occasions for sorrow as the ship approached Savu. Even Banks, who had scientific inquiry to occupy his mind, expressed homesickness. When he saw the coast of Timor, he recalled how his countryman William Dampier had visited it in 1699 and 1700: 'this thought made home recur to my mind stronger than it had done throughout the whole voyage'.

These were not the only recorded instances of nostalgia. A similar state of longing had affected Cook's crew during the circumnavigation of New Zealand. As the *Endeavour* headed south, the crew divided into two groups – those who thought that the coast would eventually lead to the discovery of the Great Southern Continent and those who did not. By 25 February 1770 only Banks and one poor midshipman believed that they would find the continent; the others were tired of the vain search and 'began to sigh for roast beef'.

From these rare insights into the mood of the whole crew, it is unclear whether the men yearned for land or for home. Banks certainly displayed a heightened appreciation of what land had to offer when sailing past New Guinea: '…distant as the land was, a very fragrant smell came off from it early in the morning with the little breeze which blew right off shore; it resembled much the smell of gum benjamin; as the sun gathered power it died away and was no longer smelt.' On arriving at Savu, Banks at first remained on the ship while a small party went ashore to trade for refreshments. As they returned, his imagination provided the reassurance he sought: 'we had the satisfaction of seeing several coconuts brought into the boat, a sure sign that peace and plenty reigned ashore'.

However, Banks wrote his most idealized description of Savu after spending two days ashore. Despite the briefness of his leave, he recorded a wealth of information and strong impressions:

> The appearance of the Island…was allowed by us all to equal in beauty, if not excel, any thing we had seen, even parched up as it was by a drought… The gentle sloping of the hills which were cleared quite to the top and planted in every part with thick groves of the fan Palm, besides woods almost of cocoa nut trees and arecas which grew near the sea side, filled the eye so completely that it hardly looked for or missed the verdure of the earth, a circumstance seldom seen in any perfection so near the line [Equator]. How beautiful it must appear when covered with its springing crop of maize, millet, indigo &c. which covers almost every foot of ground in the cultivated parts of the Island imagination can hardly conceive: the verdure of Europe set off by the stately pillars of India – palms I mean, especially the fan palm which for straightness and proportion both of the stem to itself and the head to the stem far excels all the palms that I have seen – requires a poetical imagination to describe and a mind not unacquainted with such sights to conceive.

The exuberance of this description rivals even Banks's glowing impressions of Tahiti. It reflects not only the actual beauty of Savu but also Banks's intense sensory experience of being on land after so long at sea.

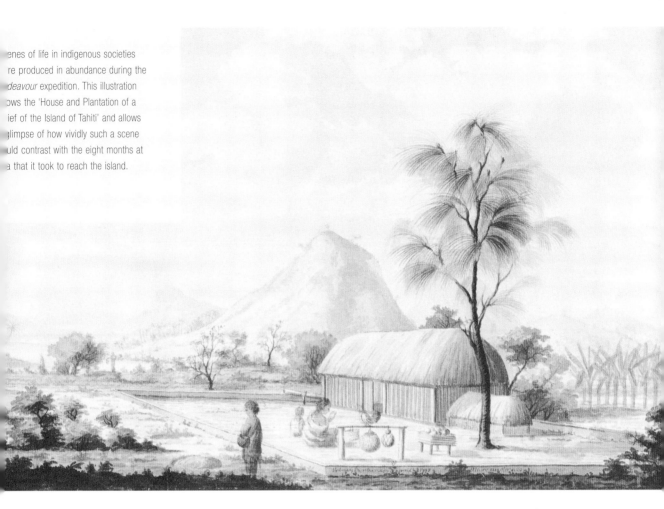

Jonathan Lamb, a historian who was one of the crew on the BBC voyage, has argued that such experiences of 'paradise' (expressed in writing) are symptomatic not just of a confined life at sea, but also of a vitamin deficiency in the shipboard diet. When Cook describes grazing cattle and coconut groves on Savu as 'temptations not to be withstood by people in our situation', he is reflecting not only the crew's state of mind, but their physical well-being too. Landfalls therefore became associated in seamen's minds with health and plenty after sickness and deprivation.

## Scurvy

While most of the *Endeavour*'s company suffered from nostalgia and homesickness, some of the crew were actually ill. There is evidence to suggest that they were suffering from the 'plague of the sea', scurvy.

Scurvy is caused by a vitamin C deficiency and remained the scourge of sailors up until the late eighteenth century. So prevalent was it that mariners considered it an occupational hazard, especially on long voyages where fresh vegetables tended to run out early on. The experience of Captain George Anson's small fleet in 1740–44 stood as the supreme warning of how scurvy could ravage a ship's company. This expedition to the

*Cardamine antiscorbutica.*

*Sydney Parkinson pinx 1769.*

Pacific began with 1955 men sailing in six ships and ended with under 700. Of these, few were fit enough to sail even one ship home. After Anson's ill-fated expedition, the success of any long voyage came to be judged, at least partially, on the health of the ship's crew.

Before reaching Batavia, the *Endeavour* voyage was a genuine success in terms of health on board. However, just because no one died from scurvy does not mean that it did not exist. Cook was so anxious to anticipate his critics on this subject that he is vague about the cases of scurvy during the voyage. In fact, throughout his journal he mentions the word scurvy only once in connection with the *Endeavour*, asserting that the dietary measures he put into practice had prevented the disease 'from getting a footing in the ship'. However, this entry was written on 13 April 1769, the day of the *Endeavour*'s arrival at Tahiti; after this date there were three official cases of scurvy, and possibly others too. In his journal Cook refers to none of these cases as instances of scurvy, even though we know from Banks, for example, that both Tupaia, the Polynesian navigator and translator, and the astronomer Charles Green were ill with the disease in New Holland.

At Savu, Banks reported on the need for refreshments for the sick three times. After the ship had found its anchorage off the island, the second lieutenant was sent ashore. 'Here he was introduced to the Raja or Indian King whom he told that we were an English man of war who had been long at sea and had many sick on board, for whom we wanted to purchase such refreshments as the island afforded.' That evening Banks himself went ashore and 'tasted their palm wine which had a very sweet taste and suited all our palates very well, giving us at the same time hopes that it might be serviceable to our sick, since, being the fresh and unfermented juice of the tree, it promised anti-scorbutic virtues'.

The reference to 'anti-scorbutic' (literally 'anti-scurvy') properties suggests that some of the sick had the dreaded disease. Cook assiduously secured as many provisions as the difficult Dutch authorities allowed the British to buy from the islanders. By the time the *Endeavour* left Savu, the ship had taken on '8 buffaloes, 30 dozen of fowls, 6 sheep, 3 hogs, some few but very few limes and coconuts, a little garlic, a good many eggs above half of which were rotten and an immense quantity of palm syrup…upon the whole more than livestock enough to carry us to Batavia'.

Tupaia was still suffering from scurvy when the ship approached Batavia because the captain sent a boat ahead 'to try to get some fruits for Tupaia who is very ill'. After the ship had anchored, Cook wrote that 'upon our arrival I had not one man upon the sick list… Mr Green and Tupaia were the only people that had any complaints occasioned by a long continuance at sea.' What could such a complaint be if not scurvy? At Batavia many of the crew contracted malaria and dysentery, and Tupaia and Green were in no fit state to withstand these shore diseases. When they subsequently died – Tupaia at Batavia, Green later at sea – Cook blamed them in his journal for not doing more to improve their debilitated state before the diseases took hold of them.

Such defensiveness reveals how Cook was anxious to protect his record on scurvy – a record on which he knew the success of the voyage would be at least partly judged. He wrote to the Admiralty from Batavia, summarizing his achievements up to that point. Among them he claimed, 'I have the satisfaction to say that I have not lost one man by sickness during the whole voyage.' Such claims have helped sustain, even to this day, a perception that Cook 'conquered' scurvy. Later in life he expressed the hope that he would be remembered not for his geographical achievements but for 'having discovered the possibility of preserving health amongst a numerous ship's company'. The truth is, however, that Cook found neither the cause nor the cure for scurvy. In fact, the conclusions that he and the ship's surgeon drew on the *Endeavour* were quite wrong and had a disastrous influence on the future prevention of scurvy on naval ships.

At the time of the *Endeavour* voyage, the Royal Navy was in an experimental mode. All ships bound for distant parts had to test various diets and medicines in the hope of finding the answer to keeping scurvy at bay. Cook was responsible for testing four possible preventives. The Victualling Board instructed him to 'make a fair trial of sauerkraut'; the Admiralty asked him to test 'wort', a form of malt; and the Sick and Hurt Board wanted him to try 'portable soup', a broth available in concentrated and tablet form, and 'robs', concentrated orange and lemon juice. All of them were to be taken as part of the seamen's diet, only the 'rob' being administered as a medicine.

Although all these measures were assiduously tried, they were used together rather than tested separately, so the results were confusing. Unsurprisingly, then, Cook drew the wrong conclusion at the end of the voyage, claiming that sauerkraut above all 'did so effectually preserve the people from a scorbutic taint'. The ship's surgeon, on the other hand, came to a different conclusion and advocated malt wort as the most effective preventive. Unfortunately, both he and Cook were wrong.

In fact the remedy for scurvy had been established over twenty years earlier, in 1747, when the naval physician James Lind had conducted controlled experiments with lemon juice aboard HMS *Salisbury* and had been advocating its beneficial effects ever since. Unfortunately, he did not hold enough influence with the Admiralty to have his voice heard, as Sir James Watt, historian of naval medicine, has shown. The dietary experiments on the high-profile *Endeavour* voyage therefore led to malt wort being promoted as the effective cure for scurvy. Lemon juice was not officially adopted on Royal Navy ships until 1794.

Cook's recommendation might have been different if he had taken note of one particular case of scurvy on the *Endeavour*. When Joseph Banks began to suffer symptoms – white spots, ulcers and swollen gums – the 'rob' of lemon juice administered by the surgeon was ineffective because, we know now, the preservation process eliminated its vitamin C content. It was only after Banks began taking lemon juice (as recommended to him by another doctor, Nathaniel Hulme, before the journey began) that his condition began to improve: 'The effect of this was surprising; in less than a week my gums became as firm as ever.'

## Diet, Rest and Hygiene

Although Cook did not solve the problem of scurvy, he did manage to keep his crew healthy in other ways. He ensured that the regular shipboard diet of porridge, salted meat, soup, cheese, hard tack biscuits and suet pudding was supplemented with fresh food whenever possible. Indeed, reprovisioning with fresh meat, fresh fish and vegetables at frequent landfalls succeeded in checking the few cases of scurvy on the approach to Tierra del Fuego, and off New Zealand and New Holland.

The ship's stop at Tolaga Bay (Uawa) in New Zealand was typical of these occasions: here Cook himself collected 'scurvy grass' and oversaw that it was 'boiled with portable soup and oatmeal every morning for the people's breakfast and this I design to continue so long as it will last or any is to be got, for I look upon it to be very wholesome and a great anti-scorbutic'. Wild celery and cranberries were also brought on board. Like scurvy grass, they are now known to contain vitamin C, although how much of it remained after boiling in large pots on the ship's stove is unclear.

Cook showed exemplary fairness in distributing fresh food, as a journal entry written in New Holland makes clear: 'Whatever refreshment we got that would bear a division I caused to be equally divided amongst the whole company generally by weight; the meanest person in the ship had an equal share with myself or anyone on board and this method every commander of a ship on such a voyage as this ought ever to observe.'

On occasion men were forced to eat the diet that Cook deemed essential for good health. Only three weeks into the voyage from England he noted that he 'punished Henry Stephens, Seaman, and Thomas Dunister, Marine, with 12 lashes each for refusing to take their allowance of fresh beef'. Later he found more subtle ways of ensuring that the specified diet was eaten.

> The sauerkraut the men at first would not eat until I put in practice a method I never once knew to fail with seamen… This was to have some of it dressed every day for the cabin table and permitted all the officers without exception to make use of it and left it to the option of the men either to take as much as they pleased or none at all. But this practice was not continued above a week before I found it necessary to put every one on board to an allowance, for such are the temper and dispositions of seamen in general that whatever you give them out of the common way…you will hear nothing but murmurings against the man that first invented it; but the moment they see their superiors set a value upon it, it becomes the finest stuff in the world and the inventor an honest fellow.

The men were also forbidden to dip their bread and hard tack biscuits in the beef and pork fat that was left over in the cooking pots. Cook, for unspecified reasons, thought the habit bad for their health. Although it was not understood at the time, the consumption of unsaturated fatty acids led to poor absorption of the nutrients in the diet.

The shipboard regime of rest and hygiene also played a part in sustaining the health of the *Endeavour* crew. For example, Cook insisted on using a three-watch system for

most of the voyage, so the men were divided into three groups and worked four hours on, eight hours off. This provided them with essential periods of uninterrupted rest. When work, such as sail-handling, required more than one watch, it would be done at hand-over time when two watches were necessarily on deck. This system avoided the need to interrupt rest periods, thereby reducing stress levels. (We also know today that maintaining low levels of stress minimizes the body's use of vitamin C, so this measure would have helped keep the men healthy.)

For similar reasons, Cook ensured that the seamen wore dry, warm clothes: thick fearnought jackets and trousers were issued in the South Atlantic 'after which I never heard one man complain of cold, not but the weather was cold enough'. The crew's linen was regularly washed in nets slung over the side of the ship, then dried by the wind in the rigging. We know this because Banks noted in his journal that 'two crabs were taken today in the clothes that hang overboard'. The decks were kept assiduously clean, the 'mates and midshipmen being commanded to scrape and clean between' them, sometimes washing them down with vinegar. Cook advocated ventilation of the decks below and, in

RIGHT: Scraping paint off the capstan. The volunteers on the BBC voyage were constantly sanding, polishing, tarring, varnishing and painting to keep the ship in good condition. Off duty, periods of uninterrupted rest were provided for by the three-watch system, as they were for the eighteenth-century seamen.

BELOW: Eighteenth-century life was recreated on the replica _Endeavour_ to the extent that the crew washed on deck with salt water hauled in canvas buckets from the sea, as Cook's sailors would have done. Here a volunteer takes a more leisurely bath during a Sunday layday.

extreme cases, fumigation by burning brimstone. All these practices helped to maintain the hygiene and health of the crew over the three long years at sea.

It must be stressed, however, that Cook was not unique in his considerate treatment of the crew. As maritime historian Randolph Cock has observed, it was in the interests of all eighteenth-century sea captains to achieve the best results possible by maintaining the health of the crew. Cook's predecessors in the Pacific, Byron and Wallis, both sought anti-scorbutic cures in their ship's diet, and fresh vegetables were regularly taken on board HMS *Dolphin* at reprovisioning stations. At a landfall in the Falkland Islands, Byron took on wood sorrel and wild celery, the 'best anti-scorbutics in the world', and Wallis's experiments with diet were passed on to Cook in a report. From him Cook also learnt about the benefits of the three-watch system, absorbing his ideas on the importance of rest and that work should be 'no more than moderate exercise'.

## Monotony and New Experiences

Decent shipboard conditions made a career at sea an acceptable, sometimes better, alternative to a living on land. Nonetheless, long voyages were still a physical and mental test of endurance. The onset of nostalgia and scurvy heightened the experiences of those who went ashore at Savu, but sickness was not the only reason why landfalls might be the source of intensified experiences; these also derived from the enclosed regime of life aboard the 'wooden world' that preceded going ashore.

### Food

Even with Cook's best efforts, the shipboard diet was monotonous and boring – something we discovered for ourselves on the BBC voyage, and that was only for six weeks. We began to understand how vivid the opportunity of trying exotic new foods must have been to the *Endeavour* crew. At Tahiti, for example, they were invited to taste dog.

> *20 JUNE 1769*
>
> In the morning [Queen Oberea] brought her canoes with everything she had…after which …we could do no less than to receive her into favour and accept the presents she had brought us, which consisted of a hog, a dog, some bread fruit and plantains. We refused to accept of the dog as being an animal we had no use for, at which she seemed surprised and told us that it was very good eating and we very soon had an opportunity to find that it was so.

Cook described in his journal how the woman chief's gift was dressed, cooked and eaten, concluding, 'it was the opinion of everyone who tasted it that they never ate sweeter meat; we therefore resolved for the future not to despise dog's flesh'. The experience was repeated nearly a year later, off the coast of southern New Zealand, when the ship's company celebrated a junior officer's birthday by roasting a dog that had been bred on board the ship and making it into a pie. At the end of the voyage Cook wrote to his

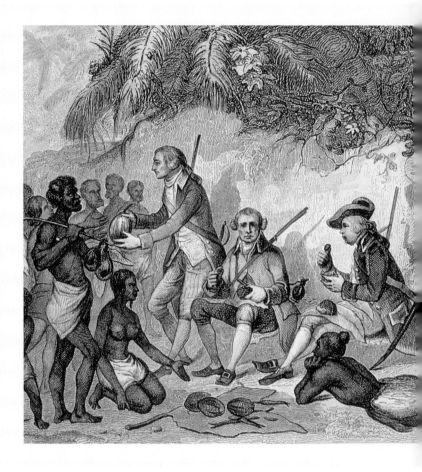

'Captain Cook Eating with Tahitians', a nineteenth-century engraving by an unknown artist. At Tahiti, New Zealand and New Holland, Banks described in great detail the means by which food was prepared, cooked and dressed, never failing to include his personal experiences, likes and dislikes. On the *Endeavour*'s departure, Cook ensured that the ship was supplied with fresh produce. Leaving New Zealand, Banks wrote about the fish that 'did not resemble any that I at least have before seen... Every mess in the ship that had prudence enough salted as much fish as lasted them many weeks after they went to sea.'

friend John Walker, saying that 'there were but few among us who did not think that a south sea dog ate as well as English lamb'.

Dog was not the only new food to make its way on to the ship. Yams and plantains purchased on the Society Island of Tahaa also added to the variety.

*28 JULY 1769*

[These were] boiled and served instead of bread – every man in the ship is fond of them and with us in the cabin they agree much better than the breadfruit did which sometimes griped us. But what makes any refreshments of this kind the more acceptable is that our bread is at present so full of vermin that notwithstanding all possible care I have sometimes had 20 in my mouth, everyone of which tasted as hot as mustard.

Perhaps the most unusual food eaten by the *Endeavour*'s company was in New Holland. There they came across kangaroos, the like of which they had never seen or tasted before. Cook reported that 'we dined of the animal shot yesterday and thought it excellent food'.

On one occasion Banks wrote that he and the ship's company 'wanted nothing to recommend any food but its not being salt, that alone was enough to make it a delicacy'.

The 'amazing abundance' of produce on Savu must have cheered them enormously:

> The productions of this island are buffaloes, sheep, hogs, fowls, horses, asses, maize, guinea corn, rice, calevanses, limes, oranges, mangoes, plantains, watermelons, tamarinds, sweet sops (*Annona squamosa*), blimbi (*Averhoa bilimbi*), besides cocoa nuts and fan palm which last is in sufficient quantities should all other crops fail to support the whole island, people, stock and all, who have been at times obliged to live upon its sugar syrup and wine for some months. We saw also a small quantity of European garden herbs as celery, marjoram, fennel and garlic and one single sugar cane. Besides these necessaries it has for the supply of luxury betel and areca, tobacco, cotton, indigo, and a little cinnamon.

Banks described the sweet sop as 'pleasant', and noted of the blimbi: 'we stewed it and made sour sauce to our stews and bouilli [boiled meat] which was very grateful to the taste'. At the ship's next landfall, in Batavia, Banks documented his opinion of no fewer than thirty-seven different varieties of East Indian fruits.

## Drink

In common with other eighteenth-century sailors, the crew of the *Endeavour* spent much of their time drunk. The reason for this was that alcohol kept better than fresh water over long voyages, especially in the tropics.

Although it was watered down, a seaman's daily ration of drink could be as much as a gallon of beer, a pint of wine or a half pint of rum. Sometimes, however, even this was not enough. Banks congratulated himself on not taking on more supplies of wine at Madeira because he believed that there was 'not a cask on board the ship that has not been tapped, to the great dissatisfaction of the owners, who in general have had the comfort to find the [men] honest enough not to have filled [them] up with salt water. In some cases however this was not a consideration of much comfort as many of the casks were 2/3s empty.' Indeed, one night off the Bay of Islands in New Zealand Cook described how the gunner Forwood was caught in this very act:

> *2 DECEMBER 1769*
> Between 12 and 4 a.m. the Gunner having the charge of the watch he together with Alexander Simpson, Richard Littleboy and [another] found means to take out of the spirit cask on the quarter deck between 10 and 12 gallons [40–45 litres] of rum being the whole that was in that cask. They were caught in the very act and part of the rum was found in the Gunner's cabin. The three men I punished with 12 lashes each, but as to the Gunner who richly deserved the whole upon his back is from his drunkenness become the only useless person on board the ship.

In fact, drunkenness was a serious problem with others on the *Endeavour*. Three of the crew died from too much alcohol, including John Reading, the boatswain's mate. His

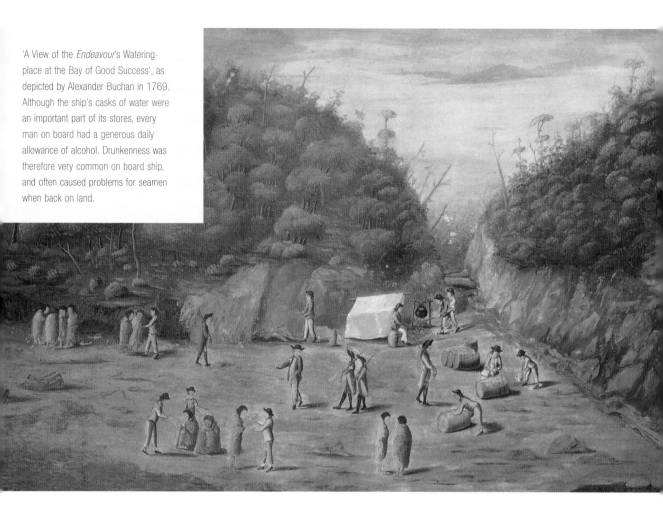

'A View of the *Endeavour*'s Watering-place at the Bay of Good Success', as depicted by Alexander Buchan in 1769. Although the ship's casks of water were an important part of its stores, every man on board had a generous daily allowance of alcohol. Drunkenness was therefore very common on board ship, and often caused problems for seamen when back on land.

death was 'occasioned by his drinking three and a half pints of rum', part of which was given to him by the boatswain. Cook noted that 'He was found very much to be in liquor last night but as this was no more than what was common with him when he could get any, no further notice was taken of him than to put him to bed where this morning about 8 o' clock he was found speechless and past recovery.'

Despite the ship's reliance on alcohol, its landfalls were often dictated by the need to refill casks with fresh water, which was essential to physical and mental well-being. Once a source had been found, the marines secured and guarded it 'with a strong party of men' supervised by an officer. Sometimes they were helped in their search, as happened at Anaura Bay in New Zealand, when the Maori drew them a map in the sand to indicate a fresh water source.

New and unfamiliar drinks were introduced to the ship at Savu. From the fan palm, Banks tried the unfermented juice, the syrup and the wine, the last of which he described as excellent. 'This is the common drink of every one upon the island and a very pleasant one. It was so to us even at first, only rather too sweet; …both rich and poor…in the morning and evening drink nothing else.' The syrup was bought from the islanders 'in immense quantity' and taken on to the ship for the whole crew on the passage to Batavia.

## Confined Spaces

While the ship was being repaired at Endeavour River in New Holland, Cook regularly gave the seamen leave to go into the country to 'shoot pigeons…gather greens' or, on Sundays, simply be at liberty to roam 'knowing that there was no danger from the natives'. Such activities were essential to counterbalance the enforced confinement of life on board ship. Here, however, even the humane hand of Captain Cook could not prevent the stresses of sea life occasionally erupting below decks in violence, abuse and suicide.

One night, during the ship's long passage to Tahiti, a marine called William Greenslade went missing and was believed drowned. Although the circumstances were unclear, they pointed to suicide. It seems Greenslade had repeatedly asked one of the captain's servants for a piece of sealskin to make into a tobacco pouch and had been repeatedly refused. He therefore stole the sealskin, but was caught by the servant, who threatened to report him to the captain. Greenslade gave him the slip and, out of shame, jumped overboard.

> …he was not missed until it was much too late even to attempt to recover him… He was a very young man scarce 21 years of age, remarkably quiet and industrious, and to make his exit the more melancholy was driven to the rash resolution by an accident so trifling that it must appear incredible to every body who is not well acquainted with the powerful effects that shame can work upon young minds.

Cook was far more outraged by a shipboard incident that happened off the coast of New Holland, near Sandy Cape, over a year later.

> Last night, some time in the middle watch, a very extraordinary affair happened to Mr Orton my clerk, he having been drinking in the evening. Some malicious person or persons in the ship took the advantage of his being drunk and cut off all the clothes from off his back, not being satisfied with this they some time after went into his cabin and cut off a part of both his ears as he lay asleep in his bed.

Suspicion fell on the midshipman James Magra (who denied responsibility) because 'he had once or twice before this in their drunken frolics cut off [Orton's] clothes and had been heard to say…that if it was not for the law he would murder him'. Although the captain suspended Magra, he never succeeded in finding out who was actually responsible. Cook nonetheless took the matter very seriously: 'I look upon such proceedings as highly dangerous in such voyages as this and the greatest insult that could be offered to my authority in this ship, as I have always been ready to hear and redress every complaint that has been made against any person in the ship.'

The affair dragged on until the ship reached Batavia, where the captain offered a reward to anyone who discovered the culprit. Soon afterwards Parkinson wrote that 'one of our midshipmen [Saunders] ran away from us here, and it was suspected that he was the person who cut off Orton's ears'.

## Discipline

All aspects of life on the *Endeavour* were regimented – a necessity to keeping the ship efficient and disciplined, as we realized on the BBC voyage of 2001. We too kept a strict watch system, scrubbed the decks, carried out maintainance, ate and slept at specific times of day. Even leisure time was circumscribed. Cook kept his men in line by flogging them for misdemeanours such as disobeying orders, insulting officers, drunkenness, theft and for committing offences and breaking the ship's rules on land. Transgression of the rules was punished by gentler means on our voyage.

The disciplined regime on the ship inevitably affected the crew's experience of freedom ashore. When the ship was preparing to leave Tahiti in search of the Great Southern Continent, two marines deserted. Cook was 'informed by some of the natives that [they] were gone to the mountains and had got each of them a wife and would not return'. Such a breach of discipline could not go unpunished. Cook sought to reassert control and get them back, but off the ship he relied on the Tahitians to help. When no one gave him 'any certain intelligence', he took hostage 'as many of the chiefs as we could', even going so far as to confine them on the ship. Eventually the missing marines came down from the hills and received double the maximum penalty – two dozen lashes each.

Flogging was a commonplace punishment in the British Navy during the eighteenth century. The offender was tied to a rigged grating and all hands were called on deck to witness his punishment. Cook was quite prepared to flog his crew, and even did so for offences such as failing to eat a ration of fresh beef, but he also used it for punishing more serious crimes, such as desertion. Joseph Banks recorded indigenous peoples' reactions to the alien practice, and described an occasion when a Maori too was flogged.

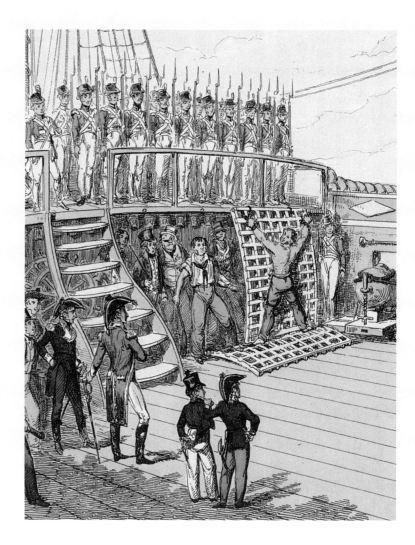

## Sex

By the time *Endeavour* reached Tahiti, the company had been at sea for nearly nine months. During that time it is unknown whether any of Cook's crew had sex with each other on the ship. However, it is more certain that they broke their abstinence on the paradise island, where they were welcomed by friendly and beautiful Tahitian women. Master's mate Francis Wilkinson recorded how they were 'very kind in all respects as usual when we were here in the *Dolphin*'.

In a peculiar form of bartering, the seamen found that they could exchange nails for sex. Captain Wallis had been the first to introduce iron to the island, and the Tahitians came to prize the metal as a valuable resource. The local women, instead of exchanging precious provisions, such as fresh meat, for the iron, found that they could supply a different demand. Consequently, a large part of the ship's stock of nails was stolen while the officers were engaged in observing the Transit of Venus. Cook reported how he had to punish 'Archibald Wolf with two dozen lashes for theft having broken into one of the storerooms and stolen from thence a large quantity of spike nails. Some few of them were found upon him.'

On 19 May it was discovered that many of the crew were suffering from yaws. Although this is not a venereal disease, the sores and swellings it produces are similar to those caused by syphilis. The news alarmed Cook not so much for his men, as for the Tahitians. He determined to find the source of the infection.

> As no such thing happened to any of the *Dolphin*'s people while she was here that I ever heard of, I had reason…to think that we had brought it along with us, which gave me no small uneasiness and did all in my power to prevent its progress… But now I have the satisfaction to find that the natives all agree that we did not bring it here. However this is little satisfaction to them who must suffer by it in a very great degree and may in time spread itself over all the islands in the South Seas, to the eternal reproach of those who first brought it among them.

Cook at first suspected the Spanish, but later found out that the French expedition led by de Bougainville had reached the island after Wallis. Whether or not they brought the disease to Tahiti was subsequently argued between the British and the French.

London society was shocked to discover that even officers and gentlemen had indulged in exchanges of a sexual nature on Tahiti. Banks, for example, although engaged to be married, openly alluded in his journal to having liaisons with Tahitian women. On one occasion, at a banquet with the Tahitians, Banks spotted 'a very pretty girl with fire in her eyes' whom he proceeded to 'load with beads and every present I could think of leaving her'. His favourite, however, was O Tahiatahia, whom he referred to as his 'flame', and there is evidence that he even fell out over her with the ship's surgeon. According to Parkinson, 'Mr Monkhouse and Mr Banks…had very high words and I expected they would have decided it by a duel which however they prudently avoided.'

When Banks returned to England, he broke off his engagement.

# The Exotic

While the intensity of some experiences ashore was a direct result of restrictions on the ship, others were overwhelming simply because they were so strange and novel. Body decoration, elaborate clothes and headdresses, intricately constructed boats and dwellings, animated dances and unfamiliar music, myriad forms of religious behaviour – all these manifestations of life confronted the *Endeavour*'s crew at different times during their voyage. Even the more mundane aspects of life, such as washing clothes, fishing and cooking, assumed a new interest when seen in exotic places.

This fascination is perhaps best expressed by the sketches of indigenous people and their everyday life as drawn by Sydney Parkinson. Tahitian costumes, Maori tattoos, Raiatean dancers and double canoes – every aspect of life was interesting. One series of Parkinson's drawings show how Tahitian women scraped bark to make cloth and then refined the material, as Banks described it, by beating it 'in the same manner as smiths'.

Cook and other journal writers of necessity interacted with the Pacific societies they encountered, but did so in different ways. Cook's journal, for example, is a record not only of his detached observations, but also of his experiences and responses to new

'Black Stains on the Skin Called Tattoo', drawn by Sydney Parkinson in New Zealand (1769). The *Endeavour*'s journal writers all described the process and designs of tattooing. In Tahiti Parkinson wrote, 'Mr Stainsby, myself and some others of our company underwent the operation and had our arms marked.' The tradition of sailors wearing tattoos followed from such contact between Europeans and Polynesians.

situations as they arose and affected him. Parkinson, on the other hand not only engaged with the Tahitian and Maori societies so that he could draw, for example, their tattoos, but also got a tattoo himself. Banks went even further. His journal reflects both his curiosity and active involvement in cultural experiences during his three years abroad. In Tahiti he dressed in indigenous clothes, stayed in people's houses and went on a tour of the island accompanied by Cook and a small party of locals. He candidly expressed his emotions of shame, shock, delight and confusion in his encounters with people. He established real connections and, for example, 'spared no pains to gain' the friendship of Tubourai, a Tahitian chief, whose sensibility and inquisitiveness he much admired.

Unfamiliar religious practices were a source of great interest to Banks and Parkinson throughout the voyage. At Raiatea, Banks 'took Mr Parkinson to the *heiva* [ceremony] that he might sketch the dresses'. The artist later recalled:

> …a large mat was laid upon the ground and they began to dance upon it putting their bodies into strange motions writhing their mouths and shaking their tails which made the numerous plaits which hung around them flutter like a peacock's train. Sometimes they stood in a row one behind the other and then they fell down with their faces to the ground leaning on their

LEFT: 'A Woman Scraping Bark to Make Cloth', drawn by Sydney Parkinson in April 1769. On Tahiti (and elsewhere in the South Seas) cloth was made from the bark of *Morus papyrifera*. After soaking it, Banks noted, the women scraped it 'with the shell called by [English merchants]…tiger's tongue, *Tellina gargadia*, dipping it continually in water until all the outer green bark is rubbed and washed away and nothing remains but the very fine fibres of the inner bark'.

RIGHT: The second part in the process of making cloth was also drawn and described by Parkinson. 'After the bark has been soaked in water for a few days, they lay it upon a flat piece of timber and beat it out as thin as they think proper with a kind of mallet of an oblong square.'

arms and shaking only their tails, the drums beating all the while with which they kept exact time. An old man stood by as a prompter and roared out as large as he could at every change. These motions they continued until they were all in a sweat.

Death, like life, held an equal fascination. While in Raiatea, Banks and Parkinson visited the most famous burial place in the Society Islands and noted how a pig and two fish were placed on a raised platform as offerings to the dead. In Tahiti, Banks observed a woman mourning outside the fort:

I went out to her and brought her in; tears stood in her eyes which the moment she entered the tent began to flow plentifully. I began to enquire the cause; she instead of answering me took from under her garment a shark's tooth and struck it into her head with great force 6 or 7 times. A profusion of blood followed these strokes and alarmed me not a little; for 2 or 3 minutes she bled freely more than a pint in quantity, during that time she talked loud in a most melancholy tone. I was not a little moved at so singular a spectacle and holding her in my arms did not cease to enquire what might be the cause of so strange an action. She took no notice of me till the bleeding ceased, nor did any Indian in the tent take any of her, all talked and laughed as if nothing melancholy was going forward; but what surprised me most of all was that as soon as the bleeding ceased she looked up smiling and immediately began to collect pieces of cloth which during her bleeding she had thrown down to catch the blood. These she carried away out of the tents and threw into the sea, carefully dispersing them abroad as if desirous that no one should be reminded of her action by the sight of them; she then went into the river and after washing her whole body returned to the tents as lively and cheerful as any one in them.

The following day Banks participated in a funeral ceremony. While the priest put on a 'most fantastical' dress, attendants prepared Banks by 'stripping off my European clothes and putting me on a small strip of cloth round my waist, the only garment I was allowed to have, but I had no pretensions to be ashamed of my nakedness for neither of the women were a bit more covered than myself. They then began to smut me and themselves with charcoal and water…as low as our shoulders.'

In the Society Islands Parkinson also drew extraordinary headdresses, one of which Banks described in detail.

[The man] put upon his head a large cylindrical basket about 4 feet [120 cm] long and 8 inches [20 cm] in diameter, on the front of which was fastened a facing of feathers bending forwards at the top and edged round with sharks teeth and the tail feathers of tropic birds: with this on he danced moving slowly and often turning his head round, sometimes swiftly throwing the end of his head-dress or *whow* so near the faces of the spectators as to make them start back, which was a joke that seldom failed of making every body laugh especially if it happened to one of us.

'Distortions of the mouth used in dancing', drawn by Sydney Parkinson in 1769. Banks described dancers at the Society Island of Raiatea: '…they dance, especially the young girls, whenever they can collect 8 or 10 together, singing most indecent words, using most indecent actions and setting their mouths askew in a most extraordinary manner, in the practice of which they are brought up from their earliest childhood; in doing this they keep time to a surprising nicety, I might almost say as true as any dancers I have seen in Europe, though their time is certainly much more simple.'

*Distortions of the Mouth used in Dancing*

Parkinson observed not only the intricacies of dress but also the strange facial contortions of the Polynesian dancers. His later sketches of Maori war dancers detail their expressions and threatening postures as they brandish paddles, spears and other weapons. The sketches convey the impact that these displays of aggression must have made on the crew. Equally vivid are the finished group drawings of the Maori war canoes.

Trade and exchange involving the ship's company were carefully controlled by Cook, but spontaneity was not entirely inhibited – sometimes the men were allowed to trade on their own behalf. In New Zealand they traded the cloth that they had acquired at Tahiti: this the Maori at Tolaga Bay (Uawa) valued 'more than anything we could give them'. Cook explained: 'I suffered everybody [on board] to purchase whatever they pleased without limitation, for by this means I knew that the natives would not only sell but get a good price for everything they brought. This I thought would induce them to bring to market whatever the country afforded and I have great reason to think that they did.'

LEFT: In July 1769 Parkinson and Banks visited the most important *marae* (burial place) on Raiatea, the island that the foremost Cook scholar J.C. Beaglehole has described as 'the centre from which the Society Islands and Tahiti were populated and the homeland to which the Maori people trace back their historic origin'. Parkinson's illustration shows a pig and two fish placed in offering on an elevated platform (*fata-rau*).

RIGHT: War headdress from the Society Island of Raiatea, drawn by Parkinson in August 1769. The wearing of this headdress was demonstrated for Banks and the shore party after they had been formally received into the home of one of the island's 'principal people' and had given gifts to the young girls of the house.

The crew bought new artefacts as well as provisions. In New Zealand the more gruesome of these were parts of human bodies which had been cannibalized. Although the seamen were horrified when they first learnt how the Maori treated their enemies, Banks later noted that the bones 'are now become a kind of article of trade among our people who constantly ask for and purchase them for whatever trifles they have'.

Experiences of the new were not exclusive to the *Endeavour*'s crew. The peoples of the Pacific found the European visitors equally strange. Tahitians, Maori and Aborigines all went on board the *Endeavour* at one time or another and witnessed the code of behaviour on that enclosed world. Sometimes that European life made its mark on land when the wooden world was reconfigured ashore. At Matavai Bay in Tahiti, for example, Cook and his men built the elaborate Fort Venus from which to observe the eclipse. At Endeavour River in New Holland, a camp and the ship itself came ashore.

Indigenous people were curious to try European foods. During the ship's three-month stay in Tahiti, for example, the chief Tubourai joined the officers and gentlemen for supper. Banks noted that he 'imitates our manners in every instance, already holding a knife more handily than a Frenchman could learn to do in years'. When Tubourai was later sick and thought he was going to die, Banks rushed to him and discovered he had

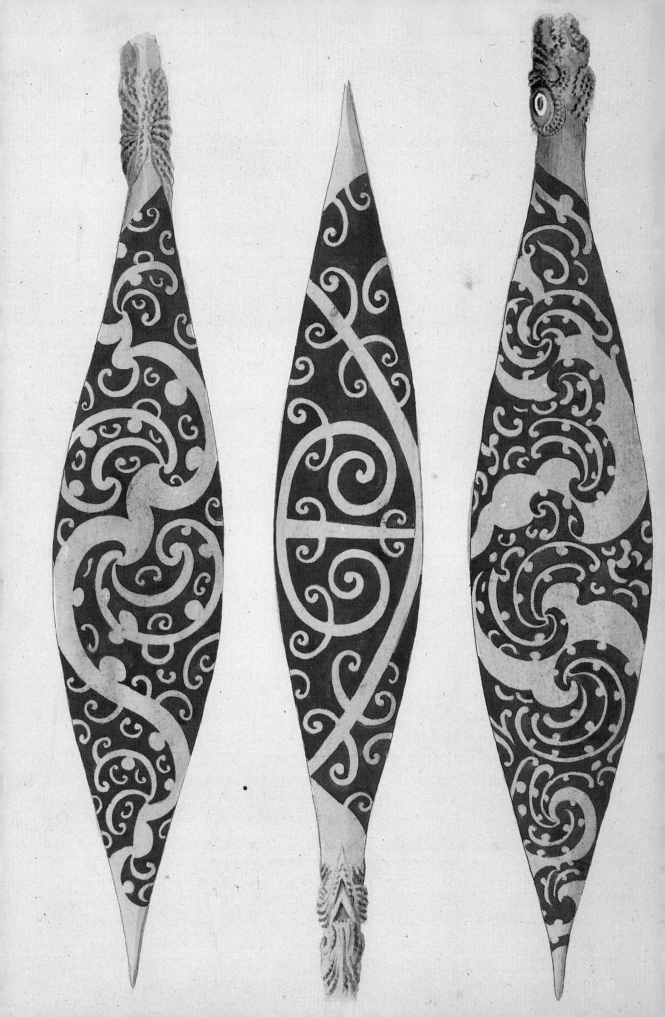

OPPOSITE: Three paddles from New Zealand, painted by Sydney Parkinson, October 1769. When the ship was becalmed near the Mahia Peninsula of North Island, six canoes approached the ship. The artist recorded that '[the Maori] paddles were curiously stained with a red colour, disposed into various strange figures; and the whole together was no contemptible workmanship'.

BELOW: Parkinson's classically composed pen and wash drawing 'New Zealand War Canoe Bidding Defiance to the Ship' shows the kind of reception that the *Endeavour* experienced off the coast of New Zealand. As Banks wrote in his journal: '...they brandish their spears, hack the air with their patoo patoos and shake their darts as if they meant every moment to begin the attack, singing all the time in a wild but not disagreeable manner and ending every strain with a loud and deep-fetched sigh in which they all join in concert.'

BELOW: Parkinson's drawings of facial contortions during Maori war dances. Once friendly contact had been established, the *Endeavour* crew found the war dances more comic than intimidating. Parkinson wrote,

'...nothing could be more droll than to see old men with grey beards assuming every antic posture imaginable, rolling their eyes about, lolling out their tongues, and in short, working themselves up to a sort of frenzy.'

eaten some tobacco given to him by one of the seamen. Banks prescribed him 'coconut milk which soon restored him to health'.

The pattern of the *Endeavour* crew experiencing new forms of drink was reversed when some of the Tahitians tasted European wine. Banks recalled how 'This day we kept the King's birthday; several of the Indians dined with us and drank his majesties health by the name of Kihiargo, for we could not teach them to pronounce a word more like King George. Tupaia however to show his loyalty got most enormously drunk.'

Banks met with less success in engaging the interest of Tubourai and his wife Tomio in a Christian service.

> During the whole service they imitated my motions, standing, sitting or kneeling as they saw me do, and so much understood that we were about something very serious that they called to the Indians without the fort to be silent; notwithstanding this, they did not when the service was over ask any questions, nor would they attend at all to any explanation we attempted to give them.

The Tahitians regarded flogging as a barbaric practice. One day, when the ship's butcher threatened Tubourai's wife, Banks reported him to the captain. 'Capt. Cook immediately ordered the offender to be punished; [Tubourai and his wife] stood quietly and saw him stripped and fastened to the rigging but as soon as the first blow was given they interfered with many tears, begging the punishment might cease, a request which the Captain would not comply with.'

In New Zealand, when a Maori was caught stealing a minute sand-glass from the quarterdeck, the punishment of flogging was extended to include indigenous people:

> The First Lieutenant took it into his head to flog [the Maori] for his crime. He was accordingly seized but when they attempted to tie him to the shrouds the Indians on board made much resistance… Just then Tupaia came up on deck, they ran to him immediately, he assured them that their friend would not be killed, he would only be whipped, on which they were well satisfied. He endured the discipline and as soon as he was let go an old man who perhaps was his father beat him very soundly and sent him down into the canoes.

Such moments allow us to glimpse the experiences of indigenous people in confronting the ship and its way of life. In this respect Banks's journal is a valuable record not just of his own responses, but also those of others. What is clear is that Tahitians, Society Islanders, Maori and Aborigines were often examining the Europeans as much as the Europeans were studying them. In fact, there is significant evidence of an indigenous person matching the continual curiosity of the Europeans. For many years a group of eight anonymous watercolours, painted in a bright, naive style, has been considered to be the work of Joseph Banks. These paintings include a depiction of a Tahitian chief mourner, Tahitian musicians, a dancing girl, Aboriginal canoes, and, perhaps most striking of all,

one of the *Endeavour*'s officers exchanging a crayfish with a Maori (see page 88). All of them reflect a cultural and anthropological interest in the subjects they describe. Collected together among Banks's papers held at the British Museum, these were believed to have been the work of that inquisitive English gentleman. As recently as 1997, however, the scholar Howard Carter found a letter written by Banks in 1812 that proved these watercolours were the work of none other than Tupaia.

It is revealing in itself that, on the basis of circumstantial evidence, these paintings were long assumed to be the work of a European. Now that Tupaia is known to have been the artist, we can see that Europeans were not the only anthropologically minded participants in the South Seas encounters. Banks often recorded that Tupaia, acting as mediator between the Europeans and the Maori, had extended his role in New Zealand to cultural enquiry. At Tolaga Bay (Uawa), for example, he is reported as discussing 'notions of religion' with a Maori priest; at other times he discussed genealogy. Now his paintings provide pictorial confirmation of his anthropological curiosity.

Tupaia, the Raiatean high priest who befriended Joseph Banks at Tahiti and subsequently joined the *Endeavour*, produced several paintings that for many years were thought to have been painted by Banks. It seems ironic that one of the observed should turn observer, using a European method of recording what he saw. As Cook historian Glyn Williams has observed, Tupaia evidently enjoyed high standing on the *Endeavour* as he was given some of the limited and irreplaceable supply of pigment normally reserved for the botanical paintings.

ABOVE: Tupaia's painting of a Tahitian dancing girl alongside a man dressed in the clothes of a chief mourner.

LEFT: Tupaia's painting records not only the sailing and war canoes of Tahiti, but also a long-house and breadfruit, banana and coconut trees.

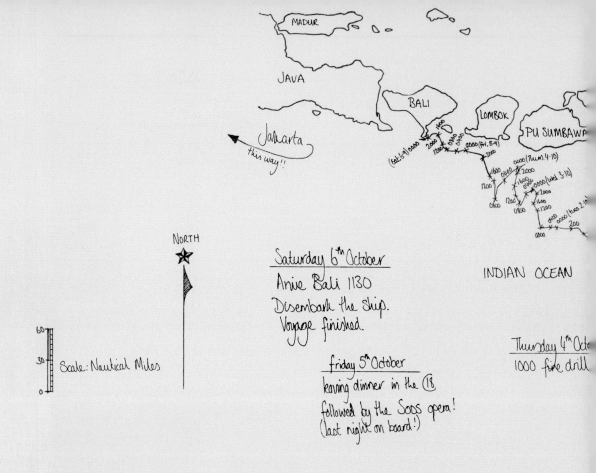

Handwritten map annotations:

MADUR

JAVA

BALI

LOMBOK

PU SUMBAWA

Jakarta this way!!

NORTH

60
30
0
Scale: Nautical Miles

INDIAN OCEAN

Saturday 6ᵗʰ October
Arrive Bali 1130
Disembark the ship.
Voyage finished.

Friday 5ᵗʰ October
Leaving dinner in the (18
followed by the Soos opera!
(last night on board!)

Thursday 4ᵗʰ Oct
1000 fire drill

Progress of the replica *Endeavour* between Timor and Bali,
25 September – 6 October 2001

## Savu

Making landfall has often been the most eagerly anticipated moment for sailors on long voyages of exploration. In that respect, our arrival at Savu in 2001 was no different. After five weeks on the ship and a long sea passage during which we had seen no land for nearly two weeks, we were keen to embrace all the island had to offer during our time ashore. Few of us had been anywhere so remote before, and everything seemed intensely novel and unfamiliar. Although our six weeks at sea cannot be compared to the three years of the *Endeavour*'s voyage, it nonetheless allowed us to get a little closer to understanding what Cook's company experienced on coming ashore.

Our time at Savu was also an opportunity for the historians and the botanists to explore the island's extraordinary continuity with the past. Of all the places at which the original *Endeavour* landed, Savu is perhaps the least Westernized. The island is still only accessible by boat, and there is little or no tourism. As a result, some aspects of life remain as Cook and Banks recorded during their short stay: we too noted grazing buffaloes, the intricate construction of the houses, the extraordinary uses of the fan palm, the traditional music, dancing and clothes, and the widespread consumption of spices such as betel.

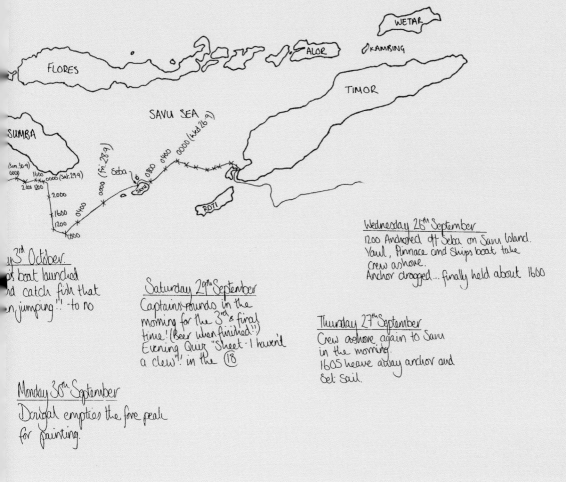

FLORES

WETAR

ALOR

KAMBING

TIMOR

SAVU SEA

SUMBA

SAVU SEA (Wed 26.9)

(Fri 28.9)

Seba

(Sun 30.9)
0000
1600
2000 1200
0000 (Sat 29.9)

2000

1600
1200
0800

0400
0000
0400
0800

SAVU

ROTI

Wednesday 26ᵗʰ September
1200 Anchored off Seba on Savu Island.
Yaul, Pinnace and Ships boat take
crew ashore.
Anchor dragged ... finally held about 1600

3rd October.
...boat launched
...d catch fish that
...n jumping!"-to no

Saturday 29ᵗʰ September
Captains rounds in the
morning for the 3rd's final
time! (Beer when finished!)
Evening Quiz "Sheet-I haven't
a clew!" in the 18

Thursday 27ᵗʰ September
Crew ashore again to Savu
in the morning.
1605 heave away anchor and
set sail.

Monday 30ᵗʰ September
Dougal empties the fore peak
for painting.

Our shore party also made friends with the many kind people who welcomed us ashore. By the time we had to return to the ship, we had chatted, exchanged names and addresses and ridden on the backs of our hosts' mopeds. Vanessa Agnew, one of the historians on board, spent some time with an English teacher called Ovidius Kana Lomi, who shared with us his knowledge of life on Savu. Some months after the visit he wrote her a letter in which he explained what the name Savu actually means.

Something which I would like to tell you is that the right word of Savu is Hawu. It means 'the island of the sand' because it was for the first time formed from the sand. It needed a long time to be an island that can be lived on like now. We may believe it or not because it was just a legend and was believed for generations, but right now because of the progress of knowledge and science this generation don't believe it.

Just as the original *Endeavour*'s voyage comes to life through its journals, so the BBC voyage is illuminated by the observations of its participants.

We had now been at sea for five weeks and our shipboard supplies were running low. The few remaining vegetables and fruit we had were turning bad. Our priority on

reaching Savu was the same as Cook's – to buy whatever fresh produce we could. On the first afternoon Caroline, the ship's cook, accompanied by Jonathan, Tom and Lucy, planned to go ashore to see what fruits, spices and vegetables available to Cook's crew might still be available today.

### JONATHAN'S JOURNAL – 26 September 2001

Now the ship is running offshore, along the northern coast of Savu. From the deck we caught sight of the same parched earth, interspersed with the plantations of tall palm and coconut trees which Banks and Cook saw. Cook's men had badly wanted to land at Timor but he wouldn't let them. This precipitated a further downswing in mood, which was not corrected until he landed here at Savu. I must say it gives me new insights into the hostility the men must have felt for Cook as he cautiously made his way hither and thither, endlessly plying off the coast of Timor. It must have come as a relief to stumble on Savu.

The plan is to anchor and go ashore with the botanists and Caroline, and to raid the fruit market for some of the 37 varieties that Banks lists as growing here and at Batavia. We're particularly interested in pineapples, mangostans, durians, karubu, blimbi and maybe betel. There is an odd split in Banks's judgements about them…he talks in a superior way about their quality, the durians smelling horribly of onions, and the pineapples tasting no better than those raised in hothouses in England. Then he says, 'bad as the character I have given of these fruits, I eat as many of them as any one and at the time thought as well and spoke as well of them as the best friends they had'. What accounts for the change? Before he ate them he was probably suffering mildly from scurvy, one of whose symptoms is an intense susceptibility to tastes and smells and sounds, as if all the senses were operating at a very high pitch. When scurvied sailors got to eat fruit, says Richard Walter of Anson's *Centurion*, 'their spirits are exhilarated by the taste itself, and the juice of fruits is swallowed, with emotions of the most voluptuous luxury'. This is why islands appear so lovely to mariners who have been too long at sea.

This longing for the shore is associated with the other notable symptom of scurvy, nostalgia, which I believe Cook's crew were suffering from on their passage to Savu, and the experience of scurvied crews arriving at paradise islands. Why, when he sights it, does Cook say, 'it was a temptation not to be resisted'? Why doesn't he just say that it was an opportunity which they were going to take? The deprivations of Cook's crew at this point in their journey were considerable although it is only hinted at in the journals. At all events, it is a temptation I shall be succumbing to as hard as I can. I'm as shore-hungry as any scurvied Jack Tar.

### VANESSA'S JOURNAL – 26 September 2001

Last night on watch, I sat with my torch and read Banks's journal. As a result, I didn't sleep much but the prospect of going ashore was so intensely exciting, I forgot my fatigue and was ready to all but swim to land.

### JONATHAN'S JOURNAL – 26 September 2001

We finally got into the pinnace and rowed ashore, landing on a white sand beach with a lot of curious folk gazing at us. Savu looks very like how it looked to Banks and Cook: arid on the hills because it is late in the dry season, and marked with plantation after plantation.

The countryside was fairly barren. There were many huts along the side of the road and people walking, often carrying water. The field boundaries, or perhaps they were landowner boundaries, were lines of trees with palm leaf stalks woven between them. Livestock consisted of pigs, buffalo, goats and sheep. The goats often had sticks around their neck to prevent them pushing through the fence. I have seen this before in the Shetland Islands. The buffalo looked like water buffalo and were quite small. Banks remarked on this also.

Shortly after their arrival, the shore party were disappointed to learn that there was very little for sale on Savu. The streets were dusty and poor and there was no money to change in the local bank. They also found out that the market did not come until the next morning.

However, Tom, Lucy and Jonathan met with an extraordinary historical coincidence. While Cook and Banks were ashore, they carried out their trade through a representative of the Dutch East India Company, a German called Johann Lange, an apparently difficult man. He was the only European on the island and acted as intermediary between the *Endeavour* and the islanders. On our visit to Savu we met with a similar person, but unlike Mr Lange, he was exceptionally hospitable and excited to welcome such rare visitors.

TOM'S JOURNAL – 26 September 2001

Quite by chance, a European (the only one I saw the whole time) stopped and asked me a question in English. He was a Catholic priest, originally from Austria, and had been living on Savu since 1967. His name was Franz and I asked him if he could show me where to get some fresh fruit for the ship. When Franz found out I was from the *Endeavour* he became very enthusiastic and insisted that he show me where the fruit grows. I jumped on the back of his moped and set off. He took on the role of Mr Lange – he acted as a go-between between the Savu people and the *Endeavour*.

JONATHAN'S JOURNAL – 26 September 2001

Franz was determined that we should see as much as possible of the island. This involved taking Tom to what he called a paradise garden, but was no more than an arack plantation – perhaps the 'paradise' referred to the narcotic qualities of the betel.

Banks paid particular interest to the betel spice and the manner in which the islanders consumed it. Now our shore party found out that it was still in use today.

TOM'S JOURNAL – 26 September 2001

Franz took me down to meet a farmer. He was an old gnarled man. His main crop was the betel nut. The trees and vines looked very healthy – the farmer had dug irrigation ditches throughout using a stick. He showed me the process of making the narcotic betel chew. Unfortunately, it stains the teeth and the lime erodes them. The farmer had lost all his teeth and had to use a pestle and mortar to grind the stuff up before putting it in his mouth. Most men I saw had stained, worn-down teeth.

While Tom was at the farm with Franz, Lucy was also invited to try some betel by a local shopkeeper. However, she was not prepared for its effects.

LUCY'S JOURNAL – 26 September 2001

I wandered up to one table and asked if some plastic bags full of dried brown stuff was betel. The shopkeeper presented me with his own open bag of betel, a piece of green vegetable and powdered lime. He demonstrated to me how to eat it: he chewed a piece of nut about the size of a 10c piece, licked the green stuff and dipped it into the powder, then put the whole lot in his mouth and chewed. So I did the same. The first sensations were burning and a lot of excess saliva, so I had to start spitting pretty soon. Then I got the giggles about the whole situation, and finally got a pleasant tingling sensation from my feet upwards – I was quite nicely out of it. Then I suddenly had the need to sit down as I felt a bit faint, so I had a drink of water and cooled off.

By the time Tom returned, Franz was insisting that the shore party come back the next day to visit the market – then there would be fruit to buy. However, he also planned for the ship's company to see a local dance of welcome.

TOM'S JOURNAL – 27 September 2001

From sunrise onwards we could see from the ship a stream of boats come towards the town. One very large ferry arrived from Timor bringing the bulk of the supplies. Apparently people come from all over Savu for this day.

VANESSA'S JOURNAL – 27 September 2001

I was filled with such pleasurable anticipation; I was primed for 'max experience'. The row ashore was fun: the ship looked splendid, everyone was in high spirits, the palm trees were beckoning and we shared a surreptitious cigarette in celebration of the moment. We ran the pinnace on to the beach, waded ashore and there was an immediate sense of overwhelming difference and sensory overload.

The sleepy town of the day before was transformed by the arrival of the market.

LUCY'S JOURNAL – 27 September 2001

The jetty was covered in people, sacks of produce, tricycles and pushcarts, bikes, roosters, dogs, goats and squealing pigs. The market was full and wherever you walked you were constantly surprised by honking motorbikes. Tom, Jonathan and Caroline seemed to have more success today – they changed some money and I saw them buying ginger, garlic, green leafy vegetables (pak choi), tomatoes, limes, snake and beans.

JONATHAN'S JOURNAL – 27 September 2001

We tried to find some fruit to liven things up, but there was hardly any to be had – certainly no mango or durians. We found some plantains and limes and some well-flavoured small tomatoes, and ate them while reciting from Banks, who clearly ate copiously and with relish all the fruits which he was later rather

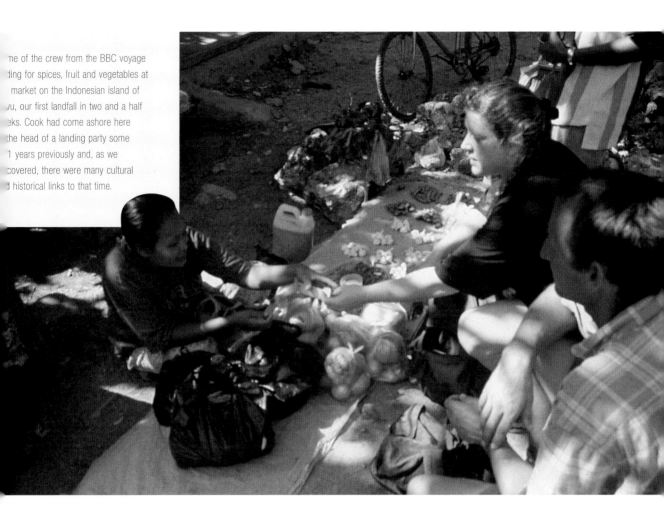

ne of the crew from the BBC voyage
...ing for spices, fruit and vegetables at
...market on the Indonesian island of
...u, our first landfall in two and a half
...ks. Cook had come ashore here
...the head of a landing party some
...1 years previously and, as we
...covered, there were many cultural
...d historical links to that time.

critical of, such as durian, pineapple and mango. It is clear that Banks had an experience of paradise on Savu. He says it would require 'a poetical imagination to describe and a mind not unacquainted with such sights to conceive' how the plantations of this land fill the eye.

### VANESSA'S JOURNAL – 27 September 2001

I managed to find indigo, ginger, cinnamon, tobacco, chillies, bananas, ceris, betel and gula lempeng, or palm sugar. Of the more exotic spices and tropical fruits, I saw none, but I was interrupted in my expedition by entreaties to go and see some local dancing. I wasn't very enthusiastic; the market, sparse as it was, was interesting. But a beat-up old truck stopped and I was hauled aboard by others from the *Endeavour*.

### JONATHAN'S JOURNAL – 27 September 2001

Franz had organized a bus, or rather a truck, to take us all to the dancing. We drove for about 2 miles [3 km] through rice paddies and plantations of palms. Just like Banks said, every bit of ground was utilized for production and the effect was very picturesque as one boundary blurred into another. People in the bus were already making ecstatic noises, I think because they had never seen peasant agriculture on this scale. Either side of the road were the buffaloes and sheep Cook had bargained for, and thatched houses on stilts, just like the ones he and Banks found so cool.

LUCY'S JOURNAL – 27 September 2001

LUCY'S JOURNAL – 27 September 2001

Soon we arrived at a large thatched building in a clearing, surrounded by shady trees and palms. Beautiful handcrafted ikat sarongs hung from lines strung up around the perimeter. Everyone tumbled out of the truck, quite blown away. The schoolboys who were trying out their English on us in the truck got out too.

JONATHAN'S JOURNAL – 27 September 2001

When we got to the compound, our ecstasy increased at the sight of beautiful women dressed in ikat sarongs down to the ankles, and powerful young men wearing crowns and elaborate peacock tails made of palm, while older men sat playing drums and bells.

In the short time he spent ashore on Savu, Banks had noted the extraordinary variety of uses which the islanders put the fan palm tree. In all our explorations we had not yet witnessed any of these uses. Now we were about to.

TOM'S JOURNAL – 27 September 2001

One thing Banks was really enthusiastic about was the fan palm and its multitude of uses. Its sap is harvested and can be drunk immediately as a refreshing drink. The sap can be made into wine or distilled

RIGHT: The artist Lucy Smith drawing the traditional dancers and musicians at Savu. Like her eighteenth-century counterpart, Sydney Parkinson, Lucy found that drawing was a means of engaging in friendly relations with the people she met.

into liquor. Treacle can be made from it and sugar in much the same way as maple syrup. The palm leaves are used for thatching houses and [making] many different domestic utensils such as bowls and mats. Even the basket which collects the sap is made out of the palm leaf.

### LUCY'S JOURNAL – 27 September 2001

The first thing our hosts did on our arrival was to take us to a palm. One of the guys, dressed in a traditional-looking ikat sarong, on to which was tied a knife in a palm-woven sheath, quickly shimmied up the trunk using first the remnants of old leaf bases (the first 5–6 feet/150–180 cm), then rocks wrapped around the trunk with cloth, placed quite far apart on alternating sides of the trunk. He carried with him a large basket – exactly the same one as in a drawing done by one of Banks's artists – and worked up in the crown (about 20 feet/6 metres off the ground) collecting juice from the smaller bowls hung up there.

Back on the ground a guide explained things to us. The climber was singing as he worked, apparently some 'joyous morning work song'. He told us that children drank the juice for breakfast every day, and the juice was so much a part of everyone's diet that people from outside Savu might once have thought that Savu people never ate anything else!

When the climber came back down, he carried with him a large palm-basket full of juice, which was frothy on top. He strained off a portion into a smaller bowl for everyone to try.

BELOW: The unfermented juice of the fan palm was brought down from the tree in woven palm baskets and offered to the shore party to sample. Banks recorded how the sap 'had a very sweet taste and suited all our palates very well, giving us at the same time hopes that it might be serviceable to our sick, as being the fresh, unfermented juice of the tree, it promised anti-scorbutic virtues'.

RIGHT: A basket used for collecting palm sap – the design of which has not changed for hundreds of years – was drawn by Lucy Smith. As Banks noted of the useful fan palm, 'the leaves serve to thatch their houses and to make baskets, umbrellas or rather conical bonnets, cups, tobacco-pipes &c &c'.

JONATHAN'S JOURNAL – 27 September 2001

The climber offered me some sap to drink from the basket. I found it delicious – like coconut, but with a refreshing acid edge, just like Banks says.

LUCY'S JOURNAL – 27 September 2001

It was pretty nice – not a very nice smell but a good taste and extremely thirst-quenching. I'm pretty sure that the flowers I examined were still in bud, which would support the theory that the juice is tapped at the time when the palm is sending all its energy into an inflorescence which is about to take off. This would seem to make the most sense.

Our botanist, Tom Hoblyn, was now invited to climb the palm tree to see the sapping process for himself.

TOM'S JOURNAL – 27 September 2001

Stones are tied to the trunk of the palm so it can be climbed and the baskets full of sap retrieved. I tried to climb up in bare feet since I was told this would be easier but I only managed to get half way – the pain was too much! When I got down I had lots of small cuts on my feet and hands – I suppose I am too

OPPOSITE: The distinctive house of a chief of Savu, which stands on stilts and is thatched with palm leaves, was drawn by Sydney Parkinson and described by Banks as 'very cool and agreeable'. Those of us who went ashore at Savu during the BBC voyage saw similar houses and witnessed several other traditional practices, such as the gathering of sap from fan palms.

RIGHT: The BBC's botanist, Tom Hoblyn, climbed a fan palm tree to see the sapping process for himself, which Banks described as follows: '[the sap] is got by cutting the buds which are to produce flowers soon after their appearance and tying under them a small basket made of the leaves of the same tree, into which the liquor drips and must be collected by people who climb the trees for that purpose every morning and evening'.

thin-skinned. Nonetheless, one person gave me one of the palm baskets that the fan palm sap is collected in. It is beautifully made, and yet so simple.

LUCY'S JOURNAL – 27 September 2001

Before I came ashore I had a look at the pictures drawn and painted by the *Endeavour*'s artists. There were four pictures from Savu: two pencil drawings by Spöring, Banks's secretary, and two by the botanical artist Parkinson. Spöring had drawn the actual palm basket from which we had been drinking, and Parkinson had sketched someone climbing the palm tree carrying baskets. I asked one of the islanders if this method of making baskets and climbing the trees has changed at all in over 200 years, and he said no.

We now moved to the centre of the clearing, where musicians were playing the drums and the dancers were getting ready to perform.

The dancing and music were great, kind of like a vastly simplified gamelan/percussive sound with lots of drumming. Their costumes were mainly ikat wrappings with ornaments woven from palm-mats, with very fine and intricate curly palm bits dangling off them. Later on the girls came out dressed very simply with ikat worn across the chest, over a very long ikat skirt, the top pulled in at the waist by a golden belt, and a single elegant wooden bangle around one wrist. Their hair was pulled tightly back and kept in a low-netted bun. The main focus of their movements was in the hands, which were turned around, long fingers in various beautiful positions.

The dancing celebrated various moments in the life of the community, such as war and the husking of rice. The women seemed called upon to smile winningly and make calming movements with their hands, while the men stamped and waved their swords about.

The *Endeavour* crew members who had been watching the display were now asked to join in the dances themselves.

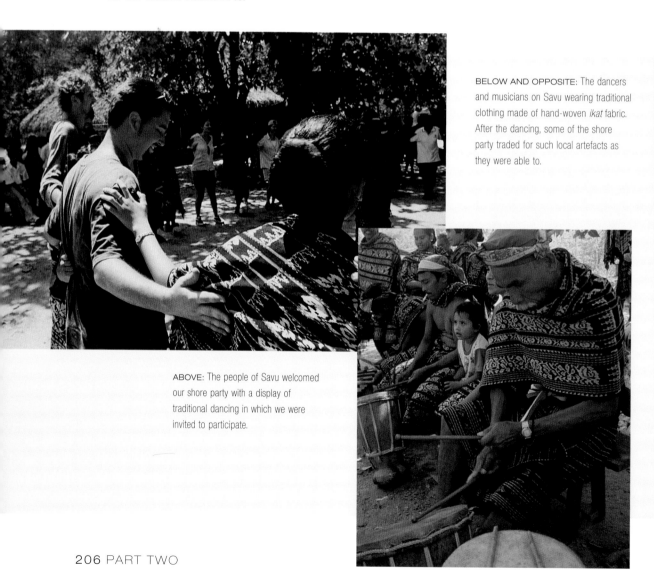

BELOW AND OPPOSITE: The dancers and musicians on Savu wearing traditional clothing made of hand-woven *ikat* fabric. After the dancing, some of the shore party traded for such local artefacts as they were able to.

ABOVE: The people of Savu welcomed our shore party with a display of traditional dancing in which we were invited to participate.

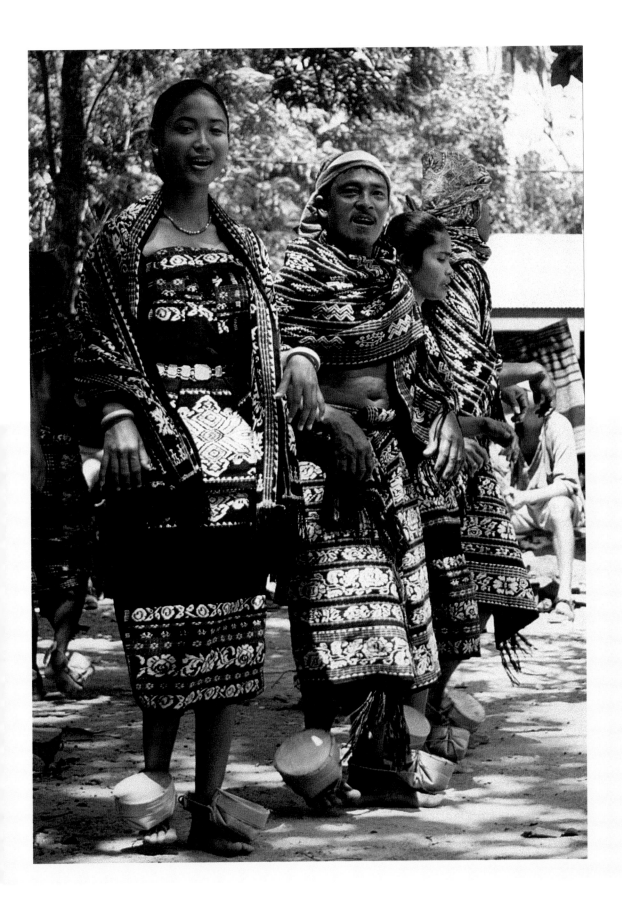

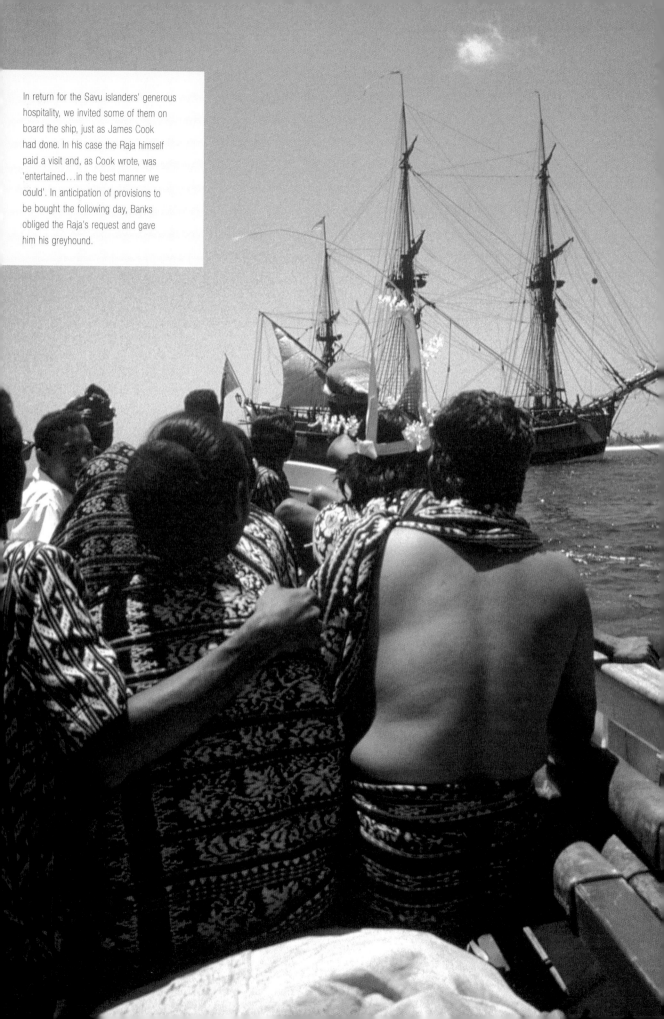

In return for the Savu islanders' generous hospitality, we invited some of them on board the ship, just as James Cook had done. In his case the Raja himself paid a visit and, as Cook wrote, was 'entertained…in the best manner we could'. In anticipation of provisions to be bought the following day, Banks obliged the Raja's request and gave him his greyhound.

Lastly, there was a dance in which we all participated, the *pedoa*: the dancers had small palm receptacles filled with pebbles attached to their feet, which they stomped and shuffled in the dusty ground. The *pedoa* had a call and response structure, the plaintive call of which was sung in a nasal, high-pitched tone by a man, whose mother, seizing my arm, pointed him out as her son. I was drawn into the circle of dancers, but was also feeling the effects of the betel and the heat.

JONATHAN'S JOURNAL – 27 September 2001

Like the countryside, the dances were all picturesque, and around me I could hear people declaring that it was the best day of the voyage.

After the dancing had finished, the shore party chatted with our hosts and some traded US dollars for local artefacts. The palm spirit, which we had not yet tasted, was now being passed around. Under Franz's direction, the islanders had been exceedingly generous in sharing the island's culture and history. In return, we invited our hosts to visit the ship before we set sail that afternoon. Cook had invited the island's raja on board, just as Tahitians, Society Islanders, Maori and Aborigines had been welcomed on to the ship earlier in his voyage.

VANESSA'S JOURNAL – 27 September 2001

In a gesture of reciprocal hospitality, the dancers, still in costume, were taken aboard the ship. It was of course a great spectacle: saronged dancers with fancy headdresses, betel-mouthed, toothless old men and young women of ethereal beauty juxtaposed against the European age of sail. It was like two relics of a bygone age meeting for the camera.

After such an extraordinary morning ashore, the contrast of being back on the ship for our final week at sea came as a surprise.

VANESSA'S JOURNAL – 27 September 2001

The food we were given when we got back to the ship was the worst I've ever seen: three-inch cubes of pork lard floating in fatty water with the odd barley kernel thrown in. Although some of the *Endeavour*'s crew have strong stomachs, no one could muster the will to eat it.

LUCY'S JOURNAL – 27 September 2001

After lunch we had a brief rest before starting on what we all knew would be a marathon afternoon, having learnt by now that you have to earn your pleasure on this ship. An anchorage is always followed by a hard haul on the capstan, and all the sails have to be put up. The whole process of setting sail seemed to drag on and on.

Before going to bed that night I lay exhausted on the deck for a while. I listened to Stu play a lovely strummed tune; two others from my watch were sitting behind me. We were all feeling quiet and wistful, nobody spoke, and I got a bit teary, letting myself cry a bit in the dark.

# Epilogue

As the ship entered the strait leading to Batavia, Joseph Banks idealized the health of the *Endeavour*'s seamen and contrasted it with the pale faces of those on board another ship anchored in the channel. 'The people were almost as spectres, no good omen of the healthiness of the country we were arrived at; our people however, who truly might be called rosy and plump, for we had not a sick man among us, jeered and flouted much at their brother seamen's white faces.'

Banks's observation proved, unfortunately, correct. The *Endeavour* was entering a city of unsanitary canals and mosquito-infested swamps. Over the following three months the ship was repaired and fully reprovisioned for the return journey to England via the Cape of Good Hope. During this time, many of the crew who had stayed healthy for two years at sea now went down with malaria and dysentery. Five of them died at Batavia, the first of whom was the surgeon, William Monkhouse. He was followed by Tayeto and then Tupaia. On 9 November 1770 Cook recorded how 'our people are so weakened by sickness that we could not muster above 20 men and officers that were able to do duty'.

The wooden world of the tall ship seen from the top of the main mast, about 100 feet (30 metres) above the weather deck. The *Endeavour* took six months to reach England from Java, anchoring off the Cape of Good Hope and St Helena en route. During the course of the entire voyage, forty-three people died, thirty-five of them on the homeward stretch between Batavia and England.

At sea the situation grew worse: mosquitoes were breeding in the ship's water and replacement supplies taken on at Prince's Island off Java also turned out to be bad. In Cook's eyes this was the cause of 'fevers and fluxes' among the crew. As the ship ploughed on through humid weather to the Cape of Good Hope, twenty-two men died. Cook wrote, 'This unwholesome air had a great share in [bringing the disease among our people] and increased it to the degree that a man was no sooner taken with it than he looked upon himself as dead; such was the despondency that reigned among the sick at this time.'

Cook's journal is often brief and matter of fact about the disease ravaging his crew. Take, for example, his entry on 27 January 1771: 'Little wind and sometimes calm. In the evening found the variation to be 2° 51' W. Departed this life Mr Sydney Parkinson, natural history painter to Mr Banks.' This is a surprisingly scant epitaph for someone with whom Cook must have spent many hours in the wardroom and Great Cabin. Perhaps, however, such restraint was the only way to cope. Cook is almost equally brief about the others who passed away. When four men died in one day he allowed himself a typically terse exclamation: 'Melancholy proof of the calamitous situation we are at present in, having hardly well men enough to tend to the sails and look after the sick, many of the latter are so ill that we have not the least hopes of their recovery.'

Over the next four weeks, the death toll mounted. Some of the seamen began to lose their minds: in the close confines of the ship one man was punished for beating up the sick; another, in good health, one day 'threw himself into a fit' after stamping and exclaiming, 'I have the gripes! I have the gripes! I shall die! I shall die!' During this time Cook established extra measures to improve hygiene and keep minds occupied: the decks were washed down with vinegar and fumigated, the men exercised in small arms and many hours were spent repairing the sails.

## Two Worlds

On arrival at the Cape of Good Hope, Cook met with a ship from India that had 'lost by sickness between 30 and 40 men and had at this time a good many down with the scurvy'. This news led him to contrast that ship's record of health against the *Endeavour*'s, and to anticipate how the two would be received in England. He reflected bitterly that although he had managed to keep his crew largely free of scurvy, the distinction would not be made between the sickness on his own ship (caused by conditions at Batavia) and ships beset by scurvy due to their captains' less vigilant approach to health.

> …we find that ships which have been little more than twelve months from England have suffered as much or more by sickness than we have done who have been out near three times as long. Yet their sufferings will hardly, if at all, be mentioned or known in England when on the other hand those of the *Endeavour*, because the voyage is uncommon, will very probably be mentioned in every newspaper, and what is not unlikely with many additional hardships we never experienced. For such are the disposition of men in general in [the case of] these voyages that they are seldom content with the hardships and dangers which will naturally occur but they must add others which hardly ever had existence but in their imaginations.

During the BBC voyage, historian Jonathan Lamb pointed out that Cook's anxiety arose not only from his concerns about how the voyage would be viewed by posterity. His journal (not for the first time) showed that he was also making a distinction between the reality of life on the ship – the wooden world – and the judgement of the outside world, of newspapers and of 'men in general'. As Jonathan said:

> That larger world is the place where Cook is never sure what's going to happen; he's never sure whether he's going to be praised or blamed. Whereas when he's out charting the ends of the Earth in his ship, he knows exactly what he's doing. Life has a kind of consistency and a purpose and a definiteness that gives him the pleasure of being the first discoverer. The other world simply interferes with that pleasure.

On 19 June 1771, less than a month away from England, Cook learnt from a passing schooner that Britain's disputes with her colonies in America had been settled. More mournfully, on 7 July a brig from Liverpool relayed how, on the basis of a newspaper

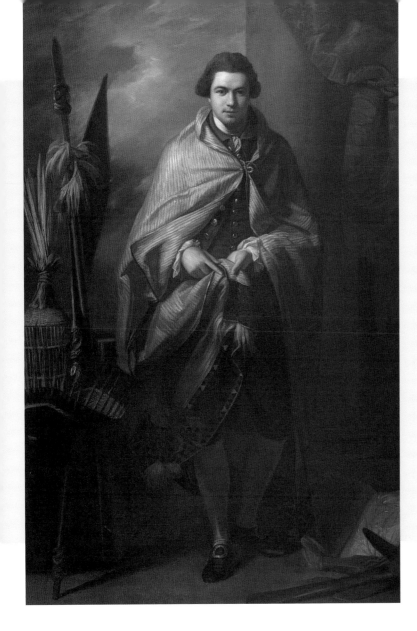

This portrait of Joseph Banks by Benjamin West, *c.* 1773, shows him wearing a Maori cloak over his English clothes and surrounded by South Seas artefacts collected on the *Endeavour* voyage. The value that these items attained back in Britain inspired the crew on Cook's second voyage to seize upon any object, however mundane, during the exploration in the Pacific. Today it is debated whether Banks is here displaying the curiosities of a dilettante or the specimens of a scientist.

rumour, wagers had been made in England that the *Endeavour* and all her crew had perished in the South Pacific. Perhaps for Cook such news reinforced the uncertain relationship between the world outside and the wooden world of the ship.

On the BBC voyage there was a perceptible divide between these two worlds. In his journal Jonathan wrote, 'Vanessa reminded me yesterday that the ship gets referred to as "the world" by the captain and the idlers. After yesterday's mammoth clean-up they said, "The world is clean, again." At one of the ship's morning meetings the first officer said, "Who wants news? Enjoy this world."' Sometimes the wooden world was a place where, in contrast to the uncertainties ashore, the simple life could be achieved, where there was a sense of security in the company we kept, the regular pattern of eating and sleeping, and the basic tasks of cleaning, maintaining and sailing the ship. Even our Saturday nights of fun were circumscribed. At other times, however, the ship seemed constraining, and contrasted unfavourably with the freedom, autonomy and responsibilities offered by life ashore. Historian Vanessa Agnew wrote about this in her journal.

> It occurred to me the other day that I have very little stress on the ship. This is perhaps due to the fact that there is perceived to be only today. Like adherents of a 12-step programme, we express no sense of anticipation about the morrow. In spite of our 'historical' mandate, we also recall no yesterday. We lack control over anything but the mundane. Our decision-making powers are reduced to simple discrimination. It's as though all complexity of communication and thought have been distilled to binary language. Like experimental apes with an on/off lever, we ask ourselves, 'Shall I eat my raisins?' or 'Shall I wash or sleep?'

The distinction between the two worlds came into sharp focus when the captain, Chris Blake, called a meeting on the quarterdeck and announced to the ship's company the news of the terrorist attacks in the USA on 11 September 2001. While most parts of the world were flooded with television images of those events, the ship had sailed on unaware through the calm Arafura Sea until Chris Blake turned on the radio the following morning.

The ship was perhaps one of the few places in the world to be isolated from the full force of those television pictures. Those who lived in the USA or had relations there immediately used the satellite telephone to check on the safety of their family and friends. After that, the world of the ship seemed all the more remote. On advice from the BBC in London, the project continued, but anti-US demonstrations in Jakarta, our final destination, made us head for Bali instead. The news of 11 September 2001 made some on board glad to be so sheltered; others felt that our isolation seemed like an indulgence and that the project had lost its purpose.

The ship came to mean different things to different people on our voyage and on Cook's. It is tempting to view the *Endeavour* voyage as the sum of its enlightened goals and undeniable achievements. The field of European knowledge had been extended in many ways under the secular eyes of the officers and gentlemen: for example, 1400 new species of plants had been added to Linnaeus's system of classification; Newton's laws of the universe were becoming better understood following the observation of the Transit of Venus; Maskelyne's lunar distance method of navigation had proved to be both reliable and practical; the Society Islands, New Zealand and eastern Australia had been accurately surveyed and detailed in charts that would become the standard well into the nineteenth century; potential sites for new British alliances, colonies and trade – the imperial ideals of Britain at this time – had been assessed; and studies of man as part of nature had been distilled into ethnographic accounts, even though the methodological means to unravel the layers of these new societies did not yet exist. The *Endeavour* voyage had opened up the South Pacific and connected a distant region of the globe with Europe. The sweep of exploration, in all senses, had been extraordinarily broad, and, through our own investigations during the six-week BBC voyage, botanists, navigators and historians had come to appreciate this in new ways. These achievements characterized the pace and areas of change in eighteenth-century Europe: modes of thought were being liberated from the constraints of religion, and better, happier lives were being advocated by philosophers through the application of knowledge and reason.

However, just as the Enlightenment can be said to have been the preserve of an educated and wealthy elite, so life on board the *Endeavour* can be said to have enlightened the gentlemen and officers more than the seamen, marines and servants.

All those on the BBC voyage, whether volunteers or specialists, found out what it was like to live and work on an eighteenth-century tall ship. It required the efforts of the whole company to hoist on board the pinnace and the yawl, to turn the capstan and haul the fat anchor ropes. Other tasks included treating the rigging with viscous Stockholm tar, which volunteers then scrubbed off their bodies with kerosene; the caulking was stripped and smoothed, the masts sanded and varnished; sails were sewn and fresh new rope was stretched and tarred; heavy barrels, buckets, cauldrons and casks were in constant motion between the decks; and every day the members of each watch were exposed to the dangers of climbing the rigging and furling and unfurling sails. The demands of the ship were insatiable. After six weeks on board the cramped vessel we could all better imagine how worn out people became on Cook's three-year voyage of exploration. It was almost as though in the process their bodies had become one and the same with the fabric of the ship and its regime. This state of dependency had consequences back on land. As Jonathan Lamb wrote in his journal:

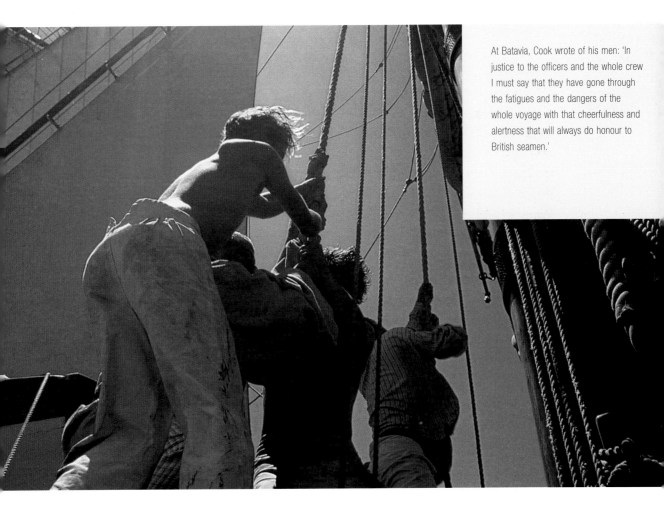

At Batavia, Cook wrote of his men: 'In justice to the officers and the whole crew I must say that they have gone through the fatigues and the dangers of the whole voyage with that cheerfulness and alertness that will always do honour to British seamen.'

When I was bent double yesterday over my scrubbing brush, I tried to imagine how it would have been for eighteenth-century sailors – the unity of the wooden world was in conflict with a natural feeling for oneself and one's future. The use of labour on this ship reminded me how their bodies were used up quickly by exhaustion, wounds, disease and industrial accidents. Perhaps they gave themselves a time limit at sea, but their behaviour ashore would put that kind of independence largely out of their power. The nineteenth-century writer Richard Henry Dana talks about a man on his ship, a skilled mathematician and astronomer, who was totally undone by booze as soon as he got ashore.

## England Again

On 11 July 1771 a lookout sighted Land's End and the next day the *Endeavour* anchored in the Downs. Cook wrote to the Admiralty expressing his intention to 'repair to their office in order to lay before them a full account of the proceedings of the whole voyage'. A few days later, the *London Evening Post* reported: 'Their voyage upon the whole has been as agreeable and successful as they could have expected.' The Transit of Venus had been accomplished, and while they had not found the Great Southern Continent, there were discoveries to show nonetheless. However, it was Banks and Solander who reaped the immediate attention and excitement with which the *Endeavour*'s return was greeted.

The botanists were the first to be received by King George III at court, having 'the honour of frequently waiting on His Majesty at Richmond who is in a course of examining their whole collection of drawings of plants and views of the country'. Linnaeus wrote a letter to Banks, praising his bravery in the field and his vast collection of newly discovered plants. The specimens and their seeds were put to immediate use: newspapers reported that 'Dr Solander has presented the Princess Dowager of Wales with several curious exotic plants for her Royal Highness's gardens at Kew'. This was the beginning of the Royal Botanic Gardens at Kew as we know it today. Banks and Solander received honorary doctorates from Oxford University and were fêted by London society, attending parties and telling of their adventures.

Although more quietly, Cook too received his rewards. He wrote to John Walker, 'I venture to inform you that the voyage has fully answered the expectation of my superiors. I had the honour of an hour's conference with the King the other day who was pleased to express his approbation of my conduct in terms that were extremely pleasing to me.' Cook was duly promoted to the rank of commander, and it was not long before his second voyage to the South Seas, capitalizing on the successes of the first, would be planned in earnest. The outcome of that voyage would see him celebrated in his own right. While he was at sea, a re-written version of the *Endeavour* journals, edited by Dr John Hawkesworth, was published. Cook read it on his return and as a result insisted on publishing his own journal of the second voyage. (Hawkesworth's version of the first remained the only account available until 1893.)

The *Endeavour* itself was paid off at Woolwich and refitted as a store ship for a voyage to the Falklands. Cook later praised the ship as the object instrumental to his success.

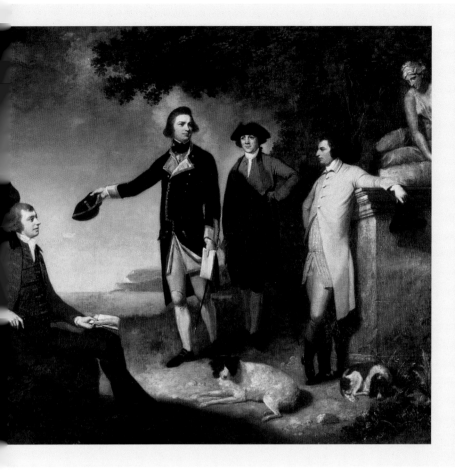

Following the successful completion of the *Endeavour* voyage, James Cook was depicted in elevated company. This painting by John Hamilton Mortimer, *c.* 1771, shows Cook (centre) flanked by Daniel Solander and Joseph Banks (left) and the Earl of Sandwich, the First Lord of the Admiralty (far right).

[It enabled me] to prosecute discoveries in those seas so much longer than any other man ever did or could do. And although discovery was not the first object of that voyage, I could venture to traverse a far greater space of sea before then un-navigated; to discover greater tracks of country in high and low south latitudes and even to explore and survey the extensive coasts of those new discovered countries than was ever performed during one voyage.

However, on her immediate arrival back in Britain, the *Endeavour* was in a poor way. During the final stretch of the homeward voyage the ship had been falling apart, and Cook recorded how 'our rigging and sails are now so bad that some thing or another is giving way every day'. Cook submitted a report to the Admiralty on the state of the *Endeavour*. It reflected how the numbers of men and their status had changed significantly since the ship first set out: 29 men had joined the ship at Batavia and the Cape of Good Hope to replace the dead and the sick, being entered in the muster books as part of the ship's company from 6 November 1770 onwards. It read: 'Complement 85, Borne 82, Mustered 80, Widow's men 2, Sick 19. Supernumeraries 8. Provisions on board 21 days of bread, 28 days arrack, 4 days beef, 4 days port, 4 weeks pease, oatmeal or rice, 4 weeks sugar; water 10 tons. Condition of the Bark: Foul.'

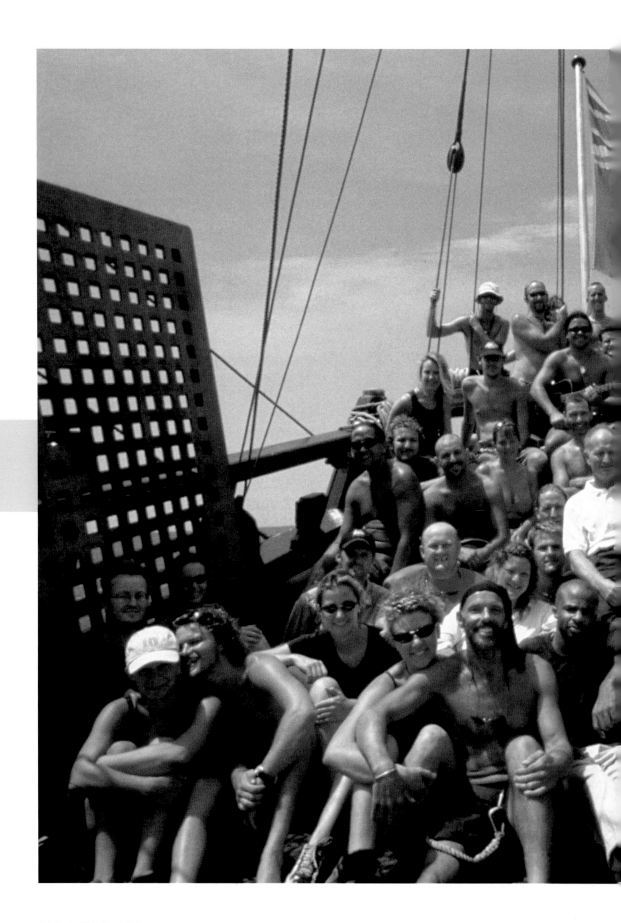

The ship's company on the BBC voyage, after six weeks on board the replica *Endeavour*, gathered on quarterdeck for this group shot as we approached our final destination, Bali. The author of this book is standing second from right.

# Acknowledgements

I would like to express my sincere thanks to the many people who have helped in the realization of this book. My first thanks go to the journal writers – Professor Vanessa Agnew (University of Michigan), Dr Claire Edwards, John Gilbert, Tom Hoblyn, John Jeffrey, Dr Merata Kawharu (University of Auckland), Professor Jonathan Lamb (Vanderbilt University), Professor Iain McCalman (Australian National University), Caroline MacDermott, Lucy Smith and Chris Terrill – whose writings form an integral part of the book and who made the history that we set out to explore in the series come alive in a fresh and exciting way. It was a great pleasure to read and share their insights, observations and feelings from the voyage and I am very grateful to them for allowing their use in this book. Restrictions on space prevented me from using all the journals written during the voyage: my apologies to those concerned.

At the Endeavour Foundation in Australia, my thanks go to captain Chris Blake, all the members of the permanent and shore crew for their able and enthusiastic assistance, and in particular to Antonia Macarthur, the ship's curator, archivist and historian, who was always at hand to answer questions and share her knowledge. Thanks also to all the BBC volunteers for their game participation in the voyage. I am very grateful to Eric Deeral for allowing me to quote from his oral history of the Gamay Warra. George Huxtable kindly read the chapter on navigation and made very helpful comments. In the latter stages of the six weeks at sea I and the book both benefited from conversations and friendships with Vanessa Agnew, Jonathan Lamb and Alex Cook. I also owe a great deal of thanks to Professor Glyn Williams, the leading historian of European voyages of exploration in the eighteenth century. Glyn generously shared his wisdom and expertise not only during the preparation for the BBC voyage, but also in reading a draft of this book and making valuable comments.

At BBC Worldwide I would like to thank the commissioning editor, Shirley Patton, for her patience and support throughout my steep learning curve of writing a book. I am grateful to Martin Redfern for his helpful advice, to Linda Blakemore for the art direction, and to Deirdre O'Day and Miriam Hyman for their picture research. Special thanks must go to Martin Hendry for all his wonderful work on the design of the book, and to Trish Burgess, the project editor, who through long telephone calls, working weekends and tireless labours on the manuscript and proofs has been a constant source of encouragement and help.

My warm thanks go to the series production team at the BBC's history department. I am extremely grateful to Laurence Rees, the executive producer, for putting me forward to write this book in the first place. His generous support is much appreciated. Ann Cattini, the production executive, has been always been there to listen and offer her encouragement throughout the production and writing of the book. It has been a genuine pleasure working with Laura Davey, the production manager, Kate Gorst, the production coordinator, who was especially kind and helpful in Australia, Vanessa Cobb, the assistant producer, Milica Budimir, who coordinated the drama shoot, Joel Legate, the camera assistant, and Stuart Bruce, who did the sound. The producer of the series Chris Terrill was understanding about fitting the demands of this book into a busy production schedule and I am very grateful for all his help.

Finally, I would like to thank the series researcher, Tanya Batchelor, not only for her hard work during the production, but also for enthusiastically reading the manuscript, offering lots of insightful advice, inspiration and focus just when I needed it, and never wavering in her support, friendship and cheeriness.

# Bibliography

## Primary Sources

*An Account of the Discoveries Made in the South Pacifick Ocean Previous to 1764*, Alexander Dalrymple, London, 1767; reissued by Hordern House for the Australian National Maritime Museum, Sydney, 1996

*The* Endeavour *Journal of Joseph Banks, 1768-1771*, Vols I and II, ed. J.C. Beaglehole, Public Library of New South Wales/Angus & Robertson, Sydney, 1962

*A Journal of a Voyage to the South Seas,* Sydney Parkinson, London, 1784; reprinted by Caliban Books, London, 1984

*The Journals of Captain James Cook, Vol. I: Voyage of the* Endeavour *1768–1771*, ed. J.C. Beaglehole, Cambridge University Press for the Hakluyt Society, Cambridge, 1955

## Secondary Sources

*The Art of Captain Cook's Voyages: The Voyage of the* Endeavour *1768–1771*, Rüdiger Joppien and Bernard Smith, Yale University Press, New Haven and London, 1985

*Background to Discovery: Pacific Exploration from Dampier to Cook*, ed. Derek Howse, University of California Press, Berkeley, 1990

*Captain Cook's World: Maps of the Life and Voyages of James Cook RN*, John Robson, University of Washington Press, Seattle, 2000

*Captain James Cook and His Times*, ed. Robin Fisher and Hugh Johnston, Douglas & McIntyre, Vancouver, and Croom Helm, London, 1979

*The Charts and Coastal Views of Captain Cook's Voyages, Vol. I: The Voyage of the* Endeavour *1768–1771*, chief ed. Andrew David, Hakluyt Society, London, in association with the Australian Academy of the Humanities, Melbourne, 1988

*Europe in the Eighteenth Century, 1713–1783*, M.S. Anderson, Longman, London and New York, 1987

*The Great Map of Mankind: British Perceptions of the World in the Age of Enlightenment*, P.J. Marshall and Glyndwr Williams, Dent, London, 1982

*His Majesty's Bark* Endeavour*: The Story of the Ship and Her People*, Antonia Macarthur, Angus & Robertson in association with the Australian National Maritime Museum, Sydney, 1997

*HM Bark* Endeavour*: Her Place in Australian History*, Ray Parkin, Melbourne University Press, Melbourne, 1997

*Joseph Banks*, Patrick O'Brian, Harvill Press, London, 1997

*The Life of Captain James Cook*, J.C. Beaglehole, A. & C. Black, London, 1974

*Mr Bligh's Bad Language: Passion, Power and Theatre on the* Bounty, Greg Denning, Cambridge University Press, Cambridge, 1992

*Nature's Government: Science, Imperial Britain and the 'Improvement' of the World*, Richard Drayton, Yale University Press, New Haven and London, 2000

*An Oxford Companion to the Romantic Age: British Culture 1776–1832*, general ed. Iain McCalman, Oxford University Press, Oxford, 1999

'Precursors of Cook: The Voyages of the *Dolphin*, 1764–8', Randolph Cock in *Mariner's Mirror*, Vol. 85, No. 1 (February 1999), pp 30–52

*Preserving the Self in the South Seas, 1680–1840*, Jonathan Lamb, University of Chicago Press, Chicago, 2001

*Science and Exploration in the Pacific: European Voyages to the Southern Oceans in the Eighteenth Century*, ed. Margarette Lincoln, The Boydell Press in association with the National Maritime Museum, Woodbridge, Suffolk, 1998

*Sydney Parkinson: Artist of Cook's* Endeavour *Voyage*, ed. D.J. Carr, Croom Helm, London, 1983

*Terra Australis to Australia*, ed. Glyndwr Williams and Alan Frost, Oxford University Press in association with the Australian Academy of the Humanities, Melbourne, 1988

*Two Worlds: First Meetings between Maori and Europeans, 1642–1772*, Anne Salmond, Viking, Auckland and London, 1991

*The Wooden World: An Anatomy of the Georgian Navy*, N.A.M. Rodger, Collins, London, 1986

# Index

## Picture Credits

BBC Worldwide would like to thank the following for providing photographs and for permission to reproduce copyright material. While every effort has been made to trace and acknowledge copyright holders, we would like to apologize should there be any errors or omissions.

Pages 1, 2–3, 7 BBC/Chris Terrill; 8 © The National Maritime Museum, London; 10, 11, 13, 15, The British Library, London; 16 © Ticktock Entertainment Ltd; 18–19, 20, 22–3 BBC/Simon Baker; 24–5 Huntingdon Library Art Collections and Botanical Gardens, San Marino, California/Superstock; 26–7 Österrische Nationalbibliothek, Vienna/Foto Leutner Fachlabor, Vienna; 29 (t) The National Maritime Museum, London, (b) The British Library, London; 30, 32 The British Library, London; 32–3 by permission of The National Library of Australia, Canberra; 34, 36–7 © The National Maritime Museum, London; 37 The British Library, London; 40–1 The Scottish National Portrait Gallery; 43 Agnew & Sons, London/Bridgeman Art Library; 45 (l) Linnean Society, London/Bridgeman Art Library, (r) © The Natural History Museum, London; 47, 48 © The National Maritime Museum, London; 50–1 The National Library of Australia, Canberra/Bridgeman Art Library; 52, 53 © The National Maritime Museum, London; 55 © Ticktock Entertainment Ltd; 56, 58 The Endeavour Foundation; 61 (tl) BBC/Lucy Smith, (tr & b) BBC/Christian Mushenko; 62 (tl & r) The British Library, London, (b) BBC/Simon Baker; 64 The British Museum, London/Bridgeman Art Library; 65 (l) The Endeavour Foundation, (r) © The National Maritime Museum, London; 66–7 The British Library, London; 67 Private Collection/Bridgeman Art Library; 68, 69 The British Library, London; 70–1 BBC/Chris Terrill; 72–3 © The National Maritime Museum, London; 75 (inset) © The Natural History Museum, London; 76, 79, 81, 82 © The Natural History Museum, London; 83 from the collection at Parham Park, West Sussex, England; 85 The British Library, London; 86, 87 © The Natural History Museum, London; 88 The British Library, London; 92 BBC; 95 (l) BBC/Christian Mushenko, (r) BBC/Lucy Smith; 97 (l) © The Natural History Museum, London, (r) BBC/Lucy Smith; 98 BBC/Simon Baker; 100 © The Natural History Museum, London; 101 BBC/Lucy Smith; 102 BBC/Chris Terrill; 103 (t) © The Natural History Museum, London, (b) BBC/Lucy Smith; 106–7 BBC/Simon Baker; 109 (t) The British Library, London, (b) BBC/Simon Baker; 110–11 The British Library, London; 113 BBC/Lucy Smith; 114 The British Library, London; 115 The Mitchell Library, State Library of New South Wales/Bridgeman Art Library; 119 The National Portrait Gallery, London; 120 The British Library, London; 123 The National Library of Australia, Canberra/Bridgeman Art Library; 125, 129 The British Library, London; 132–3 BBC; 135 The British Library, London; 137 © The Natural History Museum, London; 141 BBC/Simon Baker; 142–3 BBC/Chris Terrill; 145 (l) Private Collection/Bridgeman Art Library, (r) © The National Maritime Museum, London/The Bridgeman Art Library; 146 Private Collection/Bridgeman Art Library; 148 © The National Maritime Museum, London; 150 (t) The British Library, London, (b) © Crown Copyright 2002. By permission of the Controller of Her Majesty's Stationery Office and the UK Hydrographic Office; 152–3 © Crown Copyright 2002. By permission of the Controller of Her Majesty's Stationery Office and the UK Hydrographic Office; 153 The British Library, London; 154–5 The Mitchell Library, State Library of New South Wales; 157 © The National Maritime Museum, London; 158–9 BBC; 162 BBC/Simon Baker; 165 BBC/Chris Terrill; 166 BBC/Simon Baker; 168–9 The British Library, London; 170–1 © The National Maritime Museum, London; 173 The British Library, London; 174 © The Natural History Museum, London; 178 BBC/Chris Terrill; 180 Musée des Arts Décoratifs/Dagli Orti/Art Archive; 182 The British Library, London; 184 Private Collection/Bridgeman Art Library; 186, 187, 189, 190, 191, 192, 193, 195 The British Library, London; 196–7 BBC; 201 BBC/Chris Terrill; 202 BBC/Simon Baker; 203 (l) BBC/Simon Baker, (r) BBC/Lucy Smith; 204 The British Library, London; 205 BBC/Simon Baker; 206 (l) BBC/Simon Baker, (r) BBC/Chris Terrill; 207 BBC/Simon Baker; 208, 210–11 BBC/Chris Terrill; 213 Lincolnshire County Council, Usher Gallery, Lincoln/ Bridgeman Art Library; 215 BBC/Simon Baker; 216–17 The National Library of Australia, Canberra/Bridgeman Art Library; 218-19 BBC/Chris Terrill; 224 BBC/Simon Baker; endpapers The British Library, London.

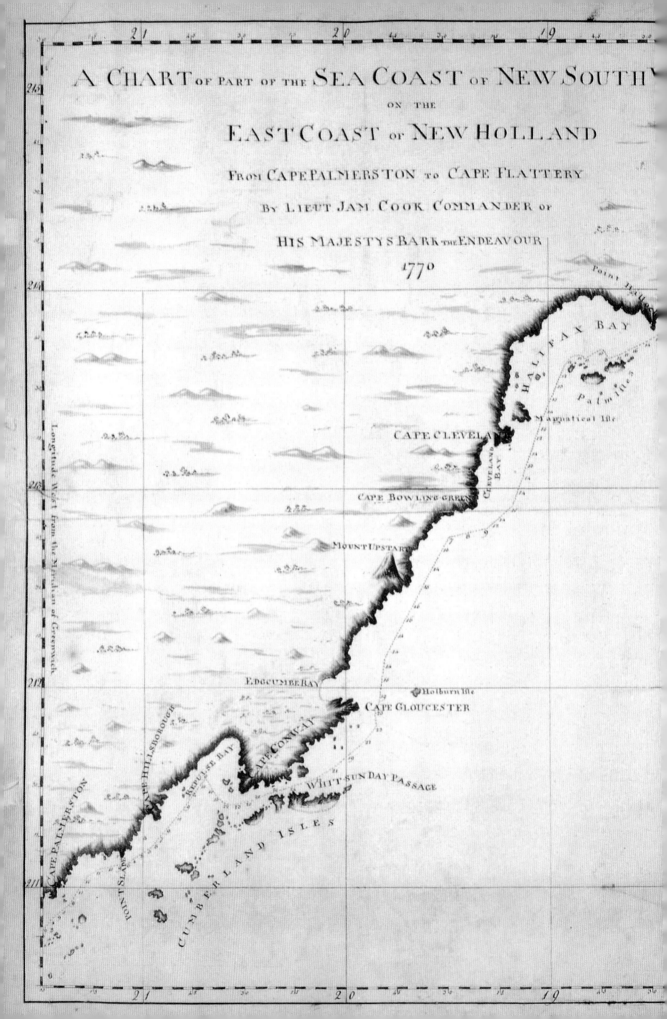

# A CHART of Part of the SEA COAST of NEW SOUTH

## ON THE

## EAST COAST of NEW HOLLAND

### From CAPE PALMERSTON to CAPE FLATTERY

### By LIEUT JAM. COOK COMMANDER of

### HIS MAJESTYS BARK the ENDEAVOUR

### 1770

Point Hall

HALIFAX BAY

Palmettos

Magnatical Isle

CAPE CLEVELAND

Cleveland Bay

CAPE BOWLING GREEN

MOUNT UPSTART

EDGCUMBE BAY

Holburn Isle

CAPE GLOUCESTER

CAPE HILLSBOROUGH

REPULSE BAY

CAPE CONWAY

WHIT SUN DAY PASSAGE

CAPE PALMERSTON

POINT SLADE

CUMBERLAND ISLES

Longitude West from the Meridian of Greenwich